# Mexican Painters

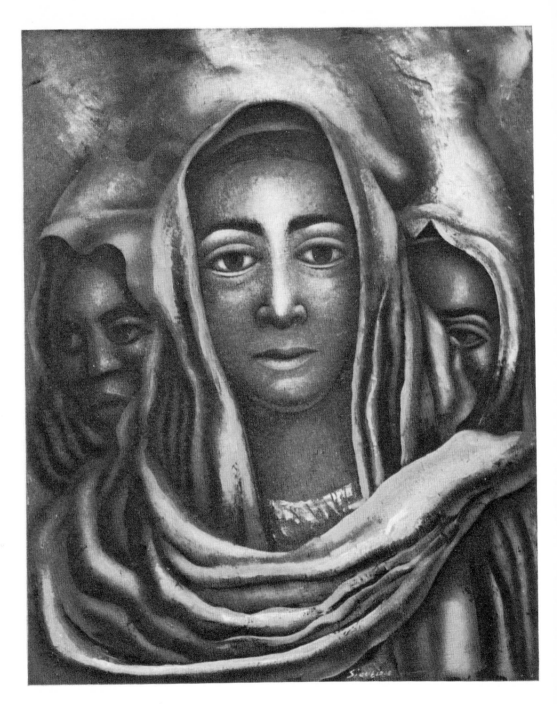

1. LA PATRONA

Duco on board, 1939. David Álfaro Siqueiros

# MEXICAN PAINTERS

RIVERA, OROZCO, SIQUEIROS
AND OTHER ARTISTS OF THE
SOCIAL REALIST SCHOOL

*by*

## MacKinley Helm

ILLUSTRATED

DOVER PUBLICATIONS, INC.
NEW YORK

Published in Canada by General Publishing Company, Ltd., 30 Lesmill Road, Don Mills, Toronto, Ontario.

This Dover edition, first published in 1989, is an unabridged republication of the work originally published by Harper & Brothers in 1941 under the title *Modern Mexican Painters* and first reprinted by Dover in 1974. This edition is published by special arrangement with Harper & Row, Publishers Inc., 10 East 53rd St., New York 10022.

The frontispiece and Plate 48, which were reproduced in full color in the original edition, are here shown in black and white.

International Standard Book Number: 0-486-26028-3
Library of Congress Catalog Card Number: 73-91489

Manufactured in the United States of America
Dover Publications, Inc., 31 East 2nd Street, Mineola, N.Y. 11501

FOR FRANCES

*the book we lived in Mexico*

# CONTENTS

# ILLUSTRATIONS

[ ix ]

[ x ]

[ xi ]

[ xii ]

[ xiii ]

# PREFACE

*(For Katherine Whitman)*

My dear Katherine,

When, in the Autumn of 1939, a small clamor arose amongst my friends for more stories about the Mexican painters, yours was one of the steadiest and most encouraging voices. What you really wanted, you said, was a book, a full-bodied, illustrated book which would range well beyond a recapitulation of the work of Diego Rivera, José Clemente Orozco and David Álfaro Siqueiros.

Of those three, the Mexican artists with the greatest celebrity in the United States of America, you were willing to hear more, but you wanted also to hear about their colleagues. You had no idea there were so many! I said I would try to describe them as I knew them, and also place them for you, so far as I was able, in relation to the movement through which, after a long interval, formal Mexican art was reborn.

Saint Luke, when his friends required him to write a new Gospel, began to trace the course of all things accurately and in order. I have tried to imitate him. But the course of Mexican art has been jumpy; set down in chronological order its history is mostly dull. The contemporary Mexicans have drawn upon a native tradition of more than two thousand years of periodic artistic accomplishment; but of direct influence upon their work, deliberately sought out and submitted to, they themselves admit to only a few sources. Two of these are Mexican—the art of the ancients who lived before the Spanish Conquest, and the traditional popular arts. They also recognize a debt to foreign monks and friars who painted mural decorations in the chapels and cloisters of colonial convents; whilst to the three centuries of industriously imitative academic

art produced on easels by their countrymen, before the current revival of Mexican aesthetics, they claim to owe precisely nothing.

A systematic appraisal of Mexican art before the Conquest is an archaeologist's job, but perhaps I can give you a fragmentary suggestion of its rich contents. As you doubtless know, there were many ancient Mexican cultures. Within each culture there was a diversity of plastic forms. A student of archaic Mexican art must distinguish between Aztec, Toltec and Maya, for example, and between Zapotec, Mixtec and Olmec. Beneath the levels of these great cultures lie the remains of more primitive societies nearly three thousand years old, and even the archaic peoples of that remote age produced artistically modelled forms. Thousands of objects of ancient Mexican art are on display in the National Museum in Mexico City and at the sites of excavation, such as Monte Alban and Chichen-Itzá; ancient mural paintings are preserved in carefully uncovered temples; illustrative and documentary painting has survived in illuminated scrolls.

To all of these sources the Mexican painters turn again and again for instruction in their native idiom. You will read in the book that certain modern painters have paid special attention to Maya forms, for example. Perhaps it would interest you to know that a good many characteristics of Maya art are discoverable, in one variation or another, in the collected remains. The Maya artist was respectful of draughtsmanship. He corrected and polished his designs fastidiously in his search for perfection and purity of line. He canvased the problems of surface and space. A taste cultivated by classical forms might be offended by the finicky elaborations of Maya design, but no one can complain that the Maya artist left uninteresting and negative areas in the surfaces he carved. He employed conventions and symbols and abstractions, so that his art became a kind of hieroglyphic language. He existed by reason of his services to the temple, so to speak, and it was his intention to convey hierarchical teaching as immediately as possible. Hence his work was, in a sense, literary. But because he was an artist as well as an interpreter he endowed his forms with nobility and flexibility and often with sensibility. All of

[ xviii ]

these qualities are to be found in the best and most characteristic Mexican painting: integrity of draughtsmanship; respect for the spectator's right to be interested; and some economical formalization of forms, together with diversity of feeling and emotion.

When it comes to identifying modern influences in the work of the contemporary painters it is necessary to look far afield. Mexican invention played freely amongst the elements of architectural design during the colonial epoch. Both figuratively and literally it gilded the Spanish baroque lily. But the colonial painters and their fashionable successors of the age of Porfirio Díaz frankly and deliberately copied their pictures from Spanish and Italian originals. With the exception of the works of three or four tentatively experimental artists of whom I have written in the first chapter, there was nothing in Mexico to explain the turn easel painting has taken during the last twenty years. No contemporary Boudin inspired a Mexican Monet; no Jacques Louis David provided a Mexican Ingres with a point of departure. Only the artisans and craftsmen, at the beginning of this century, were producing fresh and original forms: furniture and toys, fabrics and clay vessels, mural decorations for wine-shops and votive paintings on tin for the chapels of their favorite saints.

If you were a painter and wanted instruction in new techniques you could go to Europe and meet Picasso or Modigliani and examine the works of the French Impressionists and Post-Impressionists. A good many Mexican painters did exactly that, and their works, at one time or another, have plainly declared those influences. But many more went straight to the provincial sources, where they encountered two types of design: the one derived from imperishable pre-Cortesian traditions and currently found in the ornamentation of objects of practical use, such as clay vessels and woven blankets; the other a primitive and naturalistic strain of representational painting, itself independent, in a childlike way, of any tradition whatsoever. To these sources the younger painters owe many of their most characteristically Mexican plastic ideas.

Young men in Mexico are likely to say that Rivera is a classical painter with romantic leanings, and Orozco a universal painter with baroque

tendencies. They say that the appearance of "Mexicanism" in Rivera's painting is accidental, that it does not go beyond subject matter. They say that because Orozco is that rare genius who universalizes his own experience he is not to be expected to show specifically Mexican qualities in his work. But for themselves, they make a great point of being Mexican, not in a superficial and picturesque way, but spiritually and profoundly. It is remarkable that out of a background so remote, and in a contemporary *milieu* which has not yet proved its appreciative sympathy, they have been able to produce forms of art which, in spite of their diversity, are undeniably nationalistic in their several effects.

Since the modern Mexican movement is not, as you see, the flowering of an uninterrupted history of developing indigenous art, but rather the abrupt recrudescence of feeling, taste and conscience after an interval of complacent imitative painting, my story starts out more abruptly than perhaps you would have liked. It begins not with the dead but with the living. Still, the inevitability of such a beginning may seem to you, in the end, to be in itself symbolic.

<div align="center">Faithfully yours,<br>MacKinley Helm</div>

Brookline, Massachusetts
*November 15, 1940*

# ACKNOWLEDGMENTS

I take thankful pleasure in acknowledging the unsparing assistance of more than forty Mexican artists of my acquaintance. Having made the writing of this book inevitable, by virtue of producing so many distinguished works, they enabled the process of its completion by their hospitality and generously disposed resources.

For making it possible for me to meet so many painters under friendly auspices I have to thank the señorita Inés Amor, owner and director of the *Galería de Arte Mexicano* in Mexico City; the señora del Valle, curator of the University Art Gallery; señor don Alberto Misrachi of the *Central de Publicaciones*; and señor don Samuel Martí, an artist in the field of music who both initiated and shared many of my adventures of discovery and appreciation amongst the plastic arts.

Eight of the line drawings by Carlos Orozco Romero which appear here as headpieces to the several chapters were published in *13 Mexican Painters*, a small folio produced in Mexico City in 1939. The other two were drawn especially for this book. The original portrait studies are all in my possession. Most of the photographs used for the reproduction of mural and easel paintings came from the studios of Manuel Alvarez Bravo, Abraham Gonzalez, Edwin Johnson, Luis Limón and Juan Arauz Lomeli, and from *Foto* Gómez, Mexico City. The lithographs and etchings reproduced in the last chapter were photographed by Robert M. Catlin, Jr.

I acknowledge with thanks the permission of Messrs. Covici-Friede to quote from the Introduction to Diego Rivera's *Portrait of America*; of the Macmillan Company to quote from John Taylor Arms' Introduction to *Four Hedges: A Gardener's Chronicle* by Clare Leighton.

To Mr. and Mrs. Henry M. Winter of New York and Miss Anna Penney of Boston I am grateful for assistance in the ordering of manuscripts, both at home and abroad.               MacK. H.

# Mexican Painters

CHAPTER ONE

# Dr. Atl, the Saint John Baptist
# of Mexican Art

---

*Subió al Popocatépetl,*
*Bajó del Ixtaccíhuatl,*
*Y es hombre de gran valer*
*el inquieto Doctor Atl.*

From a "Fa-cha" caricature

---

THE HARBINGER OF THE MODERN Mexican art movement was not the sybarite himself, Diego María de la Concepción Rivera who later possessed it, but a half-legendary little man who is said in the popular tradition to inhabit a cave in the side of Popocatépetl. When I lived in Cuernavaca, in daily sight of Popo's snow-capped cone, I was almost persuaded to look for him there. I thought I should be able to recognize, at sight, the bearded face and bulging forehead of his innumerable self-portraits. I could imagine him, his smock exchanged for leathern girdle, eating his dinner of locusts and wild honey at the edge of the volcanic funnel whence, according to the local folklore, he was erupted, more than sixty years ago, into a tumultuous world.

[ 1 ]

I met him, in the end, not on the mountain whose son he is, but in his commodious and untidy chambers in Mexico City, whither I had been invited to lunch. From explorations of Popocatépetl and Ixtaccíhuatl, the Sleeping Woman, the prophet, it appeared, habitually returns to his house in the city to paint and write and talk, to each of which activities he devotes himself prodigiously in turn. When he talked he reached interminably into a cavernous chest, extracting an endless succession of shaggy Habana cigars. These he presently strewed, half smoked and wholly shredded, across the tiles that pave his ancient floors; while through the smoke and out of the clutter of the studio his voice unflaggingly declaimed the history of Mexican art and archaeology.

When this man works he produces, from torrents of dictated speech and nervous passes with charcoal, brush and crayon, a staggering miscellany: columns of political articles, volumes of history and criticism, sheaves of drawings, stacks of brittle landscape paintings,—all of which he signs, to support a national myth, with the fictitious name of Dr. Atl.

In 1877, when Dr. Atl was christened Gerardo Murillo in the city of Guadalajara, copies of the vaporous works of the Spanish Bartolomé Esteban Murillo molded the taste of our sister Republic. When the Mexican Murillo came of age he renounced his Spanish patronymic, together with all it stood for, and took an Indian pseudonym. Thus he declared his detachment from the dreary influences of the secondhand culture into which he was born, and acquired a name and handle fit for the beginnings of a legend.

Dr. Atl knew instinctively that the practice of the arts in Mexico in his time was counterfeit, and he was early inspired to believe that production of the genuine article depended not upon fresh importations of art and artists from Europe, but on the deferred rediscovery of the contemporary native scene. More than forty years before he was born the Golden Age of Mexico had come to a brilliant end with the death of Francisco Eduardo de Tresguerras, the native architect whose miraculous churches and convents, free and creative renderings of the baroque

and neoclassical styles, stand reminiscently in the plain of Guanajuato. No man in Mexico knew more intimately or cherished more profoundly than Dr. Atl those monuments of a culture which had perished with their building. But that culture had been Spanish and Christian, and Dr. Atl had acquired the notion, at an early age, that if there were to be a Renaissance in Mexico it must be Mexican and pagan.

When Dr. Atl was a young man the Mexican Renaissance seemed a long way off. There was only one remarkable Mexican artist then alive. If ever a man lived out of his place and time it was he—José Guadalupe Posada, who came from the northerly State of Aguascalientes and died in Mexico City in 1913: of complications induced, so it is said, by a peculiarity of drinking twenty-five gallons of *tequila* every January.

When Posada was about twenty years old he made a series of lithographs for a newspaper in Aguascalientes. From an apparently unique sheaf of proof prints in the possession of Francisco Díaz de León, a distinguished practitioner of the art of print-making in Mexico today, two lithographs are reproduced here. They are caricatures of local politicians whose names and exploits have long since been forgotten, but they are prophetic, in subject matter and in quality, of the work of four decades devoted by the artist to the perfection of a form of art still assiduously cultivated by the Mexicans.

In the year of Dr. Atl's birth Posada opened his first shop in Mexico City. There he invented a process of drawing directly in acid on zinc plates, and swiftly turned out the thousands of perceptive engravings which variously edified, amused and offended his Mexican public. Many of the drawings appeared in the pages of three or four publications antagonistic to the regime of the tireless dictator, Porfirio Díaz, but no less than fifteen thousand were commissioned by the conservative publishing house of Vanegas Arroyo. About ten years ago four hundred of Posada's prints were assembled by Paul O'Higgins, an American painter living in Mexico, for a monograph published in Mexico City, and thus the engraver was restored to local fame.

[ 3 ]

Posada's subject matter was as original and personal as his technique. Many years before the Revolution of 1910 he anticipated that eventuality. At a time when the aristocracy of the capital was affecting French taste and manners, he created revolutionary forms of art for the exposition of advanced ideas. Out of the steady flow of copy for the broadsides which he was commissioned to illustrate he chose, when he could, verses and tales celebrating political and social crises, and snubbed the popular taste for *corridos* about miracles and crimes. With elements now of tragedy, now of comedy, now of pointed caricature, he commented upon the social contrasts of the epoch: the pretensions of the upper classes, the stark compulsions of the poor.

A figure appearing over and over again in Posada's drawings is the *calavera*, or animated skeleton, a classical form in Mexican art. The Posada *calavera* fights, drinks, weeps, dances, works and loves: in short, suffers and enjoys all of the pains and pleasures of ordinary men.

Posada's influence upon the painters and engravers who followed him has been incalculable. Diego Rivera, a precocious boy, sat reverently at his feet. Rivera's more radical contemporaries complain that he failed to become a consistent revolutionary himself, but it is freely owned that he has never forgotten what he learned in that shop about craftsmanship: how to balance effective masses of matter, for example. Rivera has recorded his admiration for his teacher, whom he compares to Goya and Callot, in a mural portrait in the National Palace in Mexico City and in an Introduction to the Posada monograph. José Clemente Orozco, who was famous as a caricaturist long before he painted his celebrated murals, was also at one time a careful student of Posada's drawings. Orozco's own objects have perhaps been more pictorial and less didactic than Posada's, but his themes, like his predecessor's, were early taken from everyday life. And today there are as many as a dozen young Mexican engravers who, having steeped themselves in the Posada tradition, turn out *calaveras* which mock events and men almost as convincingly as his were wont to do.

Posada stood alone in his day, a fine artist who worked hard and

2. LITHOGRAPHIC CARTOONS FROM *El Jicote*, 1871

José Guadalupe Posada. From the collection of Francisco Díaz de León

conscientiously, critical always of the very market for his wares. More sociable evangelists of art, well-paid and unfruitful, meanwhile labored elegantly in the National Academy of San Carlos. Ingeniero Pedro S. Rodríguez, a Mexican art patron to whom I am indebted for a personal memoir of the turn of the century, describes that establishment as a *criadero de mediocridades.* Imported Spanish artists instructed their pupils in this "nursery" in the manufacture of an unwholesome sauce of neoacademicism. This, when they had properly learned to make it themselves, the young painters poured over the pictures they sold to Mexican aristocrats: conventional biblical paintings concocted from the recipes of second-rate Europeans.

Every decent instinctive feeling for art was falsified by the typical Porfirian painter. Colors were greasy, drawing was stiffly mannered, forms were out of touch with nature. The Mexico of that epoch was the original home of the Coca-Cola school of art. and Dr. Atl was its first self-appointed critic.

When Diego Rivera went to the Academy in 1899 there were, however, three or four painters whose work was distinctly better than the mediocre average. One of them, Julio Ruelas, who had just returned from Germany where he had studied under the protection of his patron, Señor don Jesús Luján, was known to the public as a romantic painter who treated poetically of macabre and fearful subjects. In private, he produced delicately executed pornographic miniatures, some of which are now bound into an original Mexican *Contes Drôlatiques* in Señor Luján's possession, and these, by no means to their aesthetic disadvantage, his pupils hastened to copy.

Ruelas' temperament was gay and witty, free and French. To poke fun at parlor art he painted bawdyhouse compositions on the back of his palette, peopling the scene with miniature portraits of his friends. He made a realistic, Goya-like study of a hanged man: to which he added a leering wench who peers under the dead man's nightshirt. He painted a few large portrait studies somewhat after the style of Manet, but his miniature portraits, with their amusing conceits, are minor pre-

Surrealist masterpieces. Antonio Ruiz, whose droll miniatures on canvas have lately begun to reach the American public, appears to be thoroughly familiar with his predecessor's technique, although he was not actually Ruelas' pupil; and Orozco, years ago, paid compliments to Ruelas' sardonic treatment of rude and harrowing events.

Ruelas' chief gift to the Mexican Academy was his fresh conception of color. Perhaps he had derived it from the Seville palette of El Greco, of which an example is to be found in the so-called self-portrait hanging in the Metropolitan Museum in New York. In any case, it was new to Mexico, and its very novelty—what a departure from Murillo's palette!—encouraged the student painters to experiment with color patterns of their own: with the patterns, in fact, which came to be recognized as the essence of Mexican painting.

Santiago Rebull, a colleague of Ruelas, was born in a sailing vessel in the middle of the Atlantic Ocean, a circumstance which may have had something to do with his eccentric disregard for academic tradition when he became a teacher. In a long if somewhat impermanent association with the Academy he taught his pupils, as he had been taught by Ingres, to work from life. Like everyone else in Mexico he painted his share of biblical pictures, but, like the best of the Renaissance painters, he used as often as he dared the characters which appear in the sacred history unclothed. The first of many suspensions from his office was occasioned by his introduction of nude models into the schoolroom. Rivera worked from life in Rebull's classes. He learned, he says, the canon of movement there, and his enthusiasm for art was reborn when Rebull independently began to set subjects from Mexican history. The public was distinctly skeptical about secular painting, but Rivera and his generation were glad to be relieved from the fatiguing reiteration of episodes in the lives of the patriarchs and the saints.

José María Velasco, a pupil of Rebull and later a teacher in the Academy, painted more than two hundred Mexican landscapes. Most of them are tight and finished to the modern eye, like Canaletto's, but they are remarkable, of their time, for their poetic realism and sensibility.

[ 6 ]

Rivera has to this day in his private collection a landscape painted by himself, when, at the age of seventeen, he was in an advanced class under Velasco.

Like Dr. Atl, Velasco was cultivated and erudite. He taught his pupils the use of scientific observation and investigation, a conception as phenomenally new to most Mexican painters at the end of the nineteenth century as it had been in England when the Pre-Raphaelite Brotherhood was formed. To increase his own equipment he attended anatomy classes in the University medical school and made independent studies in natural history. He wrote a scholarly book on the flora of the Mexican high plateau, illustrating it with hand-colored lithographs of his own authorship. Together with Landesio, the idealistic Italian landscape painter, he explored Popocatépetl, long before Dr. Atl's time, and published descriptive texts along with his lithographs and engravings of the mountain. In Mexico City in 1940, to mark the centennial anniversary of his birth, some of the Mexican artists sponsored an exhibition of his transparent, half-mystical and carefully executed studies of the Valley of Mexico.

I have heard contemporary painters respectfully mention just two other artists of an earlier generation: Félix Parra, who introduced Aztec and Maya motifs into his paintings and hastened the impending rebellion against academicism by acquainting his pupils—one of whom was Rivera —with his passion for the ancient Mexican cultures; and Saturnino Herrán, who, while his manner was Spanish to the end of his life, took his subject matter from the contemporary Mexican scene. He communicated to a whole school of new painters his indefatigable interest in the pictorial possibilities of his own time and place.

Herrán's time already sounds like ancient history to our modern ears. I find it repeatedly necessary, as I write, to remind myself that the period of which I am speaking ended only thirty years ago, ten years before the Mexican revival began with a rash of mural painting. So lately the few divinely discontented painters whose names I have been reciting were outnumbered by the fashionable artists who sold

[ 7 ]

their banal pictures into proud French houses on Maximilian's memorial avenue, the Paseo de la Reforma.

A prime favorite of those days, amongst the aristocratic families,—variations of it hang today in many upper-class Catholic houses—portrays the Trinity of Christian theology by the simple device of painting in triplicate the figure of a sickly Son. Nowhere in the world, not even in Victorian England, had bad taste in art and decoration been ever so carefully nurtured as in Mexico during the dictatorship of Porfirio Díaz.

Only amongst the common people did wholesome art naturally flourish,—folk art and the popular arts. Contemporary artists have taken notice of two types of the generally anonymous folk art, *pulquería* murals and *retablos*: the former dedicated to drink and the latter to religion. The old *pulquería* paintings, of which few remain intact, were designed to acquaint the public with the shops where *pulque*, the intoxicating vitamin-filled liquor of the *maguey* plant, is sold. In many a squalid neighborhood these decorations introduced gaiety and color into the outward scene and gave promise of the warmth and life of convivial interiors. Wine-shop proprietors vied with each other in the invention of seductive names. You can see, for example—the names still exist—the "Night of Love," the "Saint and Sinner," the "Flower of Ecstasy." The mural decorations, perishably executed in oil paint on cement, took their themes from the fancy names of the shops. Most of these paintings have long since disintegrated and the government has forbidden their replacement, for alleged hygienic reasons. The Cárdenas administration, for all its attention to the poor man's needs, was notoriously unsympathetic with his follies.

The *retablo*, a small painting on tin, usually celebrates a miraculous recovery from injury or illness or a providential escape from an accident. It represents the hero or the heroine in a predicament from which there has been a supernatural rescue, together with the divinity who worked the miracle. The forms are primitive, the colors lurid, the compositions arranged for their immediately dramatic values. Several of the

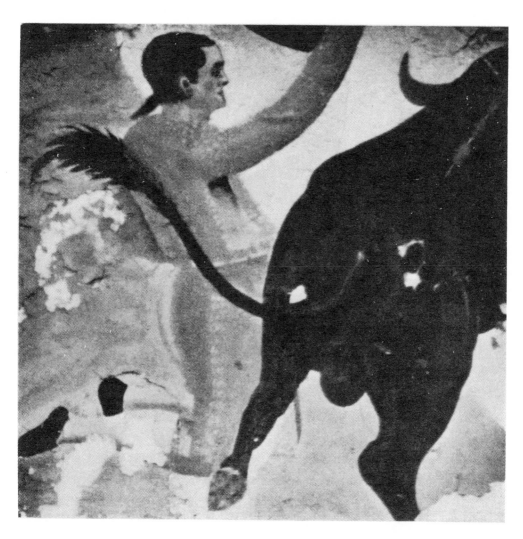

3. DETAIL FROM A DISINTEGRATING *pulquería* MURAL,
   *Los Toros*, MEXICO CITY
   Oil on cement

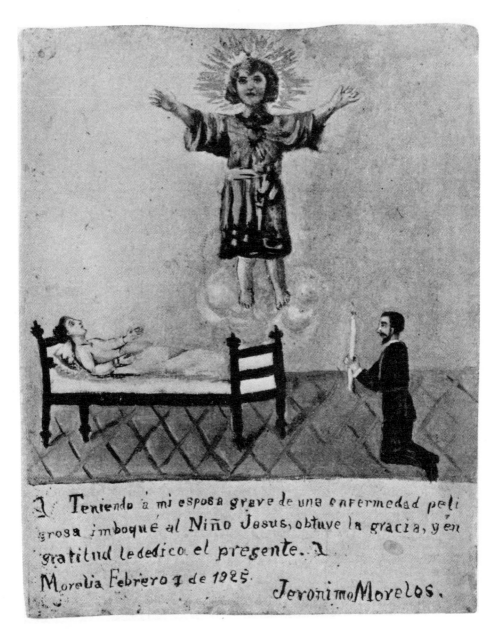

I Teniendo á mi esposa grave de una enfermedad peli
grosa imboqué al Niño Jesus, obtuve la gracia, y en
gratitud le dedico el presente. I
Morelia Febrero 7 de 1925.   Jeronimo Morelos.

4. *Retablo,* DEDICATED TO THE *Child Jesus* UPON THE
RECOVERY OF THE DONOR'S WIFE FROM A DANGEROUS
ILLNESS

Oil on tin

contemporary Mexican painters have borrowed freely from this thoroughly indigenous source.

There are many collections of *retablos* in shops and studios in Mexico, but since they were originally made to hang on the walls of churches and chapels in honor of the celestial beings to whom they were dedicated, it is doubtful whether they have been come by honestly. I have in my collection a *retablo* which I suspect to be the unlawful souvenir of an impious pilgrimage made by a provincial friend to satisfy my whim to own a tin painting of a railway wreck.

When Dr. Atl returned to Mexico in 1907, after a few years of study in Europe, he found the Academy of San Carlos in a state of turmoil because a new teacher, Antonio Fabrés, a Catalonian academician, had been imported by the Minister of Education over the protest of the director of the school. The public liked and bought the paintings of Fabrés, which were executed in the color-photographic style of Zuloaga, but the students were not happy in the atmosphere he created. Dr. Atl, who was then about thirty, promptly organized antagonisms into revolution; whereupon the usurper was presently retired.

The Doctor then undertook to lecture privately about the Impressionists whose work he had been seeing in Paris. He took a few student artists out-of-doors, away from the ateliers where they had been painting under artificial light, and encouraged others—amongst them the Surrealist painter Roberto Montenegro—to continue the researches which they had timidly begun in the field of native colonial art. To show that he was a practical man as well, he organized exhibitions of the works of youthful painters in Mexico City: of Angel Zárraga, who later removed to Paris, so it is said, to produce religious canvases beyond the range of the satirical comments of his unholy friends; of Joaquín Clausel, a prolific but imitative Impressionist who had some success in the United States; and of a quite unknown young man, Diego Rivera, whose pictures he believed in and bullied his friends into buying. With

the money from levies upon Dr. Atl's acquaintance Rivera went for the first time to Europe.

In 1908 Dr. Atl made his first attempt at mural decoration. The place, a shabby gallery in the Academy of San Carlos; the purpose, the glorification of a gentleman from Puebla who had presented a collection of pictures to the State. Of a great array of mostly imitative art the chief treasure was an original work of the Spanish Murillo whom Dr. Atl secretly despised. Nevertheless, having arranged the permanent disposition of the pictures on the Academy walls, the artist proceeded to paint, in so-called Atl-color, a eulogistic mural. Working in solitude, according to his contract, he produced, in the Impressionistic style, a frieze of nudes disporting themselves above the gilded frames of the sacred pictures.

There are several stories about the ultimate removal of these decorations. Dr. Atl says they were painted out because they were shocking, but it is also said in Mexico that the artist himself removed the rosy nymphs in the nick of time, before their uncertain chemistry could cause them to disappear of themselves. This story might be suspected of being an invention of the later muralists, of whom one, in fact, repeated it to me; for some of the rude demonstrations of Atl-color which the inventor has made in times past on the walls of his studio have a dirty look of having survived there for years. However, decorations made in that medium in 1921 in a convent patio have practically flaked away.

Atl-color was invented for use, like pastel, on the surfaces of paper, wood, plaster, fabric and board. Composed of wax, dry resins, gasoline and oil color, it is manufactured in small bars like sticks of sealing wax. The color itself is apparently unalterable, although the substance can be dissolved in gasoline for spreading with brush or palette knife, and melted like wax for thickening and diversifying textures. A surface covered with Atl-color can be freely overpainted.

Dr. Atl has used his invention in a variety of ways ever since he first made experiments with it in Rome at the beginning of the century.

Sometimes he dissolves it in gasoline and spreads it like water color on paper prepared with white of zinc. Frequently he paints with water color, superimposing Atl-color to enrich the textures. He also combines it with oil, a conjunction which is likely to produce harsh variations of surface textures because Atl-color, while brilliant, is hard.

Not long ago Dr. Atl saw, in a village *cantina* in the State of Michoacán, a small picture which looked familiar to him. It turned out to be his own first work in Atl-color. When he brought it home I went to have a look at it. It was Impressionistic in the manner of Pissarro, with period figures strolling across a shady plaza. Dr. Atl painted in this style, many years ago, a few portraits which have a way of looking abnormally loose at close view, and of rapidly tightening into form from a distance. Perhaps it would be more accurate to say, therefore, that Dr. Atl's Impressionism is not so much Pissarro as Sisley after Pissarro.

His later painting is tighter and less varied in both subject matter and treatment. Until quite lately he has invariably worked in his studio, relying upon his prodigious and well-trained memory for details of color, light and contour. Because he painted from memory and always used the same themes, Popocatépetl and Ixtaccíhuatl and the Valley of Mexico, his studies were bound to become monotonous. In the summer of 1939, however, he painted forty-eight small board and canvas pieces directly from nature. Done in oil and water color, many of these have the flexibility and fresh feeling and charm of his earlier work.

Like most of the Mexicans—Diego Rivera, Frida Kahlo and Orozco Romero are others—Dr. Atl has painted scores of self-portraits. A typical Atl for a comprehensive Mexican collection would be one of the self-portraits with Popocatépetl in the background. It should be executed in either Atl-color or charcoal, because in these media Dr. Atl does his most personal work.

One day in his studio, after a lunch of superb Mexican food cooked in Tarascan pottery vessels and served by the small daughters of his Indian cook, Dr. Atl gave me a demonstration of his charcoal technique.

Rummaging around in a dark corner of the studio, he retrieved a small, smudged cardboard box from beneath a mound of galley proofs. In this container there was a collection of dirty and scarcely distinguishable objects whch he described as his portable charcoal set. There was first of all a crumpled piece of chamois skin, encrusted with an accumulation of charcoal rubbings. The removal of this soiled and tattered fragment disclosed scatterings of charcoal and a small whittled stick about the size of a vest-pocket pencil.

"Now see," said Dr. Atl, "this is what I do." He crushed a broken stick of charcoal into dust, wrapped the chamois skin around his index finger, dabbed at the particles of carbon, rubbed the surface of a piece of paper, manipulated the masses of an impromptu composition with his finger tips, drew a few strong, sharp lines with the blackened tip of the little pointed stick, and behold! there was Popocatépetl looming up over the Valley of Mexico.

Any catalogue of the preachments which issued from the voice of Dr. Atl in the days when he cried in the Mexican wilderness should record that he was the first native painter to talk about Communism. Except for a tincture of Russian Communism filtering in chiefly from across the American border, the Mexican variety of communistic thought has been a local product, stemming not from Marx but from the Spanish legal tradition and the Indian way of life. Dr. Atl's Communism was in reality a kind of poetic, almost a biblical socialism. He persuaded his artist disciples to pool their interests in a *Centro Artistico*, an association in which they undertook to live according to a rule drawn from the life of the artisan classes. They painted houses and garden walls in provincial towns to earn money for tubes and brushes. Eventually they received a joint commission to decorate the walls of the *Anfiteatro Bolívar* in Mexico City, but the Revolution of 1910 made an end to this scheme; and when the project was revived, years later, Diego Rivera was freshly home from Paris to put it into execution himself.

Dr. Atl likes to think that the revolution in art began in the autumn of 1910, when he organized an exhibition of paintings in honor of the

5 · SELF-PORTRAIT IN BLUE

Atl-color, 1937. Dr. Atl. From the painter's collection

centenary of the Mexican Independence. He showed the work of his followers and of a few solitary painters who wanted to identify themselves with the forerunners of the prospective school of nationalistic painting. The event seems to have been scantily recorded at the time, however, and I have not been able to discover that any tangible result came of it directly.

Revolution broke out in November of that year under the leadership of Francisco Madero, a rich young man who had been conventionally educated at the University of California before he went to study democracy in the then Republic of France. Provisional governments appeared in rapid succession, none of them with the means, had the intention been present, of patronizing the arts. The *Centro Artistico* was dispersed and most of the painters left the city to join one or another of the revolutionary armies. Dr. Atl went to Paris where he was soon engaged in political intrigue; painting, as usual, in his spare time. For a few months he published a newssheet in opposition to the Huerta government which in 1913 invaded the National Palace and murdered Madero. He says his editorials spiked a French loan.

In the midst of political confusion, the change and interchange of governments, the counterpoint of innumerable private and interlocking revolutionary movements, there occurred a comic interlude from which some of the younger painters, with no discourtesy to Dr. Atl and his prophetic accomplishments, date the effective beginning of the revolution in art. There was a student strike in the Academy of San Carlos.

In spite of the immaturity of the strikers it must be admitted that their vaguely articulated objects anticipated the second—the finally secular—phase of the mural movement which was launched ten years later. However clumsily they expressed themselves, the students had correctly foreseen the inevitable relationship of art to politics during that stage of their country's development. What they obscurely wanted was new forms of both government and art to make the relationship fruitful. They had been suffering from an experiment with the Pillet system of teaching abstract painting, a method originally designed for use in the

lower schools in France. They proposed for the directorship of the Academy a young man who had just come from Paris, where he had gone in for Impressionism and the out-of-door life of the Barbizon school,—the painter Alfredo Ramos Martínez, who has since wrought his improvisations on Monet themes in a cemetery in Santa Barbara.

The first of the youthful and not wholly clarified political objects of the strike was the "redemption of Mexican economy from imperialism." The program seems, at this distance, not a little ambitious for boys and girls in their teens, but they ripen young in Mexico, politically as well as physiologically. Art students had supported Madero in his time, although his administration had been a great disappointment. He seemed to have had no plan for directing the Republic through the reconstruction. Young revolutionaries everywhere were impatient to get on with the reforms the Revolution had promised: the expulsion of foreign capital, the seizure of *haciendas*, the distribution of land amongst the peasants, in fact, the wholesale establishment of apocalyptic agrarian reforms.

The strikers, most of them children, held open-air exhibitions of the new political art and earnestly presented their case to the people at public meetings. Religious periodicals—the government was still co-operatively Catholic—met the threat to the financial security of an incredibly wealthy Church with editorials proving that the strike was subversive to the State. Under pressure from the clerical press, armed police conducted raids upon the youthful population. At one time more than a hundred Academy students were in jail: amongst them David Álfaro Siqueiros, who was then fourteen years old and hugely enjoying his first publicity. Siqueiros has described to me how, when they were released, they all went back to the Academy to throw eggs and tomatoes at the elderly director and draw obscene anticlerical compositions at their drafting boards. Out of such melodramatic, not to say malodorous, beginnings the new plastic forms of the Mexican revival gradually emerged.

When Victoriano Huerta took possession of the capital, after some

obvious intrigue on the part of the government of the United States, his new Minister of Education attempted to conciliate the young intelligentsia by appointing Martínez to the rulership of the Academy. Thus Impressionism was introduced into the art classes, and with it a new humanism, a fresh new relation to life. The students were officially sent to work out-of-doors, from nature. They flocked to the open-air school which Martínez set up in suburban Santa Anita. There they analyzed and imitated the native unstudied beauty of popular-art design, especially the traditional patterns of pottery and textiles. They made a cult of the *pulquería* murals and the naïve art of the *retablos*. They adopted all sorts of revolutionary devices, of which one was the elimination of black from their palettes. Black was, they said, the color of reaction. Mexican techniques were in process of formation for the treatment of vernacular subject matter.

When it presently appeared that the art school at Santa Anita was becoming a center of political conspiracy as well as aesthetic experimentation, some of the students who were thought to be injurious to the peace of the civil society were imprisoned or shot by the Huerta military dictatorship. Others gravely enlisted in the armies of the Carranzista generals, Herrero and Diéguez, although most of them romantically supported the idolized Emiliano Zapata, the Indian bushmaster who assumed the rank of general and called his company of bandits the Army of Liberty of the South.

Zapata, unlike other revolutionary generals, was not interested in the equal distribution of land amongst individual farmers. He simply wanted foreigners and rich landowners to withdraw from their accumulated properties and restore them to the Indian tribes, who would then return to their primitive life of hunting and fighting. Calling himself the Attila of the South, he rode at the head of his terrorizing horde through half-a-dozen rich states in the heart of the Republic. He murdered and raped and stole without mercy, although a kind of coarse whimsey sometimes attended the performance of these ceremonies. At times, a brutish and boisterous Robin Hood, he indulged in incongruous

[ 15 ]

and unpremeditated generosities, earning the love and devotion of the poor who went unharmed.

A newspaper man, H. H. Dunn, who in the practice of his profession accompanied Zapata's horde for some years and lived to write a book about him, *The Crimson Jester*, says that the general rode a black horse. In the legend which has grown up about him, now that he has become the hero of the State of Morelos, he rides a white horse. In the mural histories painted in the twenties he properly rides the legendary beast.

The mature painters and writers who lived in Mexico City, all of them loyal to the Revolution, were trying to decide, in 1914, whether to follow Carranza, the "First Chief" of operations against President Huerta, or his rival, Pancho Villa, the rogue from the North. Carranza had been suspected of a relapse into conservatism after he took up office as Governor of the State of Coahuila, in spite of all his fine talk about nationalizing subsoil resources and protecting the laboring man. Villa, on the other hand, was reckoned to be a half-educated peasant, an unscrupulous scoundrel, a suspicious and cruel *guerrillero*. The bright young men who espoused his cause held their noses and explained that the cowardly, blustering patriot who robbed the men and ruined the women in his path was after all a man of the people, and, in his devious way, desired the people's good. Besides, he was well on his way to Mexico City and the National Palace, and it appeared for a time that Obregón, commander of the Carranza forces, could hardly resist his barbarous tactics. It seemed only sensible to go to the side of the probable victor.

In the midst of this dilemma Dr. Atl, home again from Paris, appeared once more upon the political scene. Betting on the superior organization of the army of Obregón, he picked Carranza as the winner of the presidential race from the American border to the Mexican capital and persuaded a group of able young men to declare for the Chief. They all set off for the safe semi-tropical city of Orizaba, where they set up presses and printed reams of literary and graphic propaganda.

Of this so-called "Jungle Group" there were three painters, besides

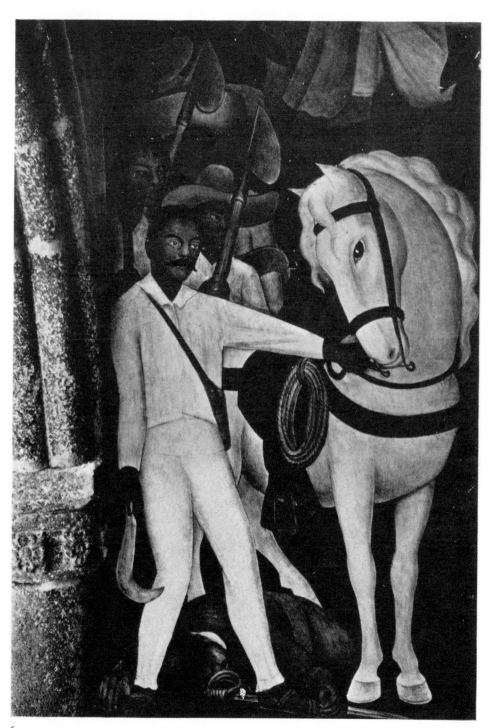

6. ZAPATA

Fresco, 1930. Diego Rivera. From the Cuernavaca murals

7. ZAPATA

Oil on canvas, undated. José Clemente Orozco. From the author's collection

Dr. Atl, who were about to become famous: Ramón Alva de la Canal, David Álfaro Siqueiros and José Clemente Orozco. Alva de la Canal was the first modern Mexican painter to use the technique of true fresco. Orozco's Orizaba caricatures, although they were subsequently to get him into trouble because it was not always clear whom they caricatured, established him at home as a powerful graphic artist. Siqueiros, who had been a lieutenant in the *Batallón Mama* at the age of fifteen, an infant commanding his peers, now at sixteen began to mature in surroundings which heightened his naturally chauvinistic sensibilities.

When, as Dr. Atl had foretold, Carranza became President of that part of the Republic which was willing to recognize him, the civilian army of artists moved upon the venerable Academy of San Carlos, closed most of the ancient galleries, and converted an amateurish school of art into a wholesome workshop. In characteristic Mexican fashion they planned monumental artistic projects for the accomplishment of which a further sequence of provisional governments, on the move from capital to capital, could never find the cash.

When Carranza became the legal President of Mexico in March, 1917, he pledged himself to administer the laws of his country as embodied in the revolutionary Constitution adopted in January of that year. Article 27 of that Constitution purportedly revived a traditional conception of property ownership. Lands which had belonged to the Indian villages in pre-Cortesian and early colonial days, and had subsequently been incorporated into privately owned estates through seizure or enforced sale, were therein declared subject to restoration to the *pueblos* for community cultivation. The State furthermore assumed the sole proprietorship of all water and subsoil rights together with the right of expropriation of land for the protection of subsoil wealth.

Article 123 treated of labor reforms: the eight-hour day, the minimum wage, workmen's compensation, trade unions, the right to strike. Other provisions of the constitution severely restricted the activities of the Catholic Church. Ecclesiastical property was secularized. Provision was made, at the pleasure of the State, for lending appropriated buildings to

the clergy for religious purposes, but it was the intention of the reformers to divert many churches and convents to secular use.

Thus the Constitution of 1917. It soon appeared that the document was, however—as Henry Bamford Parkes describes it in his *History of Mexico*—"a statement of aspirations rather than of facts." Carranza proved to be, as some of his supporters had feared, not the man to make fact out of aspiration. Still, a new movement in Mexican art was presently to be rooted in the political soil which was, in Carranza's time, in process of preparation. All of the political and social ideas then in circulation subsequently found their way into the mural paintings.

It is possible to discover, between 1917 and 1920, a few scattered indications of the turn Mexican art would take in the next administration, the relatively peaceful and liberal regime of Obregón. Lessons in drawing and painting were given in the public schools. The theater began to take on Mexican color. A group of officer-painters, some of whom were to become famous, met in Guadalajara to talk about art when their arms were not engaged.

Adolfo Best Maugard, a painter and critic, was commissioned by the Ministry of Education to install in the public industrial schools a system of art education with which he had lately been experimenting in Europe. As explained in three books which have been used in American schools, *Creative Design, Human Figures,* and *Draw Animals*, his method was intended to teach children to see and use certain universal elements of design. These included, as the author had observed them in the ancient forms of Egypt, Greece and Mexico, such basic lines as the wave, the spiral and the zigzag. Although the administration of art instruction for children has repeatedly changed hands in Mexico since that time, training in painting and drawing has been an essential part of the Mexican child's education from that day to this.

Revolution made its way into the theater, oddly enough, in the form of a Mexican ballet created for Pavlova. Manuel Castro Padilla composed convincingly Mexican music, Adolfo Best Maugard created sets and costumes from native designs, and Jaime Martínez del Rio, the former

8. SELF-PORTRAIT

Tempera on board, 1923. Adolfo Best Maugard

husband of Dolores del Rio, was the angel: so that even the money was Mexican. The proceedings seem to have caused no end of excitement in Mexico City, where nobody believed that anything native could be a form of art. In aristocratic circles the term "Mexican" was practically synonymous with "Indian," and during the long period of the Díaz dictatorship Mexicans of Spanish descent were taught to be contemptuous of the Indian and all his works. When Anna Pavlova danced in Mexican costume in Mexico City, every day for a month, the prestige of her name compelled attendance upon her performances. If any remained reluctant to see Indian forms upon the stage they were obliged to capitulate when the news subsequently arrived from New York that the dancer had created a sensation with the Mexican ballet there. Soon the *tandas*, intimate revues which followed old Spanish forms, were allowed to go native. Mexican actors were trained and hired, parts were written for Mexican types, and songs made topical allusions to national affairs.

Just as Fifth Avenue and the adjacent summer colonies went Mexican as soon as it appeared that the Museum of Modern Art had scored another success with an exhibition called "Twenty Centuries of Mexican Art," in the summer of 1940, Mexico City began to be respectful of objects of popular art as soon as the theater led the way. Mexican products began to appear in the *puestos*, the sidewalk shops which had theretofore catered to a taste for tawdry artifacts produced in the Balkans and Japan. Craftsmen were encouraged in their painstaking work by the better prices they were able to get for it.

Unfortunately, the revival of craftsmanship, although it did not lapse, did not flourish long. When American tourists discovered that their bodies were as safe in Mexico as in Youngstown and Chicago they flocked into the Republic and bought whatever was offered in the streets. It was so easy and profitable for the Mexicans to dispose of junk from out-of-door pitches, when authentic goods gave out, that fresh importations and mass produced goods from Mexican factories once again all but crowded out the craftsman. It is a great pity that the solitary artisan fares so ill today

in Mexico. Out of each thing he makes he creates a true work of art, with idea, form and function. His work is needed in our world.

Typical of the old-fashioned native craftsman is a furniture maker who was commissioned by an American lady to make twelve identical chairs for a terrace dining room. Dr. Hans Zinsser, who had it from a friend of mine, liked this story, although he told it differently.

"I suppose," said the lady to the cabinetmaker, "you will give me a substantial reduction for ordering so many chairs."

"On the contrary, Señora," replied the Indian, "they will cost you twice as much. I must be paid for the boredom of having to make twelve chairs exactly alike."

CHAPTER TWO

# The First Frescoes

*Art is for everybody, or it is nothing.*

Jacob Epstein

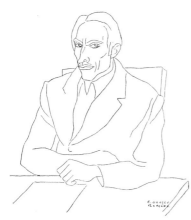

IT IS IMPOSSIBLE TO SAY, THE painters themselves do not know, just who said to whom, in the spring of 1921, "Let us get going at the murals we have been talking about for ten years."

The Mexican mural movement was like a scenario going through a ten-year metamorphosis in Hollywood before reaching production. It required building up and revision by script writers, rehearsal by specially equipped actors, a competent director, and above all a producer who would not be niggardly in mounting it.

When the Revolution of 1910 interrupted Dr. Atl's project for decorating the *Anfiteatro Bolívar*, some of the painters who were to be the actors of the future became script writers, temporarily, and toyed with the manuscript. Out in Guadalajara David Siqueiros organized a *Congreso de Artistas Soldados* amongst painters and poets who were also army officers. One of them was Amado de la Cueva, who later, in the Ministry of Education in Mexico City, painted a pair of frescoes before he could

[ 21 ]

be stopped by Diego Rivera, who wanted the space for himself. In 1926, just before his death, de la Cueva also collaborated with Siqueiros on some experimental murals—they were never finished—in the University of Guadalajara. Another of the group was Carlos Orozco Romero, the "Somnambulist" painter and sensitive draughtsman who drew the line portraits used as capitulary decorations in this book. The Congress thoroughly discussed the theme, action, setting and locale of the prospective cinema. They wanted to do something new and useful as well as entertaining. They rebuked each other for having produced theretofore only some fancy stills: small, portable nudes and *naturalezas muertas* to exhibit to sophisticated Mexicans. Now that the first World War had cut Mexico off from contact with foreign sources of techniques and subjects they promised to devote themselves to recording the facts of the Mexican Revolution in feature-length films, with plenty of close-ups, for all the people to look at and understand.

The painters soon discovered, however, as the time approached for them to set to work, that it was not going to be easy to make a revolutionary opus. They had so long been dependent upon Europe, even in the days of the open-air school at Santa Anita, that they did not know how to begin to be Mexican. Siqueiros bagged a commission to go abroad as a military attaché and went directly to Spain to talk over the new problems with Diego Rivera. Rivera's canvases, shipped home to prove that he was not wasting his government pension, had given him immense prestige amongst the young painters. He was admired for his mastery of all the known painting techniques and for his eminent part in the movement afloat in Europe to emancipate art from the academic tradition. Rivera introduced Siqueiros to Cubism, and Siqueiros told Rivera about the revolutionary art which he and his friends were planning to produce at home.

This new friendship resulted in the projection of a weekly review of art and literature to be called *Vida Americana* and published in Barcelona. The project flourished for exactly one week, but in the solitary number which appeared for the edification of the public Siqueiros published a

9. SELF-PORTRAIT
Lithograph, undated. David Álfaro Siqueiros

manifesto which, however bombastically it was adorned, proved to be one of the primary sources of technical instruction for the Mexican painters to whom it was addressed.

While Siqueiros was thus whipping the scenario into shape in Europe his friends at home began to look around for a producer. The pro-German government of Carranza was too busy trying to distract American attention from the Western Front, by means of border episodes, to undertake the patronage of art, and if the people of Mexico had not soon got tired of their new administration the mural movement might have been indefinitely postponed for want of a producer. But the people of Mexico did get tired of Carranza, and when they had all they could stand of him they quietly put him to death. They agreed that Villa should be bought off with a large personal property and Zapata pacified by the public distribution of privately owned estates in the State of Morelos. In November, 1920, General Obregón became President of Mexico, and a period of peaceful reconstruction began.

Mexican revolutionaries have a way of becoming conservative after they have fought their way to power, and Obregón was thoroughly typical of his kind. He made no universal application of the provisions of the Constitution of 1917. In fact, he distributed amongst the villages less than one per cent of available agricultural lands, and only a small number of industrial unions enjoyed the protection of his government. He deported Communists as rapidly as he could pack them off across the border to the United States whence they had come, and was decently respectful of foreign capital for its relatively modest contributions to the national treasury. All of his defections were jotted down in notebooks and subsequently incorporated into the scenario which was then in the making, by way of contrast with the ideal revolutionary dialogue and action provided by the artistic imagination.

One thing Obregón did do for Mexico, however, and that, more than anything else, started the country on its way to self-realization: he endowed the Department of Education with a literate Minister and a generous budget. José Vasconcelos, who received the educational port-

folio, was a skillful lawyer, a prodigious writer, a student of the philosophers. He initiated a revolutionary course of public education from a post in a cabinet with whose conservative membership he was entirely unsympathetic. He built hundreds of schools, equipped libraries, gave playgrounds, swimming pools and nourishing food to thousands of underprivileged children.

It is significant of the primary place of art in the culture of modern Mexico that the Minister of Education, who had plenty to do in the way of teaching a vast illiterate Indian population to read and write, should have undertaken to supply in the lower public schools expert instruction in the appreciation and creation of the forms of art. With the help of Adolfo Best Maugard he organized a new department of drawing and handicrafts and built open-air art schools for nonprofessional students. Amongst the teachers in these schools were such recognized artists as Manuel Rodríguez Lozano, Miguel Covarrubias, Julio Castellanos, Rufino Tamayo, Carlos Mérida and Antonio Ruiz. Two of Mexico's first modern muralists, Fernando Leal and Fermín Revueltas, were pupils in a public open-air school founded by Vasconcelos in Coyoacán.

José Vasconcelos was no fly-by-night revolutionary. During the Díaz regime he had been one of the so-called *post-cientificos*—they might have been called New Dealers in our day—who opposed the conservative policies of the *cientificos* who advised the dictator. The young intellectuals modestly waited for Díaz to make a mistake. This, in about the thirtieth year of his reign, the President obligingly did. He told an American journalist, for American consumption, that he had at length prepared his people for democracy, and now proposed to retire in favor of a representative and democratic government.

Díaz stupidly did not anticipate the Mexican reaction to the interview. An Olympian dictator, he was out of touch with popular feeling. Deep-seated opposition to foreign exploitation required only a little integration, some indication of leadership, to break out into a holocaust more devastating than the Wars of Independence and Reform. Foreign oil, copper, railroad and textile companies owned vast interests in the Re-

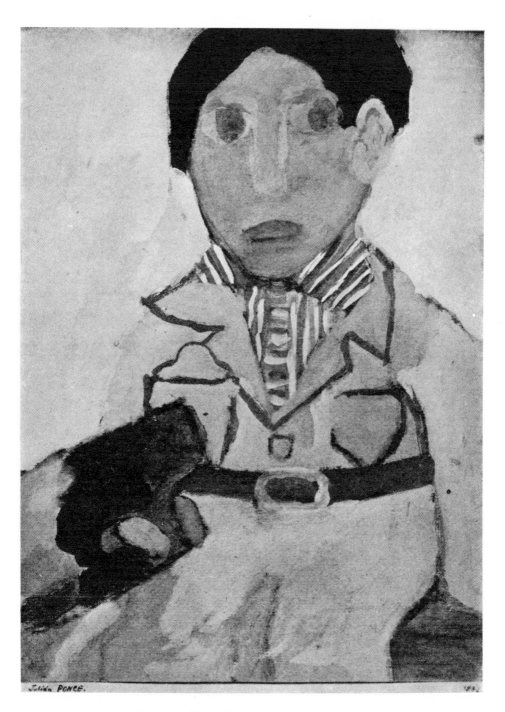

10. PORTRAIT OF A COLLEAGUE
   Tempera on board, 1932. Julián Ponce, age 14

public. The products of mines, oil fields and factories streamed out of the country, practically tax free. Such agricultural lands as were left to Mexican ownership belonged to the Church and a handful of creole families. Millions of Indian peons and industrial workers were starved or beaten into submission to their overlords. Sometimes, when hunger and the lash could not command, bullets put rebellion down.

Unbearable conditions were endured for decades, when suddenly, at the first indication of the mortality of the dictatorship, effective opposition sprang up overnight. The most responsible opposition leaders, the men with the headiest and most thoughtful program for the economic and cultural development of Mexico for the Mexicans, were the *post-cien-tíficos*, of whom Vasconcelos was one. The new Minister, although his objects had often been thwarted, had thus been trained for a decade in revolution and reconstruction when he took his post in Obregón's cabinet. He was predisposed to read the artists' scenario with a favorable eye, and take over its production.

It now remained to assemble a cast. The painters were doing their best to get ready to play the parts. Like Paul Muni, who went to Mexico to get atmosphere for the part of Juárez, some of them had gone abroad to study the Italian murals. Diego Rivera and Robert Montenegro had filled notebooks with drawings in Italy, and Rivera had even experimented in Paris with frescoes on small squares of plaster. Others stopped at home and reviewed the history of mural painting in Mexico, a roughly continuous history of many centuries.

Indian architects before the Conquest used painted decorations abundantly. A good example of a surviving twelfth-century mural which treats of the domestic and military life of the New Empire of the Mayas is described and illustrated by Jean Charlot in the *Magazine of Art* for November, 1938. After the Conquest, black and white and earth reds were used for fresco painting in the cloisters and staircases of Franciscan, Dominican and Augustinian convents. On the lately uncovered walls of the Convent of Actopan, north of Mexico City on the Laredo highway, there are superb examples of the black and white frescoes of the

[ 25 ]

early colonial period. Broadly speaking, they are Byzantine in design: stiff, symbolic, mystical. In the eighteenth century color came into more general use, and in some churches and convents the original black and white designs were plastered over to make room for decoration in the new fashion. Of this period the most interesting frescoes with which I am acquainted are those of the Convent of Tzintzuntzan, an Indian village on the shore of romantic Lake Patzcuaro, in the State of Michoacán. Seven pastel-colored panels in the upper cloister of a patio portray, in naïve and unexpectedly humanistic style, the administration of the Christian sacraments.

The best of the nineteenth-century frescoes were made by the versatile architect Tresguerras in his own churches, notably in the town of Celaya. At the end of the century Juan Cordero, likewise a Mexican, painted a true fresco in the staircase of the principal patio of the National Preparatory School in Mexico City, where the scattered cast of actors in the forthcoming mural melodrama was to be assembled in 1922. Called "Mezquite Utile Dulce," this work introduced the cactus theme which became a commonplace in twentieth-century designs. It has long since been replaced by an ugly stained-glass window, but Diego Rivera, who remembers it, says that it was done in good classical style. At about the same time Petronilo Monroy, who occasionally painted *pulquerías* for a livelihood, made some fresco panels of Old Testament women in a church in Tenanzingo, and decorated the corridor of an *hacienda* with frescoes which took their secular subject matter from the life of the farm.

Steeping themselves in the Mexican tradition, the painters who stayed at home got up the local atmosphere; the scenario approached completion; and Vasconcelos, in the absence of a director, made ready to hire performers. Few of the actors knew very much about the stage business, although one or two had postured a bit in their private apartments, but as rapidly as they could be assembled they were called to rehearsal in the Preparatory School, a part of the University of Mexico. Although the sequences scheduled for that studio were never completed, because the producer was never quite able to organize the direction, men cried

"Camera!" in several corners of the lot at about the same time, and the piece went into production.

Ramón Alva de la Canal, who is still interminably busy painting murals,—he has been decorating the hollow insides of a tasteless statue of the patriot José Maria Morelos, set up on an island in the middle of Lake Patzcuaro—was the first man actually at work on a fresco in the Preparatory School. For one reason or another this distinction has been somewhat obscured.

The principal obstacle in the way of the general recognition of Alva de la Canal's primacy as a muralist is an inscription which stands today in the lower left-hand corner of a mural made in the Preparatory School by Jean Charlot, who had turned up in Mexico in 1921. Composed in old Spanish and painted in pale letters on a colonial shield, the legend memorializing Charlot's part in the proceedings runs as follows: "This fresco was made in Mexico and was the first (to be made) after the colonial epoch. It was painted by Jean Charlot, and the fabric is the work of the master mason Luis Escobar. A.D. MCMXXII."

Now Charlot was only twenty-four years old at the time, and he was a newcomer to Mexico. He had come on a glamorous errand, to retrace the footsteps of his grandfather, an officer in the Emperor Maximilian's retinue. His ignorance of the history of Mexican art was therefore generously forgiven. But in spite of the fact that he has been in New York for many years, drawing, it is sometimes said in Mexico, upon attenuating memories of that country, there are people who still feel bitterly about the inaccuracy of the contemporary references in this piece of self-advertisement. Although Charlot did undoubtedly complete the first mural decoration in the Preparatory School, he neither made the first attempt at mural painting there, nor was he the first to use the traditional techniques of fresco painting. On the contrary, his account of the sack of Moctezuma's capital by the Spanish *Conquistadores* was painted on wet cement. Such a surface, because it dries quickly, must be spread with thin paint, with the result that the colors are bound to be poor. Some scarlet lances which give Charlot's design movement and strength, as well as

[ 27 ]

vividness, faded to the point of losing their plastic values and required to be repainted in encaustic. This story has been denied by some of Charlot's friends, but the spectator has only to believe the evidence of his eyes.

Ramón Alva de la Canal began his mural in true fresco on a dark wall in an entrance to the Preparatory School (from the Calle de San Ildefonso) some months before Charlot set to work on the staircase. He consulted with native artisans who were accustomed to painting with watery paints on wet plaster surfaces, hired one of them as a helper, and began to work out his problems in a thoroughly professional manner. He did not, however, finish his job until 1923, when he initialed the work under the hammer-and-sickle device of the newly formed artists' and artisans' Syndicate.

Ramón Alva's fresco, now badly disfigured in its lower areas, has, through imitation, the appearance of being hackneyed in subject matter: it represents the landing of the Spaniards and the planting of the Cross. When it was made, however, it was not unoriginal, although perhaps not altogether remarkable. I have not attempted to reproduce this work because the photographs, necessarily made at close range, were frankly not interesting; but I should like to note that it was conceived—as Charlot's first mural was not—in truly monumental style, particularly in the foreground, where there is an arrangement of tall, regal female figures, representative of the women of the eastern coast as described in the contemporary documents: native women who were required to be ceremonially baptized before they could become the mistresses of Conquerors. Alva's colors, moreover, were taken not from the palette of the easel painter, as most of the muralists at first took theirs, but from the earth tints traditionally used on the walls of adobe houses in Mexican villages, pinks and blues, grays, faded greens and violets.

Ramón Alva was the first modern Mexican, I should have thought, to consider consciously the great difference, both in color and design, between monumental painting and the mere projection of an easel picture. His earliest work shows that he understood how the spectator's eye

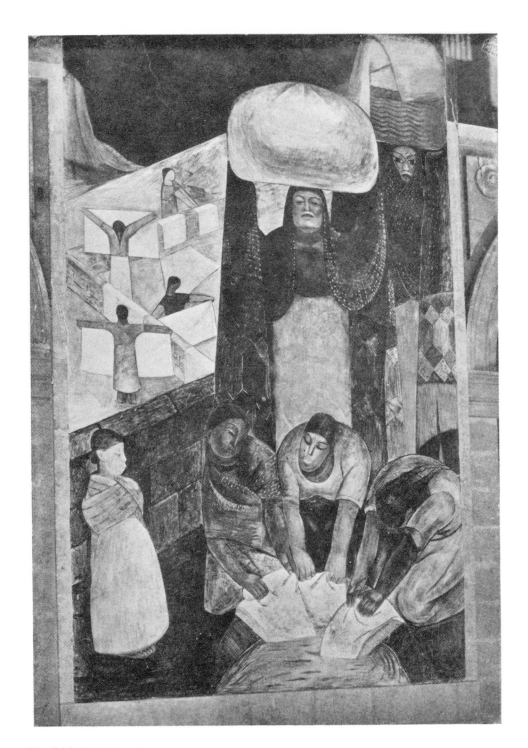

11. LAS LAVANDERAS

Fresco, Ministry of Education, Mexico City, 1923. Jean Charlot

naturally accepts the simplicity of the truly monumental scale as appropriate for large surfaces, and is confused and restless in the presence of a merely big and crowded picture. An easel painter attacking a wall for the first time is likely to be frightened by the possibility that his finished work will contain dull unrecorded areas. Hence he may employ a multiplicity of figures and details, which, upon enlargement, will bewilder the eye of the spectator. The monumental painter works differently, his design is differently conceived. He composes with large masses simply arranged, is austere with detail and ascetic in the use of color, preferring few colors and those generally in low key.

I have seen in the United States, as well as in Mexico, not a few murals—George Biddle's notably excepted—which look precisely like projections of small easel paintings on a large screen. This effect is almost inescapable when a work is painted on canvas in a painter's studio, as many American contracts for mural decoration have required, and then glued to the walls of a public building. In such a case the artist, having missed the experience of working directly on the wall, paints exactly as he does at his easel. The surfaces he covers are larger and he draws his figures to scale. That is all. And that is not monumental painting. The problem of filling space will have had a literal, not an aesthetic solution, at the expense of the spectator's natural delight in simplicity.

Charlot's style eventually progressed toward the monumental, but the typical manner of another Mexican pioneer in fresco painting, Roberto Montenegro, whose easel work is elegant and poetic, was not so readily adapted to mural design, however resolutely the painter tried to bend it to that purpose. When with his first oil painting Montenegro shared a competitive first prize with Diego Rivera for a European scholarship, he went to Paris, where he met Picasso and Juan Gris. Both of these Spanish painters encouraged the development of his naturally suprarealistic style, of which the first evidences were fantasies in the precious and fastidious manner of Aubrey Beardsley. After the publication in Paris, in 1910, of an album of his Surrealistic drawings, with an appreciative preface by Henri de Regnier, Montenegro spent a few holiday months in Mexico,

[ 29 ]

where he encountered Dr. Atl's *Centro Artistico*, and it is this circumstance, no doubt, which explains how it came to pass that twelve years later this aloof and somewhat snobbish painter, home again to stay, became a member of a syndicate of painters founded by the violent Siqueiros.

In 1914 Montenegro, whom Miguel Covarrubias caricatures in the likeness of one of Montenegro's own celebrated Tehuantepec profiles, went to live in Majorca to paint the characteristic elements of insular life,—fishing, truck gardening, sheepherding—as later he was to record, in oil and lithographic print, aspects of natively primitive life in Mexico. He undertook the decoration of a casino in Palma, but because he was unfamiliar with any of the usual mural processes he painted large canvases and hung them on the walls. Before he went home in 1919, however, he took pains to study the Italian frescoes, and was able to carry to Mexico useful notes on color and composition for large spaces.

In 1921 Montenegro and the handsome Indian painter Xavier Guerrero together made murals in tempera in the Church of St. Peter and St. Paul. Most of the painters I have talked to agree that these were the first complete mural decorations of the new epoch. The medium proved to be unsatisfactory—the designs have now practically disappeared—and Montenegro undertook the mastery of fresco technique. He experimented for many weeks in Rivera's studio, following the instructions of Cennino Cennini and Leonardo da Vinci. It appears that everybody was working furiously on the problem at that time, Rivera, Guerrero, Ramón Alva, Máximo Pacheco. Only Dr. Atl refused to bother. When the Doctor received a commission to decorate one of the patios of the convent of St. Peter and St. Paul he went to work on unsurfaced walls with sticks of Atl-color and tossed off scores of his familiar mountains and valleys, peopling them with lusty nudes: an unplanned succession of forms as impermanent as they were heterogeneous.

As a result of his researches Montenegro was able, early in 1922, to attempt some panels in true fresco in the interior stairway of the convent of St. Peter and St. Paul. Rivera was then at work with blowtorch and wax in the *Anfiteatro Bolívar,* Charlot had not yet begun his murals on

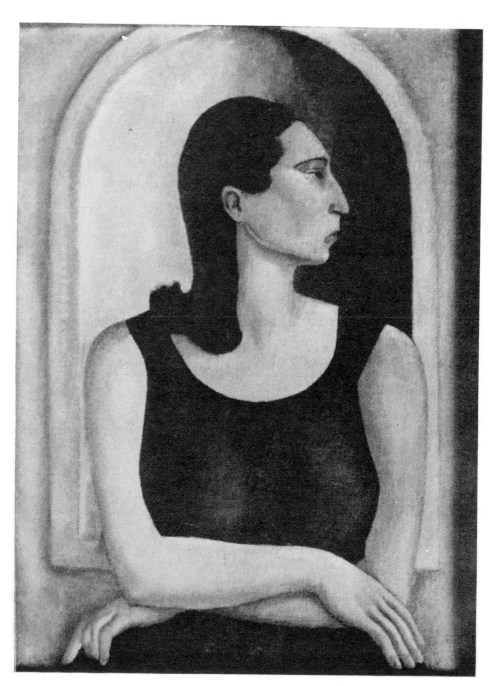

12. PROFILE

Oil on canvas, undated. Roberto Montenegro

wet cement, and Ramón Alva had just started his fresco in the Preparatory School. The ambitious general subject of Montenegro's design—the whole work was not completed until 1931—was "The Reconstruction of Mexico by Laborers and Intellectuals." The part painted in 1922 represents the *Fiesta de la Cruz*, a holiday which occurs on the third of May, when bricklayers and masons climb to the highest rafters of unfinished buildings to fix crosses of straw and flowers. It is such a scene that this fresco records. In imitation of the Italian murals there is a black sky, and the postures and relationships of the figures, although the types are more or less Mexican, are studiously traditional. The design is colorful and decorative, and not at all in the monumental style. Montenegro belongs to Society and not to the people, and his subject probably gave him no great happiness; but the *Fiesta* remains, relatively intact and whatever its worth, as the first finished fresco of the period.

When David Siqueiros returned to Mexico from his more or less imaginary military duties in Europe he was shocked to find the painters at home working in hit-and-miss fashion upon the walls of the Preparatory School and the expropriated convents. He persuaded them to join him forthwith in the formation of a craft union which included technical workers, sculptors and engravers. Siqueiros took over the general secretariat of the organization, Rivera was secretary of exterior relations, Xavier Guerrero held the portfolio of organization, and Fernando Leal supervised the treasury. Orozco was a passive associate.

Siqueiros planned a form of give-and-take instruction which would enable the painters to produce monumental and revolutionary murals. They all wanted to paint for the people, but it appeared that they had not known what to paint for the people. First of all, said Siqueiros, it was necessary to draw up a manifesto. The text of this document, in the translation of Guillermo Rivas for an article on Siqueiros in *Mexican Life*, December, 1935, goes like this, with only faint indications of the resounding splendor of the original:

Social, Political, and Aesthetic Declaration from the Syndicate of Technical

Workers, Painters, and Sculptors to the indigenous races humiliated through centuries; to the soldiers converted into hangmen by their chiefs; to the workers and peasants who are oppressed by the rich; and to the intellectuals who are not servile to the bourgeoisie:

We are with those who seek the overthrow of an old and inhuman system within which you, worker of the soil, produce riches for the overseer and politician, while you starve. Within which you, worker in the city, move the wheels of industries, weave the cloth, and create with your hands the modern comforts enjoyed by the parasites and prostitutes, while your own body is numb with cold. Within which you, Indian soldier, heroically abandon your land and give your life in the eternal hope of liberating your race from the degradations and misery of centuries.

Not only the noble labor but even the smallest manifestations of the material and spiritual vitality of our race spring from our native midst. Its admirable, exceptional, and peculiar ability to create beauty—the art of the Mexican people—is the highest and greatest spiritual expression of the world-tradition which constitutes our most valued heritage. It is great because it surges from the people; it is collective, and our own aesthetic aim is to socialize artistic expression, to destroy bourgeois individualism.

We repudiate the so-called easel art and all such art which springs from ultra-intellectual circles, for it is essentially aristocratic.

We hail the monumental expression of art because such art is public property.

We proclaim that this being the moment of social transition from a decrepit to a new order, the makers of beauty must invest their greatest efforts in the aim of materializing an art valuable to the people, and our supreme objective in art, which is today an expression for individual pleasure, is to create beauty for all, beauty that enlightens and stirs to struggle.

This buoyant instrument of reform had its origin, of course, in the firsthand revolutionary experience of the founders of the Syndicate. In many conversations I have had with Siqueiros the talk has turned upon army life. During the five or six years that some of the younger painters spent as soldiers they came to have enlarged conceptions of the richness and variety of the culture of their country. They had grown up in an

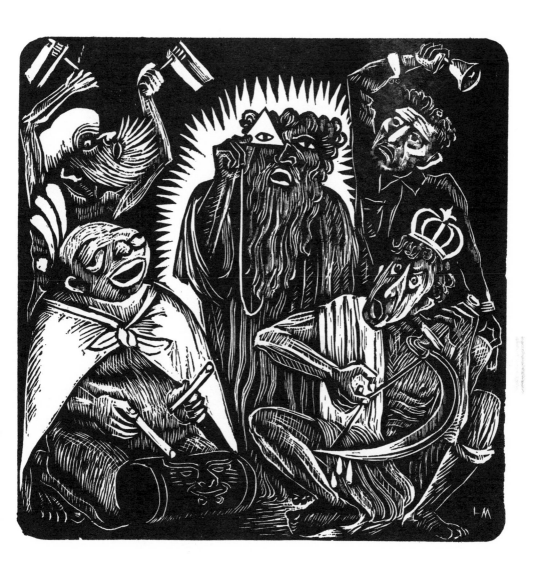

13. FATHER GOD AND THE FOUR EVANGELISTS

Wood engraving, 1932. Leopoldo Méndez. Three of the figures whooping up the new gospel of art are artists, Dr. Atl, Diego Rivera and David Álfaro Siqueiros

imitative French culture, in a society which had found Spanish ways too old-fashioned for its taste and Indian modes too primitive. During the Revolution they had made exciting personal discoveries in the Indian and Spanish traditions. Siqueiros, for example, was surprised to discover that the Indians were no lovers of battle, as Díaz had said they were, but cared only for the land, which they longed to recover.

New knowledge of the country developed into a new patriotism, a new nationalism, and led to the deliberate rejection of whatever was imported and false; not that the young intellectuals quite identified "foreign" with "false," to be sure: they admitted with perfect good grace that Mexican revolutionary ideology, especially its anticlerical doctrines, had been to some degree ordered on the basis of French formulas. Nevertheless, a new nationalistic spirit was abroad, and the Syndicate was its child.

After the members of the Syndicate had met to pool their technical resources and discuss their common intention to paint the Revolution they went out to have a look at each other's murals. It was a shock to them to find that everything they had been painting was religious: an unforeseen phenomenon to which Diego Rivera himself first called my attention. What, they asked themselves, had happened to their resolutions?

Rivera, who had been much impressed by the paintings in the Italian catacombs, put on his wall in the *Anfiteatro Bolívar*, the assembly hall of the Preparatory School, a carefully designed allegory containing many of the familiar elements of Christian painting. Some of the figures were taken from Indian models, but they represented the biblical Adam and Eve and the evangelical Virtues, all of them balanced with academic precision. In fact, there is present in this work today the whole familiar program of the creation of man and his intellectual and spiritual ascent after the banishment from Eden. The color scheme is Byzantine, the mural is resplendent with gold.

Siqueiros was discovered to have countered, on a near-by wall, with the fall of Lucifer. Another of his early fragments represents the four natural elements taking refuge under the wings of an angel. The Com-

munistic sickle on top of the coffin in an unfinished panel called "The Burial of a Workman" does not disguise the fact that the work is really an Entombment of Christ.

José Clemente Orozco's first panel in the Preparatory School—it is called "Maternity"—contains the haloed figures of mother and child attended by hovering creatures whose arms and drapes suggest angels' wings. To be sure, the mother is unclothed, and her companion is not the apocryphal Saint Anne but a reclining nude who offers the Madonna a cluster of grapes. Set in a design from Botticelli, however, these singularities hardly modify the essentially religious iconography of the piece,—although charges of blasphemy were made by the Catholic ladies of the time. As a matter of fact, the independent Orozco has never quite made a point of not being religious. Indian, Greek and Christian religious mythologies have inspired many of his mural designs.

While Alva de la Canal was at work on his religious and historical piece, the "Planting of the Cross in New Spain," Fernando Leal, a graduate of an open-air school, made an encaustic (melted wax) mural of a legend which might have been based upon the story of Christ and the adulteress early interpolated into the Gospel of John.

A comely matron of the village of Chalma, a favorite in her neighborhood, was possessed of a jealous and uxorious husband who was neither *simpatico* to herself nor personable in the eyes of his fellows. In the exercise of her right to such happiness as life this side the grave allows, she took as a lover the romantic idol of the pueblo. All the village conspired daily to protect the sweethearts from detection by the unlovable husband; but there came a day when, repairing impetuously to a near-by wood, they neglected the customary caution of asking a neighbor to oversee their enterprise. The husband observed them hastening across the fields, craftily followed them, came almost upon them as they lay under a bough. Then he lost sight of them. The Black Christ, who had hitherto, so far as anybody knew, hung indifferently upon his Cross in the parish church, had speedily come and cast a shadow over them.

To this day, there is annually celebrated in the well-nigh inaccessible

14. THE LORD OF CHALMA

Detail of fresco, Preparatory School, Mexico City, 1923. Fernando Leal

Indian pueblo an elaborate fiesta in honor of this amiably disposed if somewhat unconventional Christ. Leal's highly colored and thickly thronged mural represents almost every conceivable aspect of this feast. The honored patron, the Lord of Chalma, gazing obliquely down from his customary dwelling place upon the Cross, surveys the processions and dances offered in his homage and blesses impartially the devotee and the knave.

Opposite Alva de la Canal's fresco there is a mural of equal size, made, like Leal's, in hot wax. It is signed with the hammer and sickle, the emblem of the Syndicate, over the initials F.R. and the date 1923. This wall was done by Fermín Revueltas, who died in 1935 at the age of thirty-two. Himself a product of the open-air schools, he became a teacher in a school in Villa Guadalupe, and the subject of his rhythmical encaustic is the legend of the Virgin of Guadalupe, the dark Madonna who became the patroness of Mexico when the Spanish Virgin of Soledad lost her prestige during the Revolution of 1810.

Legend has it that the mother of the Christian God, who has always been slightly confused in Indian minds with Tenantzin, the mother of the Indian gods, lived homeless on the hill of Tepeyac, near Mexico City. One day she appeared to a deferent Indian, one Juan Diego, and asked him to find her a home. Juan Diego related his vision to the Archbishop, who, being a Spanish aristocrat and a gentleman, was somewhat skeptical; "knowing," as Anita Brenner tells the story, in *Idols Behind Altars*, "the native habit of having interviews with deities." But the Virgin was insistent. She gathered some dewy roses where no roses grew and sent them by the Indian boy to His Grace. When Diego opened the net in which he carried the flowers to the episcopal feet there appeared upon its insubstantial reticulations the image of the Lady in shining gold. After this celestial rebuke the Archbishop built a shrine to house the miraculous portrait, and presently every church in Mexico had its Guadalupe altar. Today tens of thousands of Mexican Guadalupes, Lupes, Lupitas, and Pitas are devoted to the dusky saint.

It is one of many ironies in the history of modern Mexican painting

that the political education of the painters evolved more rapidly than their aesthetics. Mexican Communism began timidly to look for support from Russia, and Rivera became a member of the Communist party; but he painted the gentle virtues recommended to Christians by St. Paul. Revueltas and Alva de la Canal signed pious murals with hammer and sickle. Siqueiros painted angels in the morning, and in afternoon retirement drew up the inflammatory manifesto of the Syndicate.

The wide publicity given to the affirmations of the Siqueiros manifesto led the outside world to suppose that a new socialistic school of painting had been formed in Mexico. Nothing of the sort ever happened. The manifesto was posted, many walls were painted by Syndicate members, revolutionary subject matter came eventually into use; but the painters themselves remained as individualistic, as inevitably anti-Communistic, as Mexicans, down in their hearts, must always be. There is not a square meter of mural painting in Mexico today that cannot be readily identified as the work of some individual painter. Only one comprehensive, self-consistent design was ever conceived and executed in Mexico City, and that was actually sponsored, in the end, not by the Syndicate but by Diego Rivera, who became the sole director, and in Mexico City almost the sole actor, of some of the intermediate parts of the dramatic production launched by José Vasconcelos in 1922.

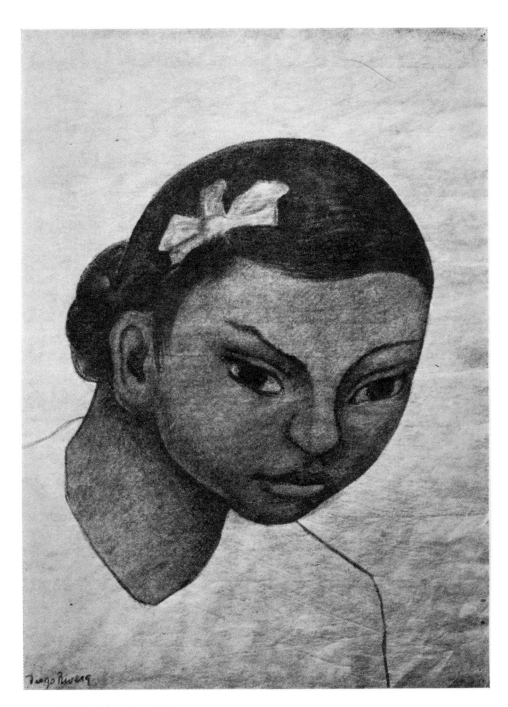

15. PORTRAIT OF ANITA

Sanguine on rice paper, undated. Diego Rivera. From a private collection

# Diego Rivera

*To be an artist, one must first of all be a man.*
Diego Rivera

THE FIRST TIME I VISITED DIEGO Rivera in his pink and blue studio in San Angel, a suburb of Mexico City, there was handed in, from the afternoon post, a printer's dummy of Bertram D. Wolfe's biography of the painter. Rivera was pleased with the format. It was evident that the book was going to be impressive, with its gilded blue cover and profusion of reproductions. Of the text, Rivera gave me the impression that he had scanty foreknowledge. He explained that he had given the biographer access to a disorderly collection of letters and documents, and he expected a book which would do him credit in English-speaking countries. From what he had been able vaguely to gather of the contents at that time he had concluded, he said, that the publishers had given it the wrong title.

"They have called it *Diego Rivera, His Life and Times,*" he told me. "From what I know that Wolfe is going to say, they should have called it *Diego Rivera, His Wifes and Times.*"

When the book eventually came out Rivera professed to be furious. He says he supposed that only political letters would be used in the book, although it seems clear that he permitted his biographer to see his papers indiscriminately. He was therefore annoyed when he discovered that some private letters had been put to what he felt was scandalous use. Perhaps his displeasure was augmented by the rage of Guadalupe Marín, who, when she learned that some of her intimate correspondence had been published, threatened suit against the publishers in the American courts. Frida Kahlo, a more recent wife, not to be outdone by her predecessor's indignation, actually went to New York in defense of her reputation.

Rivera was especially vexed because, as he thought, the book challenged his integrity as a painter. He objected to Wolfe's judgment that his Cubistic pictures were imitative of French Cubism, and irrelevant to the painter's own experience. That criticism made Rivera really angry and provoked him into finding and advertising errors from the beginning to the end of the book; and led him, so he says, to the renunciation of another of his many fateful friendships.

Rivera was born on the Feast of the Immaculate Conception, December 8, 1886, in Guanajuato, the birthplace of Mexican Independence,—a small, clean, colonial city lying out in the hot, dry sun on the hills of the richest mining country the world has ever known. Rivera's father was a schoolteacher. His paternal grandmother was a Mexican girl of Portuguese and Jewish descent; the grandfather, a Spanish-born Mason and freethinker, was a soldier in the Juárez revolution against Maximilian. Diego's mother, who was of mixed Spanish and Indian blood, was fond of reminding her family that her mother, who was clearly part Indian, had descended from a line of Spanish nobles. Baptized with nearly a dozen of their aristocratic names, Rivera has signed his pictures with only three of them, Diego for his father, María for his patroness (while his father lived, and then usually only by way of the initial letter), and his patronymic. Since his father's death he has signed his pictures merely "Diego Rivera."

[ 38 ]

From his childhood Rivera remembers an elderly cousin, Rodríguez Campaces, a silversmith who died one night over his worktable; and the exquisite silverwork that was done in Guanajuato in those days, figurines and filigree. His mature feeling for the local pottery, famous for the purity of its lines, is rooted in early familiarity with the provincial arts. He is today a sympathetic and tireless collector of objects of popular Mexican art.

At the age of ten Diego entered the Academy of San Carlos as a pupil of Velasco and Rebull, under whose direction he particularly enjoyed drawing and painting from plaster models. He is innocently pleased to show to this day a grisaille of a Greek philosopher which he painted when he was fifteen. As a matter of fact, it has many of the illusory qualities of the friezes which accompany Rivera's frescoes in the Cortés Palace in Cuernavaca, and the archaic grisailles in the Ministry of Education in Mexico, works to which the painter himself frequently calls attention.

In 1907 Rivera set out for Spain with the promise of a pension from the governor of Vera Cruz, money in his pocket from the sale of pictures to friends of Dr. Atl, and Dr. Atl's letter to Eduardo Chicharro, whose pupil Diego became in Madrid. Of the work of this period there are examples in the collection of Salo Hale and don Jesús Luján of Mexico City. One of them is a carefully painted street scene from Vizcaya. Both subject and style are in the Spanish romantic vein, neither affording any suggestion of the painter's identity. There is Rivera color in a painting of the cathedral of Avila and in a portrait of a dancer of Madrid, but otherwise these are school pieces, craftsmanlike imitations of painters he used to admire. Probably no one but Picasso in modern times is as erudite as Rivera in the technical aspects of the art of painting. He painted in scores of styles before he developed his unmistakably personal formulas on Mexican walls.

For some months he wandered about in the northern European capitals, looking at pictures, painting, meeting people. Amongst his new friends was Angeline Beloff, the gentle little creature who lived with him and took care of him in Paris, and followed him, years later, to Mexico, where

she was hurt to discover that he had forgotten how she looked. In Paris he knew all the artists, *Fauves* and Cubists, Picasso, Derain, Braque, Gris, Modigliani; and besides the painters there were sculptors and poets, novelists and critics. He liked everybody and everybody liked him. His Mexican friends, of whom there were many in Paris at the time, remember seeing his huge bulk wrapped in all weathers in a flowing cape, and recall fantastic accounts of visions which startled him at night and followed him by day along the streets of Paris.

From 1913 to 1917 Rivera painted in the Cubistic style. The professing Cubists never quite accepted him as an honest and sincere convert because he was not prepared to go the whole way with them. In most of his Cubistic pictures there are distinctly representational elements,—as, indeed, there are in many of Picasso's. Bertram Wolfe, who reproduces fifteen works of this period, explains that Rivera "reconstituted" his figures "before he had completed, so to speak, the chopping up." The purists of the Paris school, who preferred to make new patterns out of broken-down elements, were inclined to think that Diego was a little too conservative to be accepted as a fellow-traveler.

Still, in all the crowded years of his painting, Rivera has never produced richer and more harmonious color patterns than in his Cubistic works. The "Man With a Cigarette" from the collection of Salo Hale (Plate 22 in Wolfe), executed in a wide range of soft colors in which violets and blues predominate, is one of Rivera's most beautiful paintings.

It was during his Cubistic period that Rivera was introduced into the company of a group of Russian painters, in discussion with whom he formulated theories which he was later to expound in his Mexican murals. Indulging the revolutionary passion for manifestoes, the Russians in Paris drew up a collective resolution somewhat after this fashion: "We must give art to the masses. As industry must be made to provide goods for everybody in a socialist society, so must art be made to give itself to the workers."

Rivera speculated about this resolution. In the back of his mind he was amused by the thought of stupid Russian peasants gaping at the

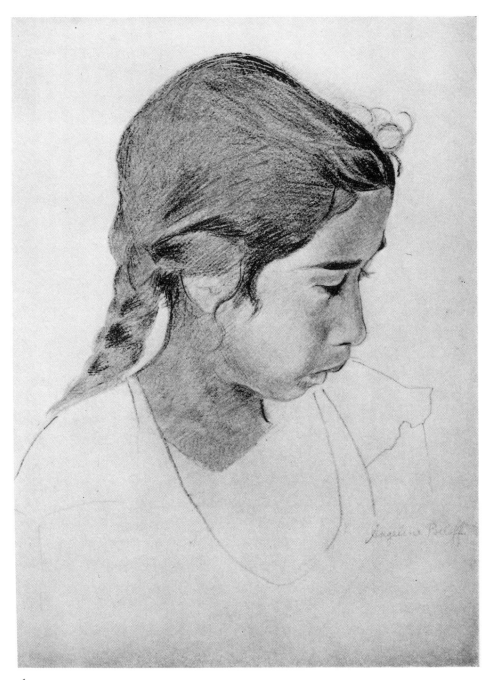

16. PORTRAIT OF A MEXICAN CHILD

Pencil drawing, undated. Angeline Beloff. From the collection of Henry M.
Winter, New York City

Cubistic canvases which the young revolutionary painters proposed to take home to them, but he phrased his ultimate dissent in tactful Marxist terminology. He suggested to the comrade-artists that they were involved in a confusion of categories, a phrase which made them instantly respectful. The enjoyment of art, he intimated, is a product of the simultaneous activity of the nervous apparatus and the mind, both of which faculties, physical and psychical, are conditioned by experience. He went on to explain that without training in looking at objects of art a man not only will not enjoy them but is likely to receive positive harm; just as a man who is not accustomed to certain food, say to Chinese or Mexican cooking, will not only find no pleasure in it but is likely to get indigestion.

Rivera was convinced that if ordinary people are to be expected to look at art with enjoyment, the artist must provide them with forms which not only employ the techniques of modern art and reflect its qualities, but are also of sufficiently simple design and engaging content to be interesting and comprehensible at first glance. This principle of spectator-aesthetics ought, I should think, to be valid for all places at all times.

The Marxist theoreticians did not object to Rivera's criticism but they asked for examples of the kind of art he meant. Rivera explained that modern forms such as he had in mind did not yet exist, but he said, he has told me, that he was thinking of mural painting because it could be produced on large spaces in public buildings. It would be easy to look at and there would be plenty of people to see. He refused an invitation to go to Russia on the spot and paint cubistically there, whilst enlarging his thesis, and made ready to return to Mexico. At home, judging from what he had heard from Siqueiros, he was sure he could find walls on which to illustrate his doctrines.

Rivera began his Mexican mural demonstrations by painting in encaustic, an example of which technique, his "Flower Festival," is in the permanent collection of the Museum of Modern Art in New York. He scratched his designs for the "Creation of Man" deep in the wet cement so that the outlines, at least, would be imperishable, and laboriously

applied the melted wax color. When he discovered that it was going to take months to do a small area in that medium he joined in the general experimentation in the more rapid technique of fresco. Like others, he discovered that the government changed its mind and its personnel swiftly in those days, and the painter who wanted to cover an appreciable amount of space had to work fast.

Shortly after his return to Mexico, Diego met Xavier Guerrero, whom he promptly employed to assist him in the *Anfiteatro Bolívar*. Guerrero came from the northern mines, where he had worked with European muralists on the decoration of mine-owners' houses. He knew the technique of painting on gesso applied to wet stucco, a process in which the painted surface is immediately rubbed with a hot iron. Because the color dries rapidly this process lacks flexibility; it is suitable only for pure decoration, such as geometrical figuring and stylized floriation. Still, when Guerrero went up to the capital he knew something about wet-wall painting, and that was more than anybody else in Mexico City knew at the time. Before Rivera's return he added somewhat to his knowledge by making a small fresco in the Ministry of Education. It appears that Rivera eventually removed Guerrero's panel to make room for a work of his own, but while the two painters were still on good terms they conducted experiments together and evolved a formula which they first used in the newly built Ministry.

So much of what has been written about fresco methods in Mexico has been either confusing or wrong that I asked Guerrero to tell me in some detail about the way in which he prepared walls for Rivera to paint. First, he explained, he spread over the whole area to be painted a one-inch layer of full-bodied plaster of slaked lime and clean mineral sand. The lime had been burned for at least two months to insure solubility: the filtered lime which is manufactured today having been not yet available in Mexico in 1922. The sand, transported from mines because Guerrero found it more free from fungus than river sand, received in Mexico City a cyanide wash of Guerrero's own devising, a further guarantee of purity. Guerrero has been justified by his works. Many Mexican frescoes have

been spoiled by the outgrowth of fungus on improperly prepared walls, but Rivera's have remained relatively clear of this defect.

The first layer of plaster was permitted to dry for a month or more, until it became resistant to humidity. Plaster applied to porous brick dries quickly, but old Mexican walls were commonly compounded of brick, stone, adobe and rubble, a mixture of masonry which requires more caution in handling than mural painters are obliged to take with standardized American building materials.

When the first layer of plaster was thoroughly dry it was brushed with distilled water. Then to the limited surface which Rivera could, on a given day, be expected to paint, the assistant applied a second layer of plaster, of less than a centimeter to two centimeters in thickness, depending upon the smoothness of the first layer. The mixture of sand and lime contained less body than that prepared for the first layer, the sand having been more finely screened. Over this layer of plaster, just before it dried, Guerrero finally applied a paste of pure lime with a trowel. He had discovered that the lime paste enhanced the brilliance of the colors.

When Rivera made his first frescoes he drew his designs directly on the surface of the wall at this moment of preparation. It was important to move rapidly because both drawing and painting had to be accomplished while the thin plaster coating was still moist. The colors do not actually *penetrate* the plaster, as is sometimes loosely said; rather, they *become* the surface of the plaster when, in the process of drying, the lime is carbonized and at length recovers its original properties as calcium carbonate, or limestone.

It was, of course, enormously difficult to draw the designs and then paint them before the plastered surface dried out. Rivera ultimately added a further, now an invariable, step in the process. He drew the designs upon the first coat of plaster and transferred them thence to transparent paper, from which an assistant could quickly return them to the wall by stencil, when the final surface was ready for the colors. His basic palette was eventually composed as follows: vine blue made from calcined grapeseeds, ultramarine, cobalt blue, emerald green, raw and burnt sienas,

[ 43 ]

almagre morado (red oxide of iron), Pozzuoli (Italian red earth), dark ochre and yellow ochre.

If scientifically correct processes had been used consistently the frescoes in the Ministry of Education would have been, technically, more successful than they proved to be, but something untoward happened which both Rivera and Guerrero are now shy of discussing. It appears that Guerrero one day suddenly announced that the Aztec painters had used nopal liquor, the juice of a common type of cactus, as a body-making color vehicle. Perhaps this information was communicated to him in a vision: it could not have been established in a laboratory. But it was a romantic idea calculated to appeal to Rivera, and nopal juice went into his mixtures of color and distilled water. The organic substance of nopal could not be chemically combined with the mineral substances of the plaster, it simply dried out on the surface; hence some of the early frescoes were disfigured by water blisters which formed under scales of nopal. Rivera has never been able to repair more than a small part of the damage.

Guerrero has described to me Rivera's first approach to his job in the Ministry of Education. The *maestro* nervously examined the area prepared for the day's assignment and somewhat uncertainly set to work reproducing his sketches. By the time he was ready to paint he was shaking with excitement. Within a quarter of an hour he had decided that the painting was bad. Before he had worked half an hour he was convinced that the informal technique would never please him. He snatched up a hammer, assaulted the wall and powdered the surface he had painted. But the next day he was calmer. He said he could not see that there was much difference, after all, between water-color and fresco painting, when you got down to it, and since he had always been a magnificent water-colorist he was presently working with the rapidity and rhythm of a born technician.

The building which houses the Ministry of Education in Mexico City is an immense structure in the neoclassical style of the eighteenth century Jesuit monastery which it displaced. It is divided into two courtyards or patios of unequal size and rises to three stories, each of which is encircled

by a corridor or cloister. José Vasconcelos, who let the contracts for the murals, originally commissioned Rivera to paint the three floors of the smaller patio, including the great staircase, and assigned to Charlot, de la Cueva, Guerrero and others the decoration of the large patio.

It appears that Rivera did not have, in the beginning, any generally conceived design for his part of the ambitious work. Fresh from visits to Yucatán and the Tehuantepec peninsula, he painted first some purely decorative panels representing the statuesque and Amazonian women of the South. These picturesque ladies proved to have no more connection with the social problems of Mexico in revolution than the portraits of buxom Lupe Marín and the cadaverous poetess Nahui Olín in the *Anfiteatro*. Considerably embarrassed, Diego thereupon began to cultivate a pictorial interest in social conditions, and shortly went to work upon a succession of panels of people at work: weaving, dyeing, harvesting; refining sugar, molding pottery; heaving and sweating in blacksmith shops and foundries.

The Tehuantepec women were painted in bright, clear colors, many of which proved to be impermanent. In the industrial designs Rivera began to use dull earth-browns and grays, colors which now appear, especially in the panel of the dyers, a little dirty. As the design developed, he introduced richer tones, adding to his palette brighter purples, deeper yellows, reds built up into flame.

Finally the first floor of the first patio was finished. Rivera looked upon it and saw that it was good and called it the Court of Labor.

Three particularly interesting characteristics of Rivera's mural style can be observed in the Court of Labor: the progression from flat to modeled painting, the development of the Rivera Mexican type, and the emergence of the propaganda motif. Beginning by drawing his figures relatively flat against backgrounds with few planes, in a manner obviously suggestive of Gauguin, Rivera proceeded to introduce modeling in the full round; although, except in the nudes, he rarely, even in the later murals, modeled in detail.

Again, beginning with individualizing figures, he went on to develop

the typical small, flat-nosed, round-shouldered brown man who became the world's symbol of the Mexican Indian: a little fellow with a globular head attached to a neckless, egg-shaped torso poured into a white shirt.

The first notes of social indignation occur in panels which show the searching of miners as they stream up from the mines, and the weighing of grain by an ungenerous overseer. Sometimes the moral is pointed out in a text, as in the quotation, "They defame and despise us because we are common people." Against these scenes of oppression are set engaging aspects of the work of the benevolent revolutionary party, such as the unselfish labors of the rural teachers, those ascetic modern missionaries to the illiterate peasantry.

When Rivera had finished the walls of the ground floor of his patio it was discovered that half-a-dozen painters had covered only a few square meters of the larger courtyard. Early in 1924, therefore, he received contracts to take charge of the decoration of the entire building and proceeded to the ground-floor corridor of the large patio, the Court of Festivals. Here he began to let go with color. Some of the panels are rich with ochre and flamboyantly decorated with bright floral backgrounds. On one hand a colorful ribbon dance; on the other a row of effigies of Judas Iscariot, awaiting consumption in the streets in a sputter of fireworks, on Holy Saturday. Using some of the choicest paper Judases in his own collection as models—several of them were on exhibition in the Museum of Modern Art in 1940—Rivera provided them, in these murals, with the faces of unpopular citizens: a priest, a general and a financier.

Four frankly popularizing panels represent parades on the First of May, Labor Day in Mexico. The pictorial fascination of this theme persisted with Rivera for a long time. In Moscow in 1928 he made forty-five May-Day water-color sketches which Mrs. John D. Rockefeller, Jr., has presented to the Museum of Modern Art. In the Mexican version the parading workmen carry banners printed with trite exhortations: "Workers and Peasants of the World, Unite," and "Peace, Land, Liberty and Schools for the Oppressed Masses." Several portraits are worked into the text. There is one of Guadalupe Marín, who had modeled for Woman

[ 46 ]

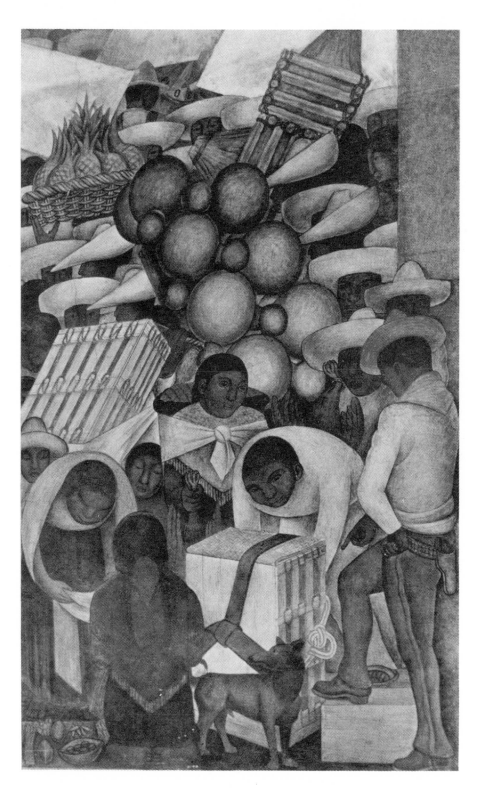

17. THE MARKET

Fresco, Ministry of Education, Mexico City. Diego Rivera

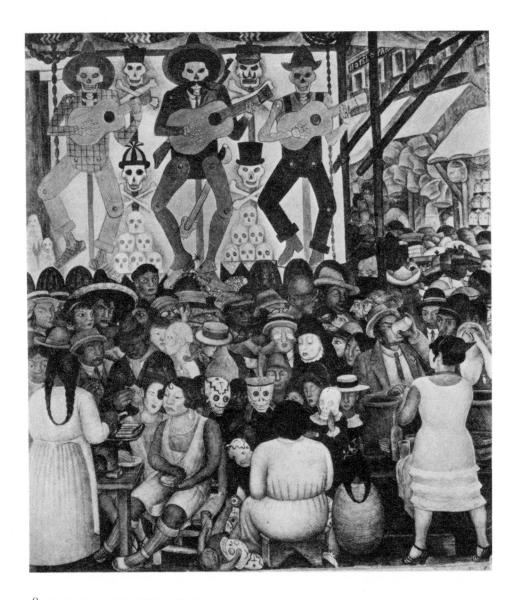

18. THE DAY OF THE DEAD

Fresco, Court of Festivals, Ministry of Education, Mexico City. Diego Rivera.
Note the self-portrait of the painter, accompanied by Lupe Marín

in the early encaustic, and had now come from her home in Guadalajara to live with the painter. It was she who inspired probably his greatest work, the murals at Chapingo. Other portraits are those of Jean Charlot, who contributed to the Court of Festivals two panels in something approaching the monumental style; Máximo Pacheco, a poverty-stricken Indian muralist who at that time assisted Rivera at the rate of three pesos a day; and Paul O'Higgins, another Rivera helper who has become a sound painter on his own account. Besides these, there is a generous assortment of self-portraits.

At the entrance to the staircase which makes its way up through the gloomy interior of the Ministry a marine allegory peopled with luminous nudes initiates a series of prospects illustrating the geographical ascent from Vera Cruz to Mexico City. Up in the highlands, where clothing is customary and a moralizing purpose appears, an *hacendado* takes his ease while the workers toil. Toward the top of the *escalera* the design becomes complicated, the propaganda explicit, the subject matter symbolic. Most of the revolutionary iconography is present: a peasant (presumably an economic martyr) is buried, lightning strikes clerical and military oppressors of the people, the land is divided, the ignorant receive instruction, the sick are healed; and at the exit to the third-floor corridor, to the left, a self-portrait crowns the work.

A final series of frescoes, painted in 1927 and 1928 in the third-floor corridor of the large patio of the Ministrty of Education, illustrates two revolutionary *corridos*, the verses of which appear on overhanging festoons. The ballads recite a kind of popular commentary on the Constitution of 1917 and, like that hopeful document at the end of its first decade, describe the aims of the Revolution rather than its accomplishment. Rivera illustrates them with thousands of the little egg-shaped people who await the liberation the Revolution promised them: *paysanos* in straw *sombreros* (which economically obscure their faces), tight-fitting shirts and seamless trousers. Their clothing adheres snugly to plump bodies, a little like old-fashioned balbriggan underwear bleached to chalky white. The real Mexican, who is bony, muscular and lithe, perhaps even a

little angular because of his ascetic diet, looks in wonder at Rivera's version of his figure.

Contrasted with the peasant figures are caricatures taken from what Diego would have called the capitalist society, the Rockefellers, the Morgans and the Fords, mopping up champagne—little did Rivera understand the puritanical inhibitions of really rich Americans—at a table decorated with streams of ticker tape; and mocking portraits of contemporary Mexicans who had engaged the muralist's ill will, like Vasconcelos, whom Rivera had known from boyhood and never liked and now ridiculed upon a white elephant.

Rivera's caricatures are not grim and violent, like Orozco's; they are grossly, hilariously funny. Diego told me one time that the Rockefellers had decently professed amusement over his portraits of themselves and even took photographs of them. This event occurred, I believe, several years before Rivera raided Radio City.

The color patterns throughout the Ministry seemed to me to be somewhat impaired by occasional compromises between close and remote effects. Immediately in front of the murals it is impossible to get proper perspective, the corridors are too narrow, while from across the patio important elements of design are lost. Orozco had a much simpler problem in the Preparatory School where his frescoes are separately framed by cloister arches. They look whole and finished when seen from the patio, although actually the transitions between them are abrupt and sometimes ugly. Rivera's frescoes, to their great disadvantage, are separated by doorways which lead to interior offices and bear no balanced relationship to the cloister arches. Some of them are confronted by solid columns which entirely hide them from a spectator standing in the patio. To offset this disability, from the standpoint of design, Rivera has drawn carefully disposed diagonal lines to intercept the prevailing verticals of the Court of Labor and the prevailing horizontals of the Court of Festivals. The diagonals have the effect of lending movement to the interrupted sequences when seen in panorama from the open court.

Before he had finished his work in the Ministry of Education, Rivera

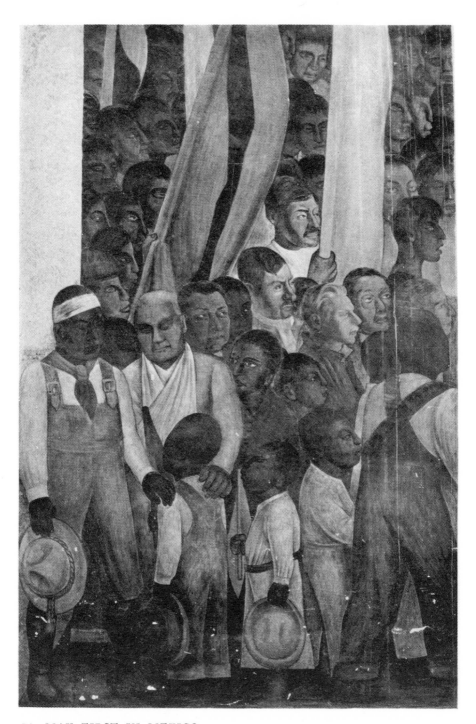

19. MAY FIRST IN MEXICO

Fresco, Ministry of Education, Mexico City. Diego Rivera. Note the portraits of Xavier Guerrero, the round face to the left of center; Paul O'Higgins, the fair-haired young man to the right of center; and Lupe Marín in profile to the right. This panel is badly disfigured

additionally undertook the decoration of a large chamber, a onetime chapel, in the National School of Agriculture at Chapingo, about forty minutes by motor from Mexico City. If this is not his most significant work—he himself puts the Detroit murals in first place—it is certainly the most beautiful. It has the feeling of a thoroughly modern Sistine Chapel, in which lip service to revolutionary doctrine is substituted for skin-deep Christian piety as a background for sheer plastic virtuosity.

Lupe Marín, the principal model for this work, appears first as a classical recumbent nude set in a lunette over an arch in the entrance to the chapel. Her black hair falls sweepingly over her eyes, her left arm follows the limpid lines of her body, the left hand gracefully at rest upon the thigh. In her right hand she holds a cactus plant, a device which Rivera often uses as a phallic symbol. Here Lupe is the freshly created Earth, an unawakened virgin. At the opposite end of the chapel a pregnant Lupe represents the Earth-Mother, fecund and liberated. Finally, she appears as Earth enslaved, half reclining in a typical Michelangelesque slave posture, imprisoned (Rivera-wise) by the priest, the soldier and the capitalist.

These splendid female nudes, together with eight vignetted male figures in the ceiling, fill the space with haunting beauty not to be felt elsewhere in Rivera's monumental work. A few panels of social themes expounded in duller color and flatter modeling, although they spoil the ideal unity of the design, scarcely divert the eye from the strong accents of the major panels with their rich color and rounded forms.

For seven fat years Rivera fed the Mexican populace with murals. Whether the people liked them or not, most of them were at least digestible food. The Chapingo designs may have been a little too rich for their taste, but Chapingo stands by itself, both artistically and geographically. The frescoes in Mexico City are as easy to look at as an illustrated primer. Meanwhile the same years had been lean in Russia, where Cubism had proved to be not in the least nourishing for the masses. In 1927 Rivera, who had been in and out of the Party, was therefore invited

to go to Moscow to illustrate his theories of Communist painting. This he did with great satisfaction, producing before the Communist Academy a pocketful of photographic illustrations of the thesis he had compounded in Paris.

Altogether he had a great success. The Academy elected him to membership in the October Group, the students of the School of Plastic Arts in Moscow appointed him to an honorary professorship, and the auto mechanics' union commanded him to stay in the USSR to decorate buildings which had not yet been built. Before the year was out, however, Rivera's friends in Russia found themselves in disfavor, after some characteristic domestic political crisis, and he was persuaded to go home to assist a Communist candidate to become President of Mexico. In 1929 he was expelled from the Party at a trial which was as incoherent as it was pretentious. Although he was later reinstated, for a time, Rivera never forgave his colleagues for humiliating him. His turning to toryism was a part of his revenge.

Rivera's next important commission came from the late American Ambassador to Mexico, Dwight W. Morrow, who engaged him to paint the walls of the loggia of the Cortés Palace in Cuernavaca, a pleasant provincial capital some fifty miles south of Mexico City. Here he produced his most colorful, objective and unified frescoes, dramatizing the history of the State of Morelos from the Conquest to the Revolution. In well-known panels of which the rhythms and rose and blue colors are enchanting, Spanish cavalrymen invade the little Aztec city. Cortés, elegantly attired, superintends the construction of his Cuernavaca palace, this very palace where the murals are. A languid *hacendado*, like the gentleman in the Ministry staircase, lies in his hammock and sips a cool drink while his agents draw blood from the backs of peons at work in the cane fields. The Church despoils and oppresses in the persons of gross and greedy monks, composed in the stereotyped Rivera form, and consoles in the tender portrait of the Franciscan Father Motolinía. It will be seen that Rivera was not wasteful of symbols.

In August, 1929, when he married Frida Kahlo, it appears that Rivera

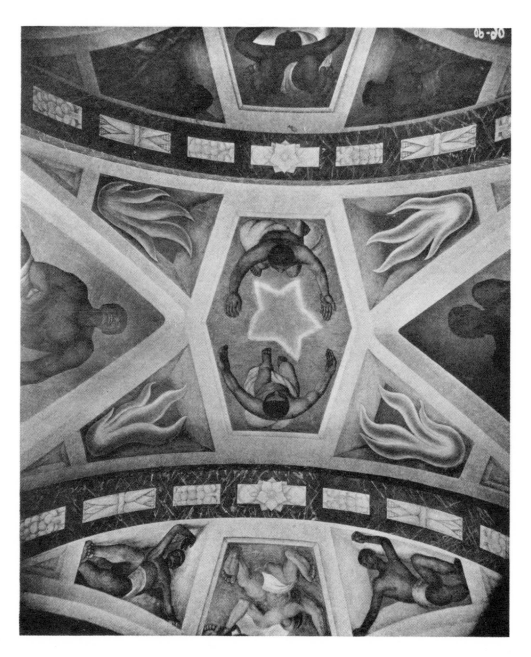

20. DECORATIVE NUDES
   Ceiling frescoes, Chapingo, Diego Rivera

was legally married for the first time in his life. There had never been any pretense of marriage to Angeline Beloff, and whatever the ceremony was of which Lupe Marín is said to have boasted to her friends, it was sufficiently informal to allow her to take another husband without the public formality of divorcing Rivera.

Frida Kahlo, hastening the blossom before the leaves, had announced at the age of thirteen that she desired to have a child by Diego Rivera. When she was seventeen she was modeling for him, having usurped, at least in his studio, the place of Lupe Marín. At nineteen she married him. A year later she was still sure enough of him to allow her sister Cristina to model for a panel in the modernistic Public Health building, and when these frescoes were finished—they are too hygienic to invite aesthetic emotions—she went with him to California where Rivera had been commissioned to paint, of all places, in the San Francisco Stock Exchange. From her as well as from him I have gathered many of the remaining elements of Diego's history.

Public announcements of Rivera's arrival in San Francisco created a sensation which must have afforded plenty of satisfaction to a man who does not in the least mind having his name in the papers. The fact that he had been expelled from the Communist Party did not, of course, prevent the newspapers from calling him communistic. Editorial writers, seconded by local painters, any one of whom would have liked the commission for himself, wrote bitter anti-Rivera editorials. From their point of view, perhaps, they had reason enough to be fearful. Rivera was by no means finished with his political program. Although I am convinced that his political convictions have never been truly profound, his hurt feelings were bound to compel him ultimately to prove that his revolutionary loyalties were as unimpeachable as any Communist's.

Taking his cue from the antagonistic character of the notices of his arrival, Rivera determined to be as charming as possible to the people he met in San Francisco, and to paint without giving offense. Because nobody can be so charming as Rivera when he is benevolently disposed, and because his interest in painting has always been more compelling than

his political enthusiasms, he succeeded in achieving an immense personal success, as well as unexpectedly ample praise for his work.

I do not myself think that the Stock Exchange murals could be called beautiful, and I defend myself for raising the point on the ground that Rivera himself subscribed to the Manifesto of 1922, a document which expressly said that the "supreme objective" of the artist was to create "beauty for all, beauty that enlightens and stirs to struggle." Now beauty in representational painting—and the Stock Exchange frescoes are surely neither more nor less than representational—depends upon a certain degree of adherence to the traditions of representational painting, of which one aspect is proportion and balance.

I do not mean to overlook the deliberate asymmetries frequently and effectively employed in modern art; I am thinking, simply, of the proportionate distribution of masses which the eye ever restlessly seeks to discover. The principal panel in Chapingo had failed to give permanent delight because it was top-heavy; the large figure of Earth with child floats dangerously above five of her tiny unprotected creatures. In the mural on the staircase of the Stock Exchange the shoulders and head of a big bedizened woman, a portrait, presumably, of Miss Helen Wills disguised as Miss California, pulls the great tall wall to the floor. The lady's lap is so full of lilliputian figures that there is no body left to support the gigantic head.

If there is a moral in the San Francisco piece it occurs only by implication, namely, that the food of which the Stock Exchange Luncheon Club is about to partake is the fruit of the labors of hard-working men. The idea is hardly disturbing enough to unsettle the gentlemen's digestions. The membership was pleased.

Rivera then moved on to the California School of Fine Arts, also in San Francisco. He generously filled an area of twelve hundred square feet instead of the hundred and twenty he had contracted to do, and called the design "Construction." It might have been called "Diego and Frida in California." Diego's bulky rump dominates the central panel,

[ 52 ]

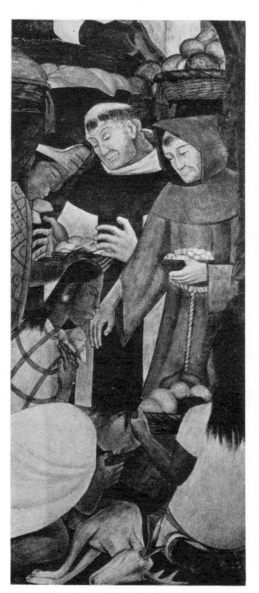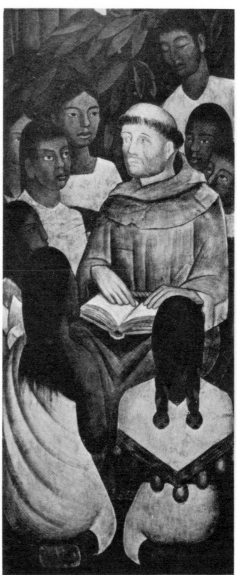

21. THE BAD MONK AND THE GOOD MONK

Frescoes, Cortés Palace, Cuernavaca. Diego Rivera

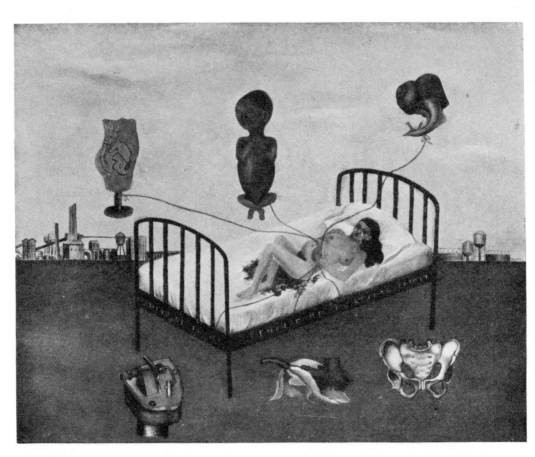

22. MY FIRST MISCARRIAGE

Oil on tin, 1932. Frida Kahlo

and Frida, at his side, has become a lady engineer. Diego had already painted her, in Mexico, as the Joan of Arc of labor, in blue jeans.

A project really worthy of Rivera's reputation and resourcefulness was begun when Edsel Ford, through the Detroit Arts Commission, offered him $10,000, a sum later increased to $25,000, to decorate the covered court of the Detroit Institute of Arts. This important work took the painter straight to the heart of industrial America, whither his path had for a long time been set. Artists everywhere were turning for inspiration to the geometrical patterns of modern machines, and now Rivera for the first time had both means and leisure to observe and reproduce those exciting new sources of design. In Mexico he had received the meager wage of twenty pesos a square meter, which worked out to about ten dollars a day, and out of that sum he was obliged to pay the mason, the mason's helper, the assistant painter, and the cost of lime, sand, paint and brushes. Rivera felt that he was on top of the world in Detroit, and in return he gave what he believes to be his finest work.

He visited factories and made sketches for three or four months and then retired to the Institute, where he produced twenty-seven panels on the general theme of industrial life. As in Mexico he proceeded circuitously. If upon entering the courtyard the spectator looks straight ahead he is likely to get the impression that Rivera had begun the new work with designs left over from his Mexican murals. Five small panels on the wall opposite the entrance illustrate the old theme of the fertility of the soil. The central decoration is an ugly little fetus curled up, presumably, in the womb of earth,—although it may contain a cross reference to Frida's first miscarriage, a shattering misfortune which occurred at this time; while to right and left are circular, crouching, primitive nudes with their laps full of fruit and vegetables. Even the studies of workmen, except for facial quality and dress, resemble the proletarian type of the Mexican murals; and at the top of one wall there are nudes and hands reminiscent of Chapingo. But in the large side panels, which after all make up the body of the ambitious decoration, Rivera vigorously introduced the new local themes of which his sketchbooks were full. His use

of the universal and primitive rhythm of the wave creates essential simplicity in the midst of crowded motifs showing Detroit at work. Here is an effective transcription of the age of machines.

The architectural pattern of the courtyard is filled out in small self-contained panels above the doorways and niches. One of these, "The Vaccination," is a composition of tender beauty in its sympathetic recollection of primitive Nativities, but it was this delightfully unpretentious piece which gave troublemakers a handle.

When the work was finished it was immediately apparent that not all of Detroit was in agreement with Rivera that he had produced his masterpiece. It was spontaneously denounced in the press and from the pulpit. According to Bertram Wolfe, the most malicious attacks came from a Catholic priest and an Episcopal clergyman, both of whom were ultimately obliged to confess, with apostolic publicity, that they had not seen the frescoes.

It is clear that the real occasion for the great outpouring of antagonisms was not any particular detail of the design, but simply its general lack of prettiness. I met one day in Rivera's studio a Detroit woman who had been brought there to be diverted. A member of a paid-up tour, she had failed to take in the significance of the visit before she reached the studio. She was shocked when she discovered where she was. "Why this," she whispered indignantly to a companion, "this is the man who spoiled our lovely museum in Detroit."

I have no doubt the lady's sentiment fairly expressed general opinion at the time. Still, every kind of specific criticism was overtly laid against the murals. It was said that they neglected the "spiritual" aspect of the city. As Rivera analyzes the complaint, it meant that he had not represented the special qualities of the new suburban culture of which the citizens were very proud. Diego was furthermore charged, in religious circles, with deliberate blasphemy: witness the disarming panel showing the vaccination of a baby.

Ecclesiastical fury seems to have subsided only when Father Coughlin addressed himself to the matter over his radio hookup. Conservative pul-

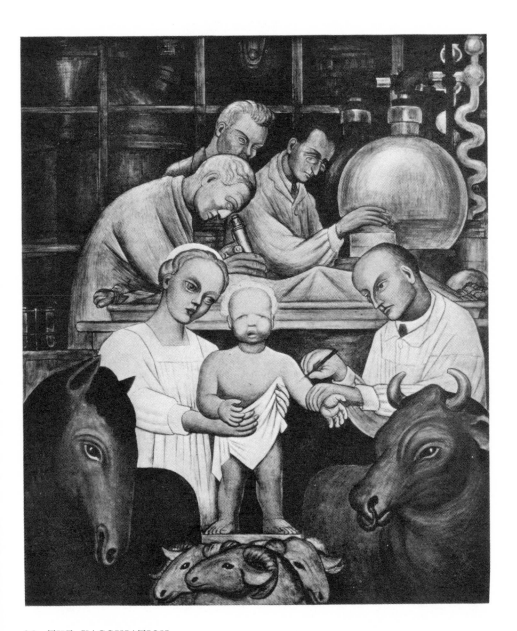

23. THE VACCINATION

Fresco, The Detroit Institute of Arts, 1933. Diego Rivera. By permission of
W. R. Valentiner, Director

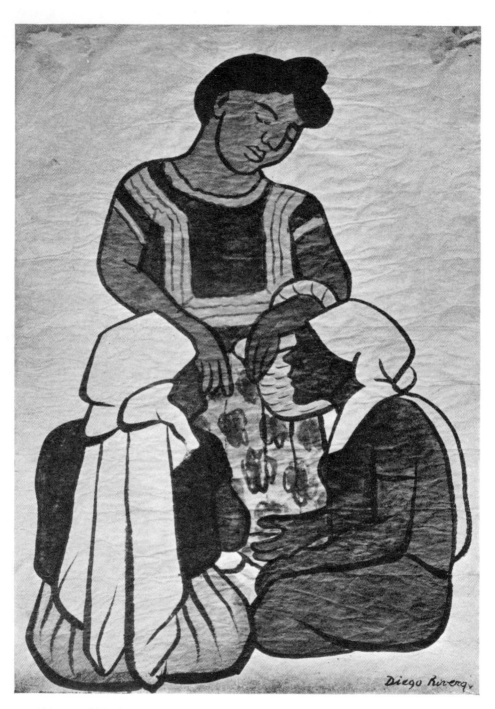

24. TEHUANTEPEC

Water color on rice paper, undated. Diego Rivera. From the author's collection

pits could not bear to be associated with the Coughlin school of criticism. Even the civil authorities were eventually abashed when a petition worthy of the pen of Siqueiros was presented by workers of all political parties, Stalinists, Socialists, Democrats and Republicans. The frescoes, said the petitioners, were a gift to the city, had become a part of the community wealth. The signatories felt themselves constitutionally bound to protect the same, if necessary with force of arms. The protest stayed, in the nick of time, the hands of the city fathers from the whitewash bucket. Finally Mr. Ford, who paid the bill, declared his personal satisfaction with Rivera's effort to express the spirit of Detroit. A portrait of Diego at that time would necessarily have been painted in high key.

Rivera's final work of that epoch, the so-called Rockefeller murals, aroused a hurricane of criticism which was not abated until the finished fresco was reduced to a heap of powdered dust upon the floor. The metropolitan newspapers of the time (May, 1933) contain abundant— if sometimes reluctant—references to the story; Rivera himself has written about it in the Introduction to *Portrait of America*; and "The Battle of Rockefeller Center" is the subject of a lively chapter in Bertram Wolfe's biography. I propose, therefore, to use my own notebooks, in which there are dozens of pages recounting Rivera's current version of the episode, not all of it consistent with the printed version of 1934, principally as a commentary on the published accounts.

The center of the controversy was a realistic portrait of Lenin which occurred in a group of men to the right of a pair of forms which looked like airplane propellers. These forms were intended to represent the Crossroads of the pompous title which had been suggested for the mural project by the architects of the building which was to house it: "Man at the Crossroads Looking with Hope and High Vision to the Choosing of a New and Better Future." It seems to be generally agreed that the portrait did not unmistakably appear in the sketches which Rivera had submitted for approval. The artist explained that it had been logically suggested, during the progress of the painting, by the concept of leadership explicit in the argument of the approved design, but the representatives

of the owners of Radio City were not thereby persuaded to like the looks of Lenin any better. They ordered the portrait removed.

Rivera was again, for the moment, a Communist in good standing. He went for advice to his comrades. I cannot think of this occasion without provocation to laughter, for I suppose Rivera had never before consulted anybody with such a show of humility. Miguel Covarrubias ought to have caricatured the occasion—the stout Diego crawling at the feet of a sophomoric Communist judiciary, a pitiful, repentant Diego, fearful of reproach. The resolution was solemnly taken that if the fresco could be preserved by the sacrifice of the portrait of Lenin and the substitution of an American sponsor of liberty—the name of Lincoln was recalled—Rivera should be directed thus to compromise.

Rivera was notified by letter that the removal of the Lenin portrait would be satisfactory to the Rockefeller family, but he chose to reject this solution of the problem. His present explanation of his obduracy is that the destruction of the fresco more nearly secured his heartfelt social and political objects than its preservation could have done. For the thousands who might have seen the fresco in its place, he says, millions of workers throughout the world were roused to revolutionary action by its obliteration. Perhaps he was then bent upon vindicating his loyalties.

In *Portrait of America* Rivera humorously describes the warlike arrangements for his dismissal from Radio City: "Towards eleven o'clock in the morning, the commander-in-chief of the building and his subordinate generals of personnel issued orders to the uniformed porters and detectives on duty to deploy their men and to begin occupying the important strategic positions on the front line and flanks and even behind the little working shack erected on the mezzanine floor which was the headquarters of the defending cohorts."

The battle was on. Rivera was called down from the scaffold, paid off, ordered out. Within an hour "the carpenter had already covered the murals as though they feared that the entire city, with its banks and its stock exchanges, its great buildings and millionaire residences, would be destroyed utterly by the mere presence of an image of Vladimir Ilyitch."

[ 56 ]

Word of the event circulated throughout the city. "Half an hour after we had evacuated the fort, a demonstration composed of the most belligerent section of the city's workers arrived before the scene of battle. At once the mounted police made a show of their heroic and incompatible prowess, charging upon the demonstrators and injuring the back of a seven-year old girl with the brutal blow of a club. Thus was won the glorious victory of capital against the portrait of Lenin in the battle of Rockefeller Center."

Rivera today does not condemn the Rockefeller family for the disaster of the ensuing total destruction of his fresco. Rather, he blames the contractors. He says that when he was working in Radio City Mr. Rockefeller came to see him one day, together with half-a-dozen collectors and art patrons, and told him that this was the first modern painting he had ever really liked. The part he liked best, Diego reports him as saying, was a glimpse of Red Square, which purportedly reminded him of his own Beauvais tapestries. It therefore must have been the contractors, Rivera declares, who demanded the removal of the murals. He charges that they went privately to seventeen tenants, amongst the thousands hiring offices on the seventy-two floors of the building, and advised them to ask the owners to remove the Bolshevik fresco. They hinted, he says, that it would shock the customers and perhaps compromise the success of the whole enterprise.

The farcical assumption that a portrait of Lenin could upset an apple-cart containing three hundred million dollars was more than Rivera could bear. It offended his sense of proportion, it drove a normally temperate man, of whom a Mexican writer has said that his convictions are *"susceptibles de variación circunstancial,"* implacably to refuse to compromise. If I have any understanding of Diego, it would seem that temperamental conflict explains his unwillingness to alter the Rockefeller murals more intelligibly than his present account of some subtle political design to convert the world. I believe his real reason for refusing to remove the portrait of Lenin was grounded in outraged emotions. For public consumption he has thought up two or three rationalizations.

With the aid of photographs surreptitiously taken in Radio City Rivera subsequently reproduced the work in the Palace of Fine Arts in Mexico City, adding a satirical portrait of Mr. Rockefeller in a café-society scene which balances Lenin and his proletarian companions; and with the Rockefeller money he painted twenty-one insurgent (and removable) frescoes for the New Workers' School in Fourteenth Street.

Although Rivera lost two or three important commissions which had been all but contracted for at the time of the Rockefeller debacle, he likes to have it known that he has been offered more mural commissions since 1933 than he had received before he went to California. Of these he has so far executed at home only the repetition of the Rockefeller murals. He has rejected, as well as government offers, invitations to do work in Honolulu, Paris, and the Republic of Colombia. Abroad, he has undertaken only the "Art in Action" murals for the Golden Gate Exposition in San Francisco, whither he was summoned in the summer of 1940 to draw a crowd by making a personal appearance. There remains in his files one invitation which he has tentatively agreed to accept, the decoration of a recreation house for Philadelphia workingmen.

Having covered acres of walls with frescoes, Rivera has been concentrating, the last few years, on work in his studio, enjoying as privately and quietly as he can, what with daily tourist invasions, the pleasures of drawing and easel painting. Now he professes to be interested in painting small surfaces, in the refinement of forms. He is absorbed in translating from fresco to oil painting the technique of securing the maximum of expression with minimum means; but above all, at least for the moment, he relishes the profounder qualities, the more varied textures and the more leisurely use of oil and tempera, as compared to fresco painting.

There is no official catalogue of Rivera's work, but he has produced altogether probably one thousand paintings and drawings,—not counting the notebook sketches, of which some Italian drawings sold by Angeline Beloff to the Gallery of Mexican Art in Mexico City are the choicest. Of this great number of works about half of the paintings and many of the drawings are in European galleries and private collections. Several

important pieces painted during the last three or four years have gone to a mysterious collection in Italy, of which the rumored owner is Mussolini, whom in the old days Rivera scarcely professed to admire. Most of the remaining pieces are in the United States, although Rivera has reserved for himself a sheaf of his finest water colors and scores of Chinese ink drawings. Probably the greatest American collection of Riveras in North America is that of Mr. Albert M. Bender of San Francisco.

Amongst his most recent works are two nude portrait studies and about thirty posture drawings of Maudelle, an American negro dancer. One of the oil paintings was lent by the painter for the "Twenty Centuries of Mexican Art" exhibition at the Museum of Modern Art and was reproduced in color in the catalogue. A few luminous and tender nudes have been done from a new model, a pretty little Mexican girl who, between his divorce from Frida and his remarriage, presided over Diego's dinner table. Besides these, there have been two or three not very convincing experiments in Surrealism. These suffer from the artist's greater interest in the several forms than in composition as a whole. Because the cheap peso has attracted throngs of tourists to Mexico there still come from his brush, alas, dozens of identical little Indian children in blue dresses.

It seems less remarkable, when you see Rivera at home in his studio, that he should produce occasional stereotyped pieces than that he is able to paint at all. In tourist season his establishment is crowded with sight-seers who waste his time wantonly, and he is kind and patient to them all. I was taking coffee with him after lunch one day, on a balcony overlooking the studio, when a large, expensive-looking American woman swept in, followed by a group of chirruping dependents. She bagged two autographs and a photograph before she consented to look at some small pictures. Diego showed her a series of water colors taken from the new model, who was helping him display the pictures for the lady.

"Oh," said she, "I don't care for these squaws. Can't you show me something with a cute little village?"

I asked Diego how he could stand that sort of thing, why he let such people come in. He loftily said he thought it was an obligation to make

his ancient works of art available to the public; and it is true that he has archaeological treasures which great museums covet. But more probably that extraordinary man, who likes praise and admiration no less than any of us, loves the excitement of working and talking in the market place which his studio seasonably becomes. He admits the rude with the gentle, the dull with the apt, lest he miss something which even for an instant might engage his inexhaustible resources of mind and heart, or at the least, contribute to the publicity. If in his politics he is often a pretender, and in his rages a man of violence, in his ordinary daily relationships he has a great capacity for genial friendship, and sincerities far deeper than his showmanship.

Of the less attractive qualities of the politician and the showman one roundabout tale remains to be told. The last time I visited Rivera he told a group of European callers that he now awaited the advent of the Fourth International. The manifesto of this event, I believe, is not yet written. If Rivera were to write it, it would probably sound a little like some enchanted pacifist's commentary upon the Christian Gospels: just faintly and sentimentally too otherworldly. Ever since Trotsky—a few months before his death—ungratefully provoked a quarrel with him, as the result of a lady's indiscretion, Diego has talked less of political economy and more of the evangelical virtues which found their way into his earliest murals.

Since a political stand was required of him, however, he found himself obliged to subscribe, during the Mexican election campaign of 1940, to the relatively conservative tenets of the anti-administration party of General Almazán. Rivera's enemies of the lately unpopular radical Left, who have taken every possible occasion to insult him, accused him of organizing the first of the melodramatic raids which brought the half-forgotten Trotsky back into the newspaper headlines in the spring of 1940. Diego was inspired to use this charge to promote a new campaign of publicity for the show he was hired to put on at the Golden Gate Exposition during the summer: when he painted murals for the customers at so much a head. Surrounding himself with Hollywood actresses,

he posed for newspaper photographers at a California airport, and told breathless stories of escape from persecution. In the published pictures he was simply a fat, prosperous and happy fugitive, intent upon forgiving all. Rivera is indifferent to the quality of publicity so long as, if there is any criticism, it is the man and not the artist who is ridiculed.

CHAPTER FOUR

# José Clemente Orozco

---

*Orozco's first work was produced in the shadow, clandestinely and heretically. . . . When there came to him the opportunity to make his painting live on the surface of public walls, we find him undecided and absorbed, like one who emerges from a dark room into the light, stuttering to find the link which will permit him to feel that he is not talking to himself.*

Jorge Cuesta

---

WHEN IN MY LETTERS FROM MEXICO to the United States I wrote about one or another of the forty artists, more or less, whom I saw off and on during the two years of my residence there, I invariably received in reply something to this effect: Rivera we know, Orozco and Siqueiros we know, but who is So-and-So?

It has even happened that people who have otherwise achieved some degree of expertness in the field of the fine arts have been relatively ill-informed about the Mexican painters. There went to Mexico not long ago a representative from an American museum of considerable reputation, charged with making arrangements for an exhibition of Mexican art. He expressed great surprise (and polite incredulity) when I told him that in my opinion there were more than thirty good painters and

about a score of print-makers in Mexico City. He confessed that he knew the work of only three painters, Rivera, Orozco, and Siqueiros, and the name of the third he was unable to pronounce.

At least in reputation Orozco and Rivera undeniably stand out head and shoulders above their contemporaries in Mexico. Their names are glibly recited in the most remote corners of their own country, were once amply celebrated in the civilized parts of Europe, and remain famous—not to say notorious—from one coast to the other in the United States. And there is at least one good reason why these painters should stand upon such an eminence. Both of them are of heroic stature. They have achieved international reputation through monumental accomplishment.

In the studios of Mexican painters who have not enjoyed equal success it is a not uncommon intellectual exercise to discuss and compare the two masters, sometimes to the disparagement of one or the other. When I found myself sitting in on one of these arguments, and pressed to take sides, I tried to say, on occasion, why and in what way I prefer one to the other. For the most part, however, I am not very much interested in trying to determine dogmatically the primacy of one or the other. Simply to compare them, however, is quite another matter, and as irresistible as it is obvious: particularly since it is possible to start with a formula aptly provided by Rivera himself.

I shall not soon forget the warm July day when Diego came to lunch in my house with a company of people interested in painting. The table was set in a glass-covered patio into which the sun was streaming. Most of us found pleasure in the heat—we were in the midst of a chilly rainy season—and were dressed for it. Rivera was buttoned up to the neck in a thick leather jacket which he seemed to be reluctant to take off. He had on beneath it, I think, an undershirt with a checkered pattern in red. He talked magnificently, as only Rivera can talk. He said that he had been thinking a good deal lately about Fernand Léger's doctrine that a thoroughly self-realized painter lives through three periods. In the beginning he is female, and requires to be made fecund by other artists. When

he acquires masculinity he is able to fecundate others. Finally he becomes hermaphroditic. In this ultimate phase his creative powers require no fecundation, and other artists are not fecundated by him. He founds no school, he becomes peerless, beyond reach.

Of modern painters, it was thereupon agreed, Cézanne and Renoir developed most naturally and completely through these symbolic periods of an artist's fulfillment, Cézanne lingering for a long time in the middle period but finally escaping it, Renoir proceeding rapidly into the third period. Some of us thought that Van Gogh ultimately entered into the hermaphroditic phase at St. Rémy: inimitable and mad; whereas Picasso seemed to have been content to remain in the middle period. Georges Rouault, after a brief Rembrandtesque phase, evolved into unapproachable hermaphrodeity.

Now by Rivera's own canon I think it may fairly be said that Orozco has reached the third period while Rivera has not. Rivera has a host of imitators, but nobody has succeeded in resembling the Orozco of the last twenty years. There is nothing to be seen in Mexico today even faintly suggestive of his influence, with the occasional exception of the lithographic prints of a young artist, Isidoro Ocampo, who has formed his technique upon Orozco's. There is a small group of young painters, friends of Ocampo, who have repudiated the Rivera school and would like to be trained by Orozco, but the master does not receive apprentices.

The two painters are so utterly different in character and equipment that it is not extraordinary to find that their styles are wholly unlike. Rivera spent many years as the pupil of one teacher or another. Orozco, who is five years older and did not reach the Academy until about the time Rivera went to Spain, is practically self-taught. Rivera has erudition. It is often said of him that if he had not been a painter he would have been a professor of something or other, of the history of art, in which he is readily proficient, or philosophy, or political economy, and his talk is as witty and graceful as it is, in the main, serious. Orozco is not, in comparison to Rivera, a man of intellect. It is hard to conceive of him as anything but a painter.

I would not suggest that Rivera's manifold interests have interfered with his application to painting,—they have not kept him from producing more work than any painter, probably, since Rubens—but it might be said of Orozco that his singleness of purpose has freed the born artist to pursue a form of plastic expression of incomparable purity. He suffers distractions as grudgingly as Giotto, whose moving frescoes Orozco's, at their best, recall.

Compared to the gregarious Rivera, Orozco is inclined to be misanthropic. He has few close friends; indeed, he seems unable to devote himself to more than one friendship at a time, and that infrequently. On the other hand, although I do not pretend to have had more than a very agreeable acquaintanceship with him, I did not find him quite so bearish as by reputation he is said to be. I had been told that he was grim, scornful, sarcastic, unsociable; that pathological self-consciousness, usually attributed to the amputation of his left hand in childhood, prevented friendly exchanges of conversation. I was therefore not a little timid at the prospect of meeting him and trying to engage him in the kind of talk I wanted to hear.

When at length I met him he was in thoroughly good spirits, although he was unwilling at first to say much about his work. He said he was afraid that putting his aesthetic ideas in order would be a matter of as many hours as the painting of a picture. His reluctance to do so seemed perfectly reasonable. But he professed entire willingness to meet me for further conversations, and he has, at one time or another, communicated to me a good deal about himself. Still, like other people, I have not found him nearly so accessible as (say) Rivera and Dr. Atl.

In view of the strained analyses of Orozco's psychology in some of the published articles about him, it should be said that it is by no means evident that his physical disability explains his diffidence. When he talks he waves his dismembered left arm about with an eloquence almost equal to that of his sound hand. The truth appears to be that Orozco's life is so nearly related to his work that he has very little to say in ordinary conversation. When he does talk—he is not a logician but an artist—he

speaks not so much out of considered judgments as out of current emotional states. His feelings lead him into contradictions and sometimes into sheer unintelligibility.

I once met Orozco on Avenida Juárez in Mexico City, just after I had returned from a journey to Guadalajara to see his newly completed frescoes in the *Hospicio*. When we were settled for talk in a near-by cafe I told him that I liked some panels in the Preparatory School, notably the black and white "Youth," quite as well as anything I had seen in Guadalajara. Orozco was annoyed. He said he would like to repudiate those frescoes as the work of a beginner. Of course that was silly,— not that he is the only painter who ever talks nonsense. Picasso, in a "Statement" reprinted in *Picasso: Forty Years of His Art*, writes the most complete nonsense about himself.

I have already suggested that Rivera's feeling for people is reflected in his painting. He often paints affectionately, in the way in which Hugh Walpole may be said to write affectionately. If there is ordinarily, I do not mean always, no particular indication of compassion, a good deal of Rivera's delight in people is nevertheless translated into paint. That is not to say that a spectator who is himself one of the types represented in a Rivera mural will invariably be pleased. The *paysanos* sometimes call the typical little Rivera Indians *"monos,"* by which they mean imitations of people, like dolls or monkeys. But for the most part Rivera's Mexican murals are likable. People enjoy them, the public for which they are primarily intended is rarely offended by them.

Clemente Orozco, on the other hand, gives nary a damn for anybody. He paints entirely to please himself. This indifference to the spectator's feelings has led to a relatively greater maturity in his mural designs, and the enjoyment of his work is a correspondingly aristocratic experience.

When Dr. Atl persuaded the painters of an earlier day to subscribe to the policies of Carranza, as against those of Pancho Villa, and carried them off to Orizaba, Orozco amongst them, it was not long before that sardonic man began to make fun of his own party. He admits no loyalties, the world is his oyster. He is a painter, not a man of principle. He

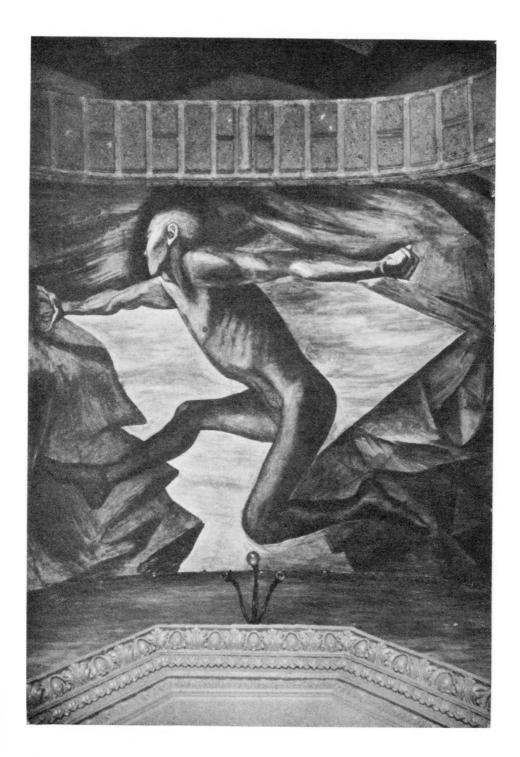

25. YOUTH

Fresco, National Preparatory School, Mexico City. José Clemente Orozco

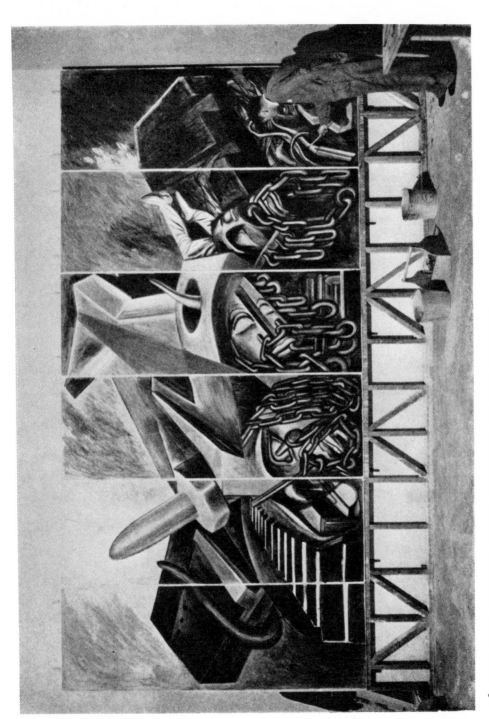

26. THE DIVE BOMBER, WITH PORTRAIT OF THE PAINTER

Fresco, 1940. José Clemente Orozco. By permission of the Museum of
Modern Art, New York

would abandon self-interest or betray a comrade for a picture. People wonder what side he is on. He is not on any. One day the Catholic Church officially tries to veil his pictures, another day Catholic churchmen sponsor them for publication. Today he will appear to be a revolutionary, tomorrow, an antirevolutionary. Set beside the overtly propagandizing painting of Rivera, Orozco's work is a little confusing unless this principle is recognized.

As Orozco's attitude toward life is melancholy so is his painting melancholy. He universalizes the sorrows which he observes to be characteristic of his time. This want of individualization sometimes perplexes people. In Guadalajara, when Orozco painted a largely discussed panel in the staircase of the Palace, showing Stalin, Hitler and Mussolini in a context which turned out to be ominously prescient, the Stalinists congratulated him on caricaturing the errors of Trotsky, and Trotsky is reported to have said, "This is exactly what I have always said about Stalin." Similarly, the Church people were complacent, the anticlericals were smug. When the Catholics of Guadalajara shall have produced the Orozco monograph which they are now endeavoring to finance, it will probably be distributed by anti-Catholic booksellers.

Siqueiros one day summed up in a neat sentence what I have been trying to say about the relationship between Orozco's intellectual and plastic activities. Orozco and I were talking in the Blue Room in Miss Amor's gallery in Mexico City when Siqueiros dropped in. We were discussing the designs of the Guadalajara murals, of which the last group had just been completed, and Siqueiros said, "Orozco, I think you are a great painter, but you are a lousy philosopher."

There are writers who have tried to represent Orozco as a man with a good deal of social and moral feeling, a Puritan, compared to whom Rivera is a cynical and realistic man of the world. One of the older painters in Mexico, a man who has known Orozco and Rivera a great deal longer than I have, said to me at one time: "Suppose Orozco and Rivera are looking at a whore. Orozco feels anguished and says, 'This is wrong,' and shows in his painting how evil it is of society to allow prostitution.

[ 67 ]

Rivera shrugs his shoulders and says, 'The girl is probably having a good time.' "

I am not at all sure of this interpretation of Orozco. I believe he feels deeply, that he is ruled by his emotions, but I think his feelings are entirely those of a painter and not of a moralist. I have seen dozens of his rare 1917 drawings, water colors and gouaches of the sporting life of Mexico, and I do not detect any tender sentiment in them. Rivera is vastly more naïve.

When I spoke to Orozco about the conflicting characterizations of his personality, that he is tender, that he is cruel, that he is good, that he is evil, that he is loving, that he is bitter—opposing qualities that exist improbably in a single personality—he would not allow himself to be any of these things. He compared himself to an actor who simulates characteristics and emotions. He is interested, he said, only in communicating the emotions appropriate to the subjects which he paints. In such a case, the origins of the feeling tones of his murals would lie in immediate sensible experience rather than in the deep wells of his own personality.

In so many ways are Orozco and Rivera different; still, it is frequently said in Mexico that if one had not existed the other might have ceased to exist. They admire each other, although Orozco is reticent in admitting his admiration. He shows that he is impressed by Rivera by the use of the left-handed compliment. Rivera, who is the most generous painter I have ever known,—perhaps because he is very comfortably self-realized—expresses his favorable regard for Orozco more directly.

It would, I think, be impossible to write a life of Orozco comparable to Bertram Wolfe's lusty biography of Rivera because Orozco's career has been relatively empty of remarkable incident. At the moment he seems to be cultivating the grand manner—no one will say that he is not entitled to it—and his autobiographical reminiscences have become so romantic that it is difficult to sift a few facts out of an abundance of suspiciously fictitious recollections: fictitious, that is, when checked by the tradition about him. On the other hand, there is quite probably a considerable element of legend in the tradition. As in the United States, popular

legend in Mexico likes log-cabin beginnings, but unlike the American hero, the Mexican is inclined to forget the adobe hut, the native equivalent of the log cabin.

Orozco was born in the farming village of Zapotlan, Jalisco, in 1883. When he was four years old his family removed to Mexico City, at twelve he went to an agricultural school, and not until he was twenty, well above the average age, did he reach the Preparatory School. There he studied mathematics in anticipation of a course in architecture. When he went to the Academy for practical instruction in design he took no formal lessons in drawing and painting, although he attended a few life classes in order to work from models. Thus he is, in a sense, self-taught; but he is also undoubtedly a genius. He believes, theoretically, that self-instruction in painting is at least wasteful, and although he will not take pupils himself, he advises young painters to go into apprenticeship. Rivera, who is a product of academies and ateliers, contrarily tells inquiring young painters to hire a studio and paint by themselves.

Orozco first emerged as an artist when, at the age of thirty, he contributed to the publications of the "Jungle Group" in Orizaba a series of caricatures based on his observations of revolutionary activities. Some of them, like the etchings of Goya,—he loathes being called the Mexican Goya—portrayed the horrors of war: murder and rape, the mangling and disfiguration of bodies, the looting of houses. These were readily interpreted as showing the excesses of the armies opposed to Carranza. But he also caricatured a victorious army of leering officers and drunken, roistering soldiers, attended by vicious and repulsive women, and these drawings could not possibly be understood to represent anybody but the *Carranzistas* themselves. If Orozco could have made an exhibition of this work in calmer times it would have enhanced his modest reputation, but instead it was a source of irritation to the party in power. He received official warnings that he would be more comfortable somewhere outside of Mexico, and in 1917 he left for California, where he spent a couple of years picking up a scanty living with his paints.

The interval from 1919, when he returned from California, to 1922,

when he joined the Siqueiros Syndicate, I have not been able to fill in from Orozco's own story. He likes to say now that his life began when he started to paint murals. Other painters have told me that he painted *pulquería* walls, but this he denies (as he also denies the legend describing him as a barefooted waif trudging the streets of Mexico). There is, of course, no extant *pulquería* painting attributable to him.

Although the drawings made before 1920 are rare and valuable now, Orozco was generally thought at that time to be scarcely more than a cartoonist who liked to draw pictures of vulgar little girls and scenes from bawdyhouses. Many of these were hung up or cut out and pasted on the walls of his brother's café, an establishment frequented by impoverished painters. The patrons called the restaurant *Los Monitos*, after Orozco's monkeyshines upon the walls. The Bohemian crowd also subscribed to a weekly periodical which Orozco published for a time under the name of *El Malora* (The Nuisance), a sort of Mexican *La Vie Parisienne*. One hundred drawings and paintings of this period were confiscated by American customs officials, in the interest of North American morals.

Until recently the largest private collection of Orozco's early work belonged to his friend and first critical protagonist, José Juan Tablada. Now dispersed,— Señor Alberto Misrachi of Mexico City bought most of it— it included pencil drawings, pastels, water colors and a few small oils. A onetime owner of some of the early pieces, professing to find in them suggestions of Degas, Toulouse-Lautrec, and even Van Gogh, supplied them with French titles, and eventually they were offered for sale as the work of Orozco's "French Period." Actually, Orozco has never had a French period. It is even to be doubted whether he had seen many reproductions of French pictures before 1920. Until 1932 he had never been in Europe.

Although his subjects, taken from public houses and bars and movies, repeated some of the motifs of the French school, Orozco's treatment was thoroughly Mexican, and more than that, extremely personal. The French painters had gone out of their way to hunt up and observe, before they

painted it, the life of people who belonged to the picturesque fringes of lower-class society. Orozco was not obliged to make trips to the slums. He was already there. Perhaps it is precisely because these early works came so naturally to him that for years he has been trying to say they are unimportant. Nevertheless, a recent revival of interest in his early period has given him pleasure. He has even traded new paintings for earlier sketches because, I imagine, he secretly enjoys them, and not merely to call them in out of the market.

When Orozco became a member of the Siqueiros Syndicate in 1922 he was a member of no political party. He joined not as a Communist but as a painter who wanted to get a job. Just as in former times painters sometimes entered monasteries because the Church was the patron of art, so in 1922 in Mexico some of them became politicians because the government was the custodian of patronage. For a time the Syndicate prospered as the vehicle of this protectorship. Orozco belonged to the Revolution always as a free painter, not as a radical politician, nor even as an anticlerical reformer. From the beginning of the mural movement he was interested in revolution in style rather than subject matter.

His first fresco, a luminous rose and golden and rust-colored "Maternity," proved to be something short of revolutionary in treatment as well as subject, but he quickly thereafter began to find himself. He made a violent panel, ridiculously called "Spring," of which a huge upside-down nude was the central figure. This piece, never quite completed, was followed by a great close-cropped, mustachioed, thick-necked Christ, putting an axe to his Cross. Orozco later removed all of "Spring" and most of the Christ, and in 1923 began in the north corridor of the large patio of the Preparatory School the first of a long series of magnificent frescoes in his personal manner.

The finest of these, called "The Trench," introduces the unmistakable Orozco style: the diagonal lines, the oblique angles, the color patterns of black and white and gray and brown. The bodies of the soldiers are naked above the waist, the legs are clothed in white, the feet are bare, the torsos mighty, the angularly outstretched arms expressive and powerful, the

[ 71 ]

hands strong yet sensitive. The bodies here are drawn from nature and not yet formulated like medieval wood carvings, an adaptation of whose stylized designs, particularly from the crucifixes, Orozco later employed.

It is said that Orozco painted the six panels of the second floor of the same corridor during the last two weeks of the Obregón regime. Polite society had found his frescoes offensive, the *Damas Católicas* had even tried to destroy them, and it was clear that the new government under Calles would find no funds for the continuation of Orozco's work. Hence these panels are both bitter in subject and loose in design. The hyper-sensitive artist reacted more swiftly to personal hurt than to the grievances of society.

Here Justice, drunk and blind, leans on the arm of Corruption. In the "Last Judgment" a lecherous god attends the prayers of "believers," the character of whose piety is indicated by haloes of gold coins: Orozco's compliment to the *Damas Católicas*. Never again has Orozco painted so subjectively and insultingly, although he has since been under compulsion to hurry.

Two years later, in 1926, a new Minister of Education invited Orozco to finish his work according to the original plans. For the staircase of the great patio of the Preparatory School, and the top floor of the north corridor, he made frescoes of great distinction in composition, color, and intensity of feeling. Perhaps they are most remarkable for the quality of stillness. If Orozco has not subsequently surpassed this work it is because, as Laurence E. Schmeckebier has suggested in his *Modern Mexican Art*, he could go no farther on that road: as Housman, after *A Shropshire Lad*, could go no farther on his.

In this place there first appeared many elements of design which have since become immediately recognizable characteristics of Orozco's painting: reclining nude figures which have nothing to do with logical subject matter, but are beautiful, necessary and decorative elements of composition; and active nude torsos rendered in highly stylized forms. From this point on Orozco invented increasingly effective—although often agoniz-

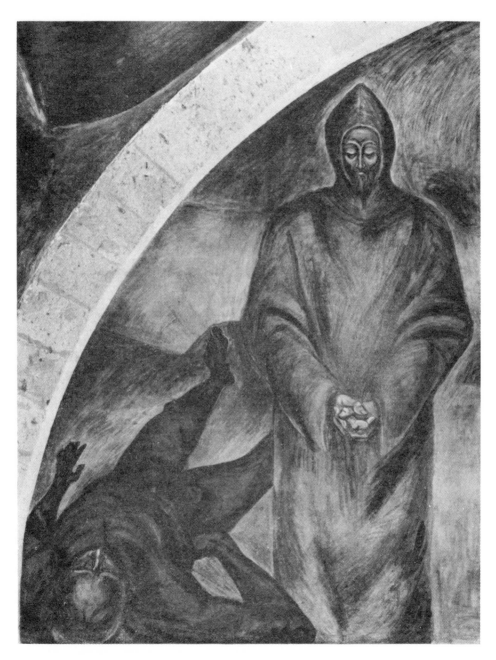

27. FRANCISCAN MISSIONARY

Fresco, Hospicio Cabañas, Guadalajara. José Clemente Orozco

ing—complications of the torso; and yet nobody in contemporary times has painted thighs and legs with more tender and fleshly simplicity.

It is in this setting that there occurs the nude figure called Youth, of which I once expressed my admiration to Orozco. This ill-nourished, ribby and aspiring boy, painted entirely in black and white, is undeniably one of Orozco's masterpieces in quality and feeling. Here also are the first of the Orozco Franciscan monks. The Franciscan missionary is the painter's symbol of goodness and love. One of the noblest figures in all of modern Mexican painting is that of a friar in the Chapel of the *Hospicio* in Guadalajara. The face may be thought to be reminiscent of El Greco but the hands are unmistakably the hands of Orozco, strong, able, generous; and the body under the luminous habit melts with tenderness and mercy. I was reminded, when I saw this painting, of Fra Angelico's mystical words: "No man can paint Christ unless he is in Christ." Orozco paints the Franciscan way of life as though he had enjoyed some mystical intuition of it.

The military motifs with which Orozco is often associated in the American mind reappeared in the frescoes of the upper corridor of the Preparatory School: for example, in the "Soldaderas," a composition in which the painter Carlos Mérida finds Orozco at the peak of his power. Three soldiers are tramping diagonally across the foreground to the right. Their sombreros and rifles, at right angles to the plodding bodies, form diagonals in the direction of the left. The arm of an attendant woman and the leg of the child she is carrying form further parallel diagonals in the direction of the lower right. Painted softly in gray, the figures plastically modeled, the rhythms wonderfully poetic, the diagonal architecture sharp and exciting, the piece invariably arouses emotion.

Bright color was introduced into this series of frescoes, although not always with pleasurable effect. In one instance there is an unsympathetic blue background for a group of low-keyed figures. The impeccable draughtsman moved uncertainly in the field of color. Still, his blues and oranges and infrequent greens served to light up the grays and browns, the blacks and whites, in which he habitually painted his people.

[ 73 ]

In 1930 Orozco went to California of his own will, to decorate an interesting wall surface in one of the Pomona College buildings, a thickly molded and arched recession in a handsome room. There was a great outcry at the time. Editors and letter writers sharply inquired in the newspapers why a Mexican of unknown morals and not an American painter of known reputation had been engaged to paint a picture for wholesome American students. The distracted director of Pomona's Fine Arts department, the art historian Joseph Pijoan, was obliged to publish a statement. He properly and pointedly replied that what was needed first of all was a man who knew how to paint frescoes.

A muscular Prometheus, freely and naturalistically modeled, dominates the Pomona mural. He is attended, on one side, by a groping multitude which reaches for the heavenly fire; while on the other side a passive and cynical citizenry is exhorted to ignore it. The symbolism is a little obvious, but the color scheme, twice later used by Orozco in his Guadalajara master works, is thrilling. It ascends from Orozco's usual browns and grays to the brilliant tones of the flames into which the hands of Prometheus are plunged.

In the same year Orozco painted, in the refectory of the New School for Social Research in New York City, some panels which chiefly serve to illustrate his greatest weakness as a muralist, the insecurity of the total design for a decoration occupying relatively unbroken space. Variety is, of course, to be desired and expected, and must be supplied by the decoration where architectural interest is wanting. Still, the eye looks for a lowest common denominator of harmony, so to speak, within the several parts. In the New School chamber there are at least four separate styles. Furthermore, to put some life into the tiresome parallelepiped he was required to paint, Orozco got out all of his bright colors and used them in profusion. The result is confusing.

Orozco began his most important American commission in 1932, the three thousand square feet of the basement bookroom of the Baker Library at Dartmouth College. He went to Hanover with his family and settled into residence as a member of the faculty. He had complete freedom to

choose his subject and material, submitted no designs in advance of his contract, and before he began to paint he enjoyed plenty of leisure in which to feel the atmosphere of the place. He conceived of an epic work narrating the cultural history of the Continent of North America. Of the romantic history of his own country he was already well-informed, and of the culture of the college community in which he was going to paint he proposed to inform himself by experience. Before he had progressed very far with the actual painting he made his first tour of Europe, an expedition which seems to have left no marked effect upon his style, and upon his return to Hanover he resumed his work where he had left off.

It may be said in general that, as was to be expected, the Mexican part of the epic is better than the North American. The series begins with types of Indians migrating into Mexico in prehistoric times,—ten-foot nudes, infinitely repeated in profile, their anatomies wrought into characteristic Orozco patterns. A glance at the grim horrors of the ancient practice of human sacrifice is followed by suggestions of the Golden Age of the high plateau in pre-Cortesian times, the Toltec period, of which the center of culture was Teotihuacán, a city of pyramids and temples near the present City of Mexico.

Of less aesthetic sensibility than the Mayas, who built their elaborate cities in the coastal plains, the Toltecs developed an efficient military hierarchy and held most of the southern highlands of Mexico in vassalage. The chief diety of their pantheon was Quetzalcoatl, the fair-skinned and white-bearded god of air and water, a beneficent divinity around whom there grew up a reforming cult whose excessive morality seems to have occasioned the decadence and downfall of the tribe: his followers having given up fighting for sports, conquest for culture.

Because of the asceticism of the early practitioners of the new cult, historians have wondered whether Quetzalcoatl might not have been the apotheosis of a pre-Cortesian Christian missionary. Presently, however, the new piety was exchanged for sensuality and love of luxury; and when, in addition to discovering the laborsaving use of metals, the Toltecs learned the delightfully relaxing effect of the juice of the *maguey* plant,

[ 75 ]

Quetzalcoatl returned over the sea whence he had come. As he took his departure he promised, like the Messiah, a *parousia* and a day of judgment.

It is this legend which Orozco illustrates in the greater portion of the west wall in the Baker Library. Quetzalcoatl, in the dress of a Greek philosopher, is surrounded by ugly masked deities. With his advent there is a revival of agriculture, art and contemplation. But Quetzalcoatl, like Prometheus in the Pomona College mural, is confronted with plenty of opposition from people whose hearts are hardened, and he is soon seen departing across the sea on a raft of serpents. The Quetzalcoatl wall is painted throughout in low key. The greens are hard and cold, and warmth appears only in the clay reds and pinks.

Like the early Christians awaiting the promised return of their Lord, the ancients of Mexico settled down in anticipation of Quetzalcoatl's second coming. Even in the later Aztec times there were those who thought his prophecy was fulfilled by the Spaniards, whose arrival Orozco represents by the usual symbols: Cortés with an El Greco face in light purple values; a Franciscan monk planting the Cross; a foreground of slaughter and a background of flaming ships, all according to Bernal Diáz del Castillo's diary of the Conquest.

The Machine Age, bitter and metallic, makes a prelude to Orozco's parallel conception of North American history. Unlike Rivera's literal blueprints of mechanical contrivances in Detroit, Orozco's machines are malignant abstractions. Northern civilization is eventually characterized, however, not by an industrial panopticon but by a set piece containing rows of stupid-looking farm-bred people at a town meeting. To be sure, modern Mexico fares no better. It is summed up in forms representing the unseemly scramble for personal wealth which has characterized the several phases of the people's Revolution.

Orozco's commentary on modern education does no great credit to what Orozco saw at Dartmouth: a dehydrated fetus is extracted from a skeleton by a *calavera* in an academic gown. The painter's predilection for the *calavera* motif is indulged again in a skeleton clad in boots and

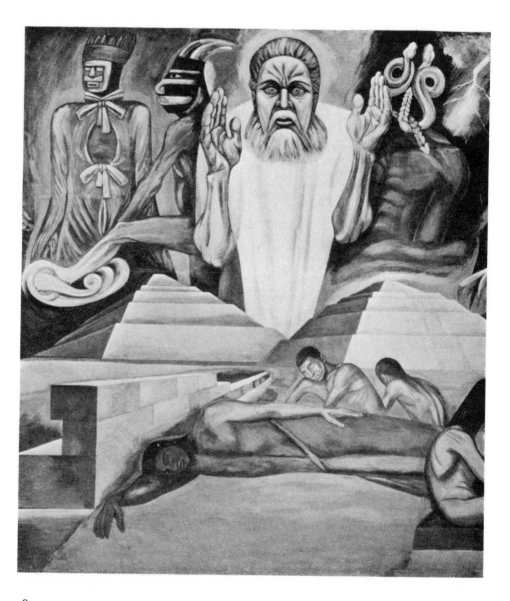

28. THE ADVENT OF QUETZALCOATL

Fresco, the Fisher Ames Baker Memorial Library, 1933. José Clemente Orozco. By permission of Dartmouth College

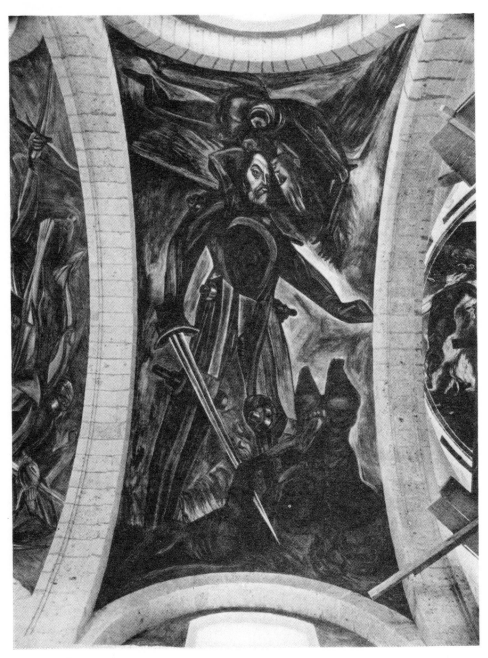

29. CORTÉS

Fresco, Hospicio Cabañas, Guadalajara. José Clemente Orozco

tunic, an Unknown Soldier heaped with gaudy wreaths, a caricature of both color and design. Still another early Orozco theme reappears in the Christ who returns to an embattled world to destroy his Cross. The color pattern of the Crucifixion is characteristic of Orozco when he paints in high key. The figure is painted in bright green, blue, purple, yellow and flame tones, against sardonic tones of green and brown.

When the murals were finished in the spring of 1934 Lewis Mumford wrote a respectful and sympathetic—if somewhat romantic—piece about them for the *New Republic*. He supported Orozco against the opposition by saying that the painter's picture of New England was at least free of antique shops specializing in backwoods ware. Orozco's New England was based, he said, on the days of the China clippers, on a thoroughly mundiall literary tradition. He reminded the polite people of Hanover who complained of the ugliness of the murals—many had failed to see that the forms, subtly and rhythmically reiterated, are infinitely beautiful—that the painter had encountered plenty of squalor in their midst: notably the dirty tangle of tenements in White River Junction, six miles down the Connecticut Valley.

For myself, I say what a treasure house Orozco has made of a basement; but also, what a pity it is that so great a painter had to be memorialized in a dusky catacomb into which only the hardiest of the faithful can bear to descend from the upholstered elegance of Georgian halls. It was Dartmouth's laudable intention to announce the truth that art is inherent in a complete culture, and it is too bad that for the rehearsal of such a gospel only a subterranean chamber could be found. Pomona had been willing to expose that experimental doctrine to the light. Still, one must not be too captious. It was sporting of the sons of the Wesleyan earl to be host to Orozco at all.

In the Palace of Fine Arts in Mexico City, on a wall opposite Rivera's reconstituted Rockefeller murals, Orozco relieved himself of the restraints of Hanover in a gruesome piece which swirls with destruction and death and riots with raucous whores and naked soldiers. Aesthetically this work is chiefly remarkable for the enrichment of color design and the formula-

[ 77 ]

tion of the muscular but structurally simplified torso which became thereafter a fixed and notable element of Orozco's figure treatment. Details of this mural appear over and over again in the artist's lithographs, etchings and easel paintings.

From 1935 to August, 1939, in Guadalajara, the capital of his native State, Orozco applied himself strenuously and continuously to his major works, the fresco decoration of four hundred and thirty square meters of wall in the *Paraninfo* of the University, four hundred square meters in the Government Palace, and twelve hundred square meters in the *Hospicio Cabañas*. This monumental accomplishment is his Mexican memorial.

One of Orozco's themes in the University suggests the kind of subject material that got him into trouble in 1916 and 1917. It is a criticism of the Revolution, an examination of the errors, especially the Marxist errors, of revolutionary leaders. Scores of emaciated nudes, hungry and desperate, shake their fists at ineffectual and greedy superiors, whose only reply is to point to chapter and verse in revolutionary bibles. Plastic interest centers especially in a group of half-a-dozen nude torsos on which the flesh is hung like draperies over strongly indicated bony structures. At first glance the unclothed bodies look as though they were clad; but they are robed in flesh. This is the ultimate Orozco pattern or symbol of ill-nourished man. Its effect is moving and powerful beyond description.

In the same chamber, an examination hall, Orozco has placed one of his most appalling tragic episodes. In the lower foreground lies the distorted skeleton of an undergrown man, dead of starvation. Behind this bony remnant kneels a gaunt, nude beggar, his arms falling like lengths of fabric from his shoulders, his face an agony of destitution. At the mendicant's shoulder stands a miserable naked companion eternalizing want. I looked at this shattering composition and Housman's lines came to my lips:

> Horror and scorn and hate and fear and indignation—
> Oh why did I awake? when shall I sleep again?

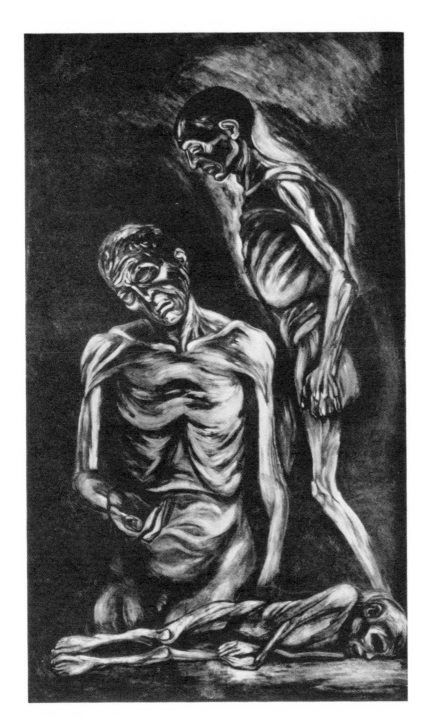

30. BEGGARY

Fresco, University of Guadalajara. José Clemente Orozco

The colors of the wall panels in the *Paraninfo* are the customary blacks, whites, grays, greens, and flame yellows and reds. Ghastly greens are used for flesh tones. In the dome above them the color is more brilliant, even shrill: although generally thought to be decorative, especially at midday.

From the University Orozco proceeded to the *Palacio*, where he painted the walls of the grand staircase. As you walk up the staircase and raise your head, practically to the point of breaking your neck, you are confronted by the massive head of the revolutionary hero, Father Miguel Hidalgo y Costillo. Father Hidalgo, a parish priest, first defied the lawful authorities by encouraging his people to plant mulberry trees and grapevines against the King's will, and finally, on September 16, 1810, summoned them to church to launch the rebellion which led to the Independence of Mexico. In Orozco's murals he appears with his ears encased in great brushes of white hair, his huge frame clothed in a clerical frock coat; and in his gigantic fist he clutches a flaming torch which unifies the sweeping design of the great arch. Beneath him a battle rages, men slaughter each other in hand-to-hand combat with knives.

This surface is more richly colored than anything Orozco had theretofore done. To the characteristic blacks and whites, greens and flame tones, there are added rich blues, poignant new yellows and purplish reds. A host of banners introduces a great variety of tones of red. Unfortunately the color is already rapidly fading. Orozco is said to have used, for some unaccountable reason, certain vegetable colors, especially black, in both University and Palace. The process of oxidation obviously could not bind them.

On one of the side walls of the *escalera* there is a congress of the totalitarian nations. Clownish figures caricaturing Hitler and Mussolini, Stalin and the Mikado, balance upon their noses and heads and fingertips preposterous combinations of hammer and sickle, swastika, fasces and Cross, for the entertainment of the disorderly delegates to a Surrealistic league of nations. I find in my notes of impressions of Guadalajara that I wrote unconsciously of "shouts and screams and the clamor of drums," as though the mural could be heard as well as seen; and I seem,

at this greater distance, still to recall in my ears the uproar of a profane and hysterical Tower of Babel.

There is a local legend that the Governor of Jalisco descended ceremoniously from his chambers when Orozco climbed down from the scaffolding to announce the completion of the Palace murals. His Excellency, a little astonished, politely inquired what the pictures were supposed to mean. Orozco himself looked perfectly blank, ducked his head in the courtyard fountain, vigorously shook water out of his hair and eyes and gaped again, bewildered, at his handiwork. "You've got me, Governor," he said. "I'll tell you tomorrow."

The story scarcely caricatures the confusion of the people who have gone to the bother of looking at the Guadalajara murals, and perfectly satirizes Orozco's own reiterated inability to define their intellectual contents. The Governor could be any Helen Hokinson clubwoman bent upon self-improvement. Orozco, if he were impelled to any communication, might say to her, "Madam, kindly take another look at my pictures. You are perfectly at liberty to like them or dislike them. That is all I can tell you. I cannot tell you what they mean."

Orozco does not at all mind being asked what his murals mean. On the contrary, I think he enjoys having an opportunity to make his arbitrary, enigmatic and quotable answers,—just as he enjoys hearing and reading speculative interpretations of his work. He becomes expansive when people tell him that he was inspired by prophetic gifts when he painted the Palace wall which I have just described. But in the end, the spectator may reach the disturbing conclusion that there is perhaps just a little too much of the hocus-pocus of mystification, not quite enough of frankness, in Orozco's declaration of plastic or intellectual intention.

It would be pleasant to give up trying to find a pattern of more than plastic significance in some of Orozco's obscure designs. Then the spectator could let himself go in the enjoyment of their purely pictorial contents, then he would be free for aesthetic experience of a very high order. But the trouble is that the murals so nearly "represent" something that they are unsettling to the mind as they would not be if they obviously

31. FIRST BATTLE OF THE REVOLUTION
Fresco, Government Palace, Guadalajara. José Clemente Orozco

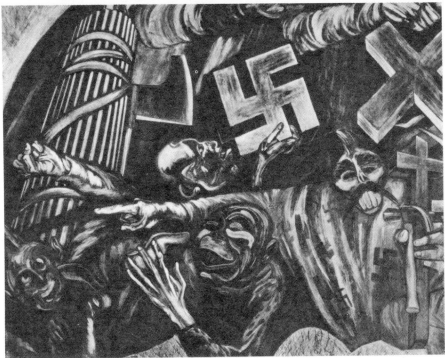

32. DETAILS FROM THE CONGRESS OF NATIONS

Fresco, Government Palace, Guadalajara. José Clemente Orozco

"meant" nothing at all. It is tantalizing to be able to apprehend the presence of intellectual meaning, however vaguely, and yet to be unable to comprehend it.

If it is true that Orozco's intention is to engage the beholder's emotions only, and not his intellect, then the painter should have been careful not to use subjects and symbols which arouse the spectator's curiosity. But of course it is not true that no intellectual ideas are involved in these designs, and Orozco will, upon occasion, intimate something of what he had in his mind when he designed the composition for such-and-such a space. Still, there is no official *schema* for the interpretation of any of the Guadalajara designs as a whole, and it remains hazardous to repeat what one has heard about the meaning of this or that fragment unless one has heard it from Orozco, who honestly appears to be not always clear himself; or perhaps from some friend of the painter, such as the photographer Juan Arauz Lomeli, who has been closely associated with the work. Too often in the past someone has suggested a silly explanation of some detail, and Orozco has said, "You are exactly right," and then a fabulous and usually absurd interpretation has been handed on as the true word of the master.

In general, the Orozco frescoes, even when they suggest literary ideas, or contain fragments of social commentary, are free from conscious propaganda. It has already been intimated that if Orozco is a passionate painter, he is not a patriotic politician. He is not a missionary, he preaches no gospel. He is, if he is more than a painter, a not very profound commentator upon current ideas. He is certainly not a calculating exponent of them. The comment which he most commonly seems to make is that all systematic ideologies impose hardships upon simple people; that when their effect is not positively cruel it is pathetic, or at the very least, futile. On the contrary, he seems to say, whatever of truth, goodness and beauty there is in human life is authored by beneficent individuals and not by an ideology embodied in an institution.

Such is Orozco's own attitude towards men and organized endeavors. When he is not deliberately painting something without any meaning

[ 81 ]

at all, apart from the quality of the painting itself,—when, that is, he is letting his mind dwell on significant ideas—he invariably resolves his intellectual problems by reference to individuals. Hence it is that in his latest and most complete work, the decoration of the *Hospicio Cabañas* in Guadalajara, he gives praise or dispraise to a variety of individuals.

The orphanage was founded early in the nineteenth century by Bishop Juan de la Cruz Ruiz de Cabañas y Crespo, who, when he died in 1824, bequeathed his rich estates for its permanent endowment. Nowhere in the world can there be a more delightful home for orphaned children. The playgrounds are gardened patios. The dormitories are bright and light and cheerfully disposed, with comfortable beds covered with colored counterpanes. Good food is abundantly served in sunny refectories. The atmosphere of the place is extraordinarily free and lighthearted. Some years ago the State took over from the Church the management of the house, but so much money comes in from the Bishop's bequest that the good man's young beneficiaries are still richly supported.

The chapel, which is about to be made into a library, is a handsome and highly original structure of a basically Renaissance type, although it shows neoclassical influence. It is of cruciform shape, with the crossing occurring at the exact center of the longer limb. The altar formerly stood under a central dome, facing the east. Healthy children, in the old days, heard Mass from benches in the south bay. Invalid children were wheeled from the infirmary into the north bay. The doorway of the eastern transept, opposite the entrance, gives onto a patio with fountain and pool.

The dome of the chapel is supported by sixteen columns and illuminated by panes of translucent uncolored glass. Below the columns and above the four major arches of the crossing, sixteen panels form the drum of the cupola. All of these panels contain symbolic designs. Four immense triangles which occur between the lower plane of the drum and the arches of the crossing are filled with heroic nudes. In the ceiling of each of the two long bays there are three curved panels corresponding to supporting arches. Finally, the arches frame three wall surfaces on each side of both

33. THE FOUR ELEMENTS

Fresco, Dome of the Hospicio Cabañas, Guadalajara. José Clemente Orozco

34. RECOLLECTIONS OF AZTEC DAYS

Fresco lunettes, Hospicio Cabañas, Guadalajara. José Clemente Orozco

bays, and each transept contains one such frame. Such is the complex architectural setting of Orozco's master work: altogether, fourteen large wall panels and four lunettes, six ceiling arches, sixteen drum panels, four major triangles and a huge dome. All of these surfaces were handed over to Orozco to be covered with frescoes.

It is impossible to assign a general subject descriptive of the whole plan of decoration, but most of the designs have something to do, in a general way, with the history of Mexico: although not in any sense a child's picture-book history of that Republic. Perhaps the criticism most commonly heard in Guadalajara is that the frescoes are in no way related to the use to which the building is to be put.

My own first impression of the work was, I must confess, disappointing. Although there was a good deal of bright color, the surfaces seemed to be somewhat flat and thin. But when I had examined the several panels separately, and then looked again across the whole length of the building, I came to see that, except for a few weak fragments, the design was undeniably endowed with plastic unity and beauty. I felt as though I were beholding a pattern of which the accidental details had been wrought in stained glass: glass to which plenty of movement and excitement had been communicated. My first quick look for modeled forms and literary meaning had put me off the track of immediate appreciation.

The dome of the chapel is the climax of Orozco's preoccupation with the decorative and emotionally stimulating values of flame tones. At its apex stands the foreshortened figure of a Man of Fire. Flames which seem to proceed from his legs and arms envelop him and obscure his face. Orozco drew this figure in dozens of shapes in charcoal and finally painted it from a glowing sketch in oil which is now in the Thayer collection in Milton, Connecticut. A Man of the Sea has a blue face of incalculable emotional power. The figure of the Man of Earth describes a semicircle, following the lines of the circular stone casing of the dome. Air is represented by a mighty nude whose muscular right arm is outstretched above the Earth. A circle within the circle of the dome is formed by the arms of Earth, Sea, and Air, and within and around this central rhythm there

plays an infinite variety of moving counter-rhythms. Here this great and original master of fresco is undoubtedly at the height of his fantastic baroque power.

It is a pity to relate that all of the details of the decoration of the *Hospicio* do not reach the high perfection of the dome, but there remain several distinguished panels. To the right of the main entrance, at the upper level, is the Franciscan monk mentioned earlier in this chapter. Opposite him is a missionary nun, likewise drawn with tender beauty and expressive of great strength of mind and character. At the feet of each lies the now familiar figure of a decorative Indian nude. In the first ceiling panel of the south bay there is another Franciscan at whose feet, receiving the padre's blessing, there kneels a naked Indian in one of Orozco's most melting postures. Next there is a battle scene between mounted *Conquistadores* and terrified Indians, with two unrealistic horses sharing the center of pictorial interest and recalling the Aztec dread of the supernatural-seeming mounts of the Spanish cavalry. The ceiling of this bay is completed by a portrait of Philip II carrying a Cross and a crown, in his cruel face the story of his domination by the Church, his institution and patronage of the heartless Inquisition. All three of these panels, completed in the first of Orozco's two years of work in the *Hospicio*, are of a high level of achievement.

The first panel in the north bay, a companion piece to the Franciscan monk in the south bay, represents Cortés, and as elsewhere, notably in the Preparatory School, Orozco has painted him sympathetically. His armor looks a little as though it had been manufactured in Detroit, but the massive bolts with which it is assembled strike a modern and an ornamental note. The second panel contains a boldly drawn scene of hand-to-hand combat, and the third an epic portrait of a mechanical horse,—of which a droll detail is the tail, composed of links of steel. The mechanical horse has been variously interpreted as a symbol of some political ideology or other, notably Fascism, but it is not likely that he is anything more than one of Orozco's plastic fancies.

Long before the side panels were completed Orozco received notice

that the then Governor of Jalisco, Señor C. Everardo Topete, the patron of the *Hospicio* project, was about to be succeeded by a man who could not be expected to interest himself in finding funds for its continuance. He was obliged to continue his work rapidly, under the same urgency which had required him to do two months' work in two weeks in the Preparatory School. Much of the remainder is therefore far below the level of Orozco at his best. A series of designs which represents the Revolution marches along the whole of the west wall, adding nothing to our knowledge of Orozco although it includes some of his characteristic themes: his criticism of regimentation and his regret for the extinction of the Aztec culture. The color scheme runs from cold steel grays at the beginning into great areas of rich color at the end.

The unrelated panels of the east wall are neither very interesting nor very profound, on the whole, although there is a sympathetic portrait of the founder of the Orphanage; and immediately inside the formal entrance there is a preposterously ill-designed posterlike drawing, crude in color and composition, of the *Hospicio* itself. I hope when Orozco sees it again he will remove it. On the north wall, finally, there are portraits of Cervantes and El Greco. The tribute to El Greco is a suitable acknowledgment of the one influence from the history of art which Orozco will admit and critics can honestly declare.

Even the casual spectator would, I think, detect in the whole range of the Guadalajara murals the presence of much faulty technique. For example, there are numerous breaks between areas painted on successive days. I have been told by Paul O'Higgins that Orozco explains that fresco is, by nature, painted in this way, a piece at a time, each piece finished on its day for all time, and that it is unaesthetic to try to cover up the nature of the process. Not everybody will, I am confident, be convinced that the frequently obvious separation into daily stints is, on the contrary, aesthetic. Furthermore, all of these murals, even the newest of them, are marred by spottiness caused by moisture striking up to the atmosphere from improperly prepared or painted surfaces. Hardly was the work completed before the paint began to peel, and large areas to

crack and become misty. These walls surely cannot survive, like the Italian frescoes, through many generations.

When I first visited Guadalajara, two months after the completion of the frescoes, I was told that few people had braved the danger to life and limb of climbing over the piles of scaffolding and earth which shockingly remained in the chapel; but I am sure that whoever visits the *Hospicio* today, in a sympathetic spirit, is likely to carry in his mind's eye for a long time the profoundly moving elemental figures of the luminous and rhythmic dome; the four heroic nudes upholding the drum, types of ancient and modern Mexican warriors; and the long succession of compelling forms flowing, however unevenly, up and down the length of bay and transept.

When I think of these things,—and of a little lunette which might stand as Orozco's signature, a group of a dozen masked and naked Indians whose bony structure and musculature are sharply drawn in white upon a green ground, with the free and daring brush stroke of which Orozco has made himself the master—I feel well repaid for my hours of study in Guadalajara; and perhaps a little ungrateful in reporting the minor weaknesses that mar the perfection of a masterpiece.

Unlike Rivera, Orozco today feels committed to fresco painting because, compared to easel painting, he finds it more complete, its materials richer; he is unhappy and restless when he has no walls to decorate. Yet during the few months which intervened between the completion of the Guadalajara murals and the beginning of a new commission in Jiquilpan, the home town of the former President, Lázaro Cárdenas,—a work interrupted in the summer of 1940 by an invitation to make some portable frescoes for the Museum of Modern Art in New York—he laconically painted a few pieces in casein and in oil on paper. These papers chiefly recall the time when he painted women from bawdyhouses and cheap theaters, but the new Orozco is also in them, a more sober, indeed a somber Orozco, a more finished master of color and design. Collectors must be grateful that intervals occur between mural commissions, because then the monumental painter records in small compass the qualities they

admire on the irremovable walls. That museums and private collectors are eager for Orozco's work was demonstrated in March, 1940, when ninety-three drawings and paintings from the years 1931-1940 were exhibited by Miss Amor in Mexico City. Nearly all of the items offered for sale then were sold within a week. The Museum of Modern Art currently owns five of his oil paintings.

An interesting and unexpected confirmation of what I had already written about the meaning of Orozco's mural compositions came to me in a letter from the painter at the end of June, 1940. I had written to him to ask what the "Dive Bomber" was going to be like, because I had not then expected it to be finished in time to be described in this account of the painter. He expressly said that his design had "no meaning or symbolism except the one that the spectator may think it has." He indicated that the plastic forms, taken from the familiar contemporary materials of war, were of interest to him simply because they were susceptible of conveying the feeling tones of power and might. His use of the words "power" and "might" interested me enormously, as well, because they are words I had used over and over again in writing and talking about him. At about the same time he was having his little joke with the public by writing the unintelligible text for a Museum Bulletin entitled *Orozco "Explains."*

CHAPTER FIVE

# Siqueiros and the Younger Muralists

*She saw no reason for depicting subjects she considered un-pleasant. A sketch of our kitchen, in which we lived, seemed to her to lack dignity. She preferred a sketch of our best room, which we never sat in and seldom saw.\**

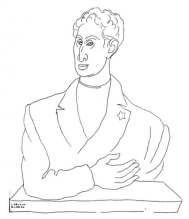

MEXICAN JAILS ARE delightfully informal. They may be a little chill and comfortless if you have no money for warm clothing and blankets, but they afford certain amenities which perhaps somewhat offset the absence of the standard comforts of American prisons. There is, for instance, the traditional institution of Ladies' Night, when romance sweeps through the bleak courtyards and into the cold chambers of confinement. Arrangements can also be made, according to one's means, for little intervals of escape from the dreariness of routine. You may sleep in jail and spend the sunny days in the public plazas; or you may while away the long hours of daylight playing ball in the prison courtyard and then go out to spend the night with a friend.

In Guanajuato, where Diego Rivera was born, the prison is one of the

\* From *Northwest Passage*, by Kenneth Roberts, copyright, 1936, 1937, reprinted by permission of Doubleday, Doran and Company, Inc.

sights of the town. When I was there, in December, 1939, one of the particular attractions of the prison was a man who had thirty-seven murders to his discredit. His crimes had netted him a pretty little fortune, which stood him in good stead during the thirty-seven months of imprisonment his diversions had equitably secured to him. He was altogether the prison hero of the moment. My companion and I were therefore greatly disappointed when we visited the jail. We could not see this prodigy. He had stepped out to do a little shopping.

This flexibility in the prison life of Mexico explains why David Álfaro Siqueiros, who in one way or another has seen a good deal of jails, has not, until the present moment, been more unfavorably disturbed in his career as a painter. He began going to jail at the age of thirteen, in defense of his principles, and the prisons of Mexico have had an inexorable if sporadic attraction for him ever since. Almost immediately upon his return from Spain, where he was a colonel in the Republican army, he got into trouble with the police. His sentence on that occasion characteristically did not entirely rob him of the freedom of Mexico City. He was merely requested not to invade the provinces, and he really suffered only from the distraction of reflecting, over the manipulation of his paint-guns, that at any moment the police might walk into the studio and remind him of his inevitable return to jail. He put in a good year of hard, productive work before disaster befell him in the shape of a serious charge which faces him as I write: a charge of complicity in a raid upon Trotsky's house some months before that nearly forgotten man was killed.

Siqueiros, who was born in Chihuahua in 1898, belongs to a family famous for its vitality and longevity. His great-grandfather lived to be 115 years old, his grandfather was 101. Siqueiros still hopes to be painting, like Titian, when he is ninety. His father, a celebrated lawyer, enjoyed a national reputation as a wit and a Don Juan. It is said of him that he made love to more women and married fewer than any man of his time. The son, it appears, early began to take after his father. His reminiscences are full of references to the "wife and child" of other times and seasons. During the space of a few months when I saw him almost

daily (in 1939-1940) he seemed to have settled down with a beautiful and extremely intelligent woman, a capable writer; but when he came to my house to say *adios* upon my return to the United States he was accompanied by the lady's successor.

He also has enough of his father's cleverness to get the best of the ready-witted Diego, upon occasion. Rivera once told a newspaper reporter that Siqueiros was the Benvenuto Cellini of Mexican art. Siqueiros perceived that the comparison was not altogether favorably intended. If Rivera meant to say that his younger colleague was versatile, he might also have meant to suggest that he was an adventurer and an amateur. Siqueiros therefore hinted in public places that Diego was the Benvenuto Chelínes—the money getter—of the movement. For whatever reason, the two are not very good friends.

While Siqueiros was still in the Preparatory School, at the age of thirteen, he began his professional career by attending night classes in the Academy. Within a month he had discovered the scope of his permanent interests: he became one of the leading spirits in a student strike and vindicated his generalship by sharing the humiliation of his comrades in jail. Released from his first term of imprisonment he joined the open-air school at Santa Anita, where he was soon in the thick of a conspiracy against the rich Yucatecan, Victoriano Huerta. When he was fourteen he became a sergeant in the revolutionary *Batallón Mama*, an army of children, and at fifteen, a veteran of many battles, he was made a lieutenant.

In 1917 he organized the *Congreso de Artistas Soldados* in Guadalajara. The young men painted a little and talked a lot. Their vocations, interrupted by the civil wars, needed renewal. They actually knew not very much about painting. When Siqueiros had an unexpected opportunity to find out, as a nominal military attaché, what was going on abroad, he spent all of his time writing and talking about what he meant to do in Mexico. Meanwhile his contemporaries went to work making murals: Rivera, Orozco, Charlot, Alva de la Canal, Cahero, Leal, Montenegro, Guerrero. All of them anticipated Siqueiros in demonstrating the principles of which he had written in the single issue of his *Vida Americana*

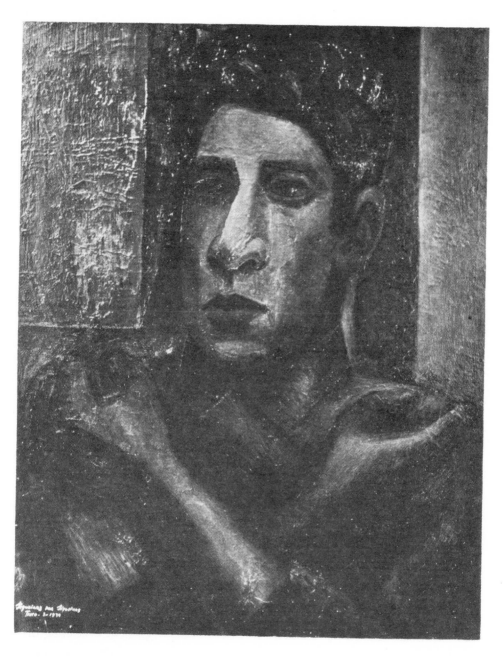

35. SELF-PORTRAIT
Oil on canvas, Taxco, 1930. David Álfaro Siqueiros

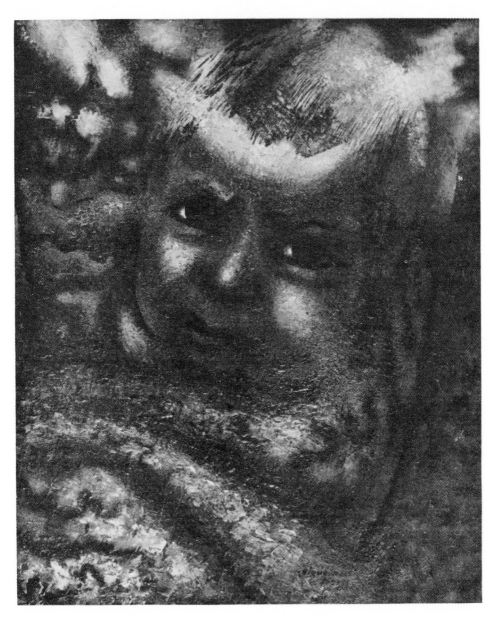

36. TARAHUMARE BABY
 Duco on board, 1939. David Álfaro Siqueiros. From a private collection

in Barcelona. Upon his belated return he joined the others in the Preparatory School project and began the first of a long series of largely unfinished projects. To this day, his critics in Mexico say (not quite fairly) that for all his smoke he has produced comparatively little fire.

If Siqueiros has failed to achieve as wide a reputation as Orozco and Rivera it is not because he has an inferior gift as a painter. He is a very fine painter. He is simply congenitally unable to carry out many of his projects to a successful conclusion. Orozco, who has no extracurricular attachments, paints as much and as fast as external circumstances permit. Rivera has kept his political interests under shrewd control, and the greater part of his enormous energy is spent amongst his cans of paint. But Siqueiros is the victim of a violent nature, a man of uncontrollable excesses. He will throw down his painting-machines at any moment to rush out into the street to make a demonstration, or throw stones (according to the newspapers) at capitalistic windows. So his assignment in the staircase of the Preparatory School was never completed. The fragments which remain to this day are barely discernible; are visible, in fact, only in the brightest light of clear midday. The technique is crude and amateurish, in that the daily areas do not match in color values, but the strong, primitive nudes are monumentally conceived. His well-known "Burial of a Worker," for example, paradoxically instinct with religious feeling, still has power to move. It is much admired by other painters.

It was a bitter blow to Siqueiros when the Syndicate of Technical Workers, Painters, Sculptors and Engravers fell apart simply because of the inability of any two Mexicans, let alone a dozen, to work harmoniously together. When, in addition, the propagandizing organ of the Syndicate, *El Machete*, of which he was editor-in-chief, was outlawed by the Minister of Education, he felt obliged to make a complete break with the government. That is another reason why, with all his energy and capacity, he should have left so little to show for his connection with the revival of fresco painting in Mexico. Turning to the labor movement instead, he became the director-general of all trade-unions in the State of Jalisco, and

at length he was made general secretary of the national confederation of Mexican syndicates.

When Rivera became the court painter to the Mexican government, assigning unimportant oddments of work to the young men who followed him out of the Syndicate, the *Machete* staff spent so much time in picket lines, trade-union activities and jails—Siqueiros served a continuous sentence of twelve months in 1930—that there was no leisure for painting. Although Siqueiros and his followers produced little, they referred contemptuously to the Rivera group as Romantics and set themselves up as the only faithful exponents of revolutionary art for the masses. To advertise their campaign amongst the people they published two additional journals, for which they wrote the text and drew and engraved the illustrations: an anticlerical paper called *El 130*, and a more literary journal, *El Martillo* (The Hammer). Siqueiros did much of his editorial work in his cell; and when he was released (in 1931) he was obliged to leave the country. At the moment of his exile two foreigners were exhibiting his work in Mexico City, the Russian moving-picture director Eisenstein, and the American poet Hart Crane.

Some of the works shown at that time had been produced in jail. Siqueiros' prison routine had not been arduous, his confinement in Taxco had been lightened by intervals of freedom; but his extreme poverty had permitted him few of the materials of painting. Most of the oils painted in 1930—some of them are in the collection of William Spratling of Taxco —have turned black because Siqueiros used paints of cheap and inferior quality, generally of his own unskilled manufacture. Only the wood engravings and the lithographs, for which Spratling had supplied the stones, survive in their original strength and clarity. The lithographs are directly and finely drawn, and are becoming rare and valuable. Thirteen of the Taxco woodcuts were published by Spratling in 1931. Most of them record in the simplest terms what the artist saw in the penitentiary: the bleak expressions of imprisoned men, the sorrow of their visiting wives. They were published on white paper, but I cherish a few trial prints on papers of sympathetic sepia tones.

Exiled from Mexico, Siqueiros went to Los Angeles where, with a group of American pupils, he initiated a little mural movement of his own. He painted a few public frescoes of inflammatory character and a somewhat milder mural decoration for the house of Dudley Murphy, the Hollywood director. Presently, because of the revolutionary contents of his outdoor murals, Siqueiros was compelled to leave Los Angeles. The fresco that was particularly disliked by conservative society there was the Plaza Arts Center "Crucifixion," in which figures representing the Latin-American races are bound to a Cross surmounted by the American Eagle. The Angelenos thought this was a piece of impertinence.

When Siqueiros left the United States he was gratefully possessed of new ideas and techniques which he has been developing ever since. He had been amazed to learn how much had been accomplished in American laboratories in the field of plastic discoveries and inventions, of which American painters seemed to him to be ignorant. He discovered for himself the use of nitrocellulose (Duco), bakelite and the synthetic resins. He practiced with new tools which had been developed for the use of commercial and industrial painters, notably the spray gun. He was inspired with the notion that the techniques of art must advance with the new technical media of production. In Los Angeles he innovated the study of mural composition from the point of view of the spectator, and planned murals in which the beholder could see something from every angle, without distortion: an idea which Orozco has only lately taken up.

From California Siqueiros went to Buenos Aires, where he organized still another group of painters and published another manifesto. Painting with spray guns on a colored cement wall, he produced his famous "Plastic Study," in illustration of his theory of spectatorship. I have not seen this fresco, but even the photographs are exciting. It covers the wall of a semicylindrical volume and is about two hundred square meters in area. The design for it was executed in photomontage. The figures which principally compose the piece are monumentally conceived, plastically modeled, sometimes effectively distorted, and apparently brilliantly lighted.

Siqueiros has never faked artificial or illusionary architectural devices

to fill space, a practice much resorted to in Mexico in the early nineteen-twenties. Instead, he conceives of an area to be painted as an integral part of a unified architectural design and decorates it accordingly. When there is an unbroken reach of walls and ceiling, his design preserves this unity.

Together with the painters Antonio Pujol, Rufino Tamayo and Luis Arenal, Siqueiros went to New York in 1934 as a convention delegate of LEAR, an association of writers and artists who had matured since the days of the Syndicate of 1922. He established a workshop for experimentation in the use of Duco, and most of his paintings in American collections were made in that shop: for example, the "Echo of a Scream," Edward M. Warburg's gift to the Museum of Modern Art. Pujol and Arenal, who later painted a fresco of his own in the Bellevue hospital, stayed on for a time with him, and Roberto Berdecio shortly arrived to join forces. Berdecio, a Guggenheim fellow for 1939, remained in New York to produce plastic forms in the Siqueiros Duco technique, designing them to compete, in respect to plastic sensations, with three-dimensional objects in the rooms which they will presumably decorate.

When the Spanish civil war began Siqueiros offered himself for a commission in the Republican army and gave up painting until his return to Mexico in 1939. The paintings produced in that year—they were shown early in 1940 at the Pierre Matisse Gallery in New York—were made in Duco on a patented three-ply board. They range from fantastic landscapes—the technique lends itself to fantasy—to figure studies remembered from the Spanish war or painted from models typical of the common life of the people of Mexico.

I saw Siqueiros frequently during the last six months of 1939, while he was at work preparing for the first exhibition of his painting in many years, and observed the daily progress of his technique. The first two or three pieces,—one of them the nude figure of a wounded woman with a gangrenous hand, another a study of a woman weeping—were brilliant and powerful but a little hard. The backgrounds seemed scarcely more interesting in texture than an automobile fender. But the last pieces pre-

pared for the exhibition—Siqueiros was distracted, in one way or another, from fulfilling an agreement for a greater number of pictures—were more plastic, more various in texture and richer in color, than anything I had seen amongst his earlier works.

A piece called "The Mask," now in the Matisse collection, shows an adaptability in the representation of textures such as would have been thought impossible when Siqueiros began to paint in the new medium in New York. The steel mask worn by the central figure, an Indian peasant on a holiday, is metallic, impenetrable; his cotton tunic, on the contrary, is soft and flexible. Likewise in the matter of feeling tones, Siqueiros made a prodigious advance in a few months. Into the accompanying study of a Tarahumare baby, made at about the same time, he projected more tenderness than would have been expected from the spray of a paint gun; and in the face and bearing of the mother in the great "La Patrona," the jacket decoration*and frontispiece of this book, there is uncommon beauty mingled with nobility.

For his miracles of modeling Siqueiros has used the brush rather more than he perhaps would be willing to admit in public. In his most recent mural painting, I have seen him take the greatest pains with brushes. In fact, his new Mexican murals, which are sharper, more colorful, more severely brittle and "modern" than anything he had theretofore produced, superbly illustrate the effectiveness of a combination of new and traditional techniques.

The setting for this work is a boxlike area on the second landing of the principal staircase in a modernistic building built by the electricians of Mexico City to house a co-operative enterprise. Under a single roof are grocery and clothing stores, offices, day schools for children and night schools for members, hospital services, gymnasium, and the most attractive concert auditorium in the city. Siqueiros made a continuous photomontage design to cover the three walls and the ceiling of the space allotted to him. The subject-tone of the piece—with its familiar theme of the disintegration and destruction of the contemporary world—is set by a yellow parrot haranguing a throng of people through a microphone. Set

*[Original edition only.]

against the "thing said" by the forces of reaction is the "thing done" in modern society: the top-hatted banker stays comfortably at home while the young workingman goes to the battle front; a destitute mother, without food to offer, tries to comfort her hungry child; a Negro is lynched; factories hum with activity and yet the poor remain impoverished. The cruelties and ironies of modern life are wrought into tight, solid plastic forms between a frieze of machine motifs at the bottom and a ceiling laid out in sharp diagonals.

It is well within the range of this versatile painter, who stands midway between the classicism of Rivera and the baroque tendencies of Orozco, that some of these forms are severely classical while others are notably romantic or excessively modern. The textures are fascinating: the thighs of one nude stand out in actual relief, built up and modeled in paint; rough areas alternate with smooth; flesh textures are contrasted with steel and iron. The surface is irresistible alike to hand and eye. A cannon appears to project beyond the surface of the wall and the hand is impelled to test the illusion. Wires of actual metallic substance are used to tie elements of the painted design.

Perhaps one of the most interesting additions made by the Duco technique to the whole range of historic plastic values lies in the suggestion it conveys of planes anterior to the painted surface. However much depth there is in an oil painting on canvas, its planes are invariably posterior to the surface. The anterior planes visible in many of Siqueiros' new pieces enrich them greatly. Siqueiros himself likes the rich textural effects it is possible to secure by the application of many layers of transparent paint, and by the color intensities emerging when pigments are not mixed on the palette but transparently overlaid with the spray gun.

It is a pity that after so many fruitful years of serious work Siqueiros has not yet achieved the success with the collecting public that his painting seems to deserve. Perhaps people have been put off by a few of the published reviews of his exhibitions. Occasionally a writer has been unable to get back of the painter's uncommon techniques to what has been overtly accomplished. Siqueiros is no amateur in the use of Duco

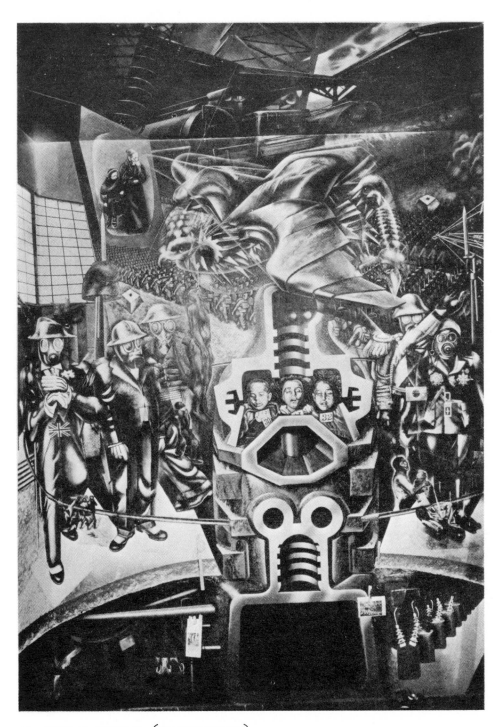

37. MURAL DETAIL (UNFINISHED)

Duco on cement, Electrical Syndicate, Mexico City, 1940. David Álfaro Siqueiros, et al.

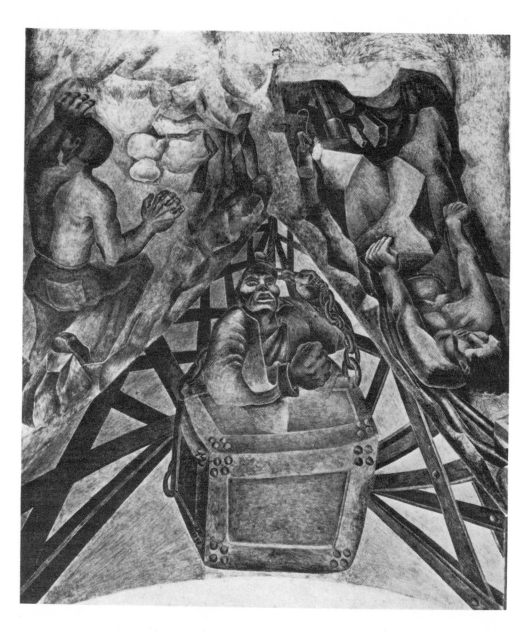

38. LIFE IN THE MINES
  Fresco detail, Abelardo Rodríguez Market, Mexico City. Antonio Pujol

and painting machines. One might therefore have hoped that the novelty of his method would wear off, at least in professional circles; yet even quite recent reports of his work have sometimes suggested that the technique is tricky and somehow ignoble.

For my part, I cannot believe that there is any intrinsic aesthetic dignity in the familiar use of brush and palette knife. Although many artists have regarded themselves as belonging to a race apart, they cannot base their feeling of superiority to other mortals on the exploitation of implements which are employed by house painters and ceramic workers as well. A man is a good painter if he gets good results with his colors, no matter how he applies them. People for whose enjoyment pictures are made ought not to be inhibited from taking pleasure in a form of art because of its curiously advertised means of accomplishment.

As one of three people responsible for assembling the Siqueiros exhibition shown at the Pierre Matisse Gallery in February, 1940, I was particularly anxious, because of my great admiration for the painter, that it should be imposing both in size and quality. He had been too long absent from the public eye. For a few weeks after his establishment in a well-lighted studio in a quiet suburb of Mexico City, Siqueiros produced a picture a week. Then he took a vacation in Taxco. The time for the New York show rapidly approached, and still the number of pieces for which we had contracted was far from complete. We sent urgent messages to him, asking him to come home and get back to work. When he returned he received the unexpected commission to paint Duco murals for the electrical syndicate. He told us he could do them in ten days and still have ample time to paint the five or six missing pictures. At the end of ten days we discovered that the electricians had not yet so much as wired the staircase for lighting, and Siqueiros had not begun his work. We gave up hope of getting any additional paintings and dispatched those already on hand to New York. Nor were the new murals quite completed when Siqueiros, still on parole as the result of an earlier escapade, was obliged to fly for his life from Mexico City. A self-confessed participant in the

semifinal machine-gun attempt on the life of Leon Trotsky denounced Siqueiros as one of the conspirators.

With Siqueiros there was working, in the spring of 1940, a group of painters and helpers who hoped the new mural would mark the beginning of a new movement, or at least a fresh period in the history of Mexican mural painting. They disparaged the romantic elements of the first mural epoch and talked of a new classicism, a new humanism based upon the actualities of contemporary social life and expressed conscientiously by the new techniques. Three of the group, Rodríguez Luna, Prieto and Renau, were refugees from Spain. Other assistants were an American youth who called himself Josh Kligerman, a young man with undoubted possibilities, although he surprisingly began life in a dairy; Luis Arenal, the brother of a lady to whom Siqueiros was long devoted; and Antonio Pujol, the talented painter who had worked with Siqueiros in New York.

Pujol, whom I first called upon when he was resting in jail after committing some relatively harmless peccadillo, was a sometime pupil of Rufino Tamayo and Carlos Mérida, both of whom have exhibited regularly in New York. As a youth Pujol worked principally with a group of young painters of the Rivera school. Then for a time his painting reflected the influence of Tamayo: particularly in certain curious arrangements of relatively alien, although not inharmonious, forms in a single design. His own best murals are in the *Mercado* Abelardo Rodríguez in Mexico City, a modern market place built on the site of, and to some extent incorporating, an old convent dedicated to St. Gregory; and of these the most moving is a fresco which portrays the perils of mining. A miner pathetically absorbs, as he swings into a shaft, the diminishing light and color from the upper earth. Below him, in the narrow compass of the pit, his companions are at work with their drills. An irregular fragment shows a dismembered corpse, another realistically represents a victim of silicosis coughing himself to death. The sentiment which inspired and unified the work of the whole community of painters engaged by the government to decorate the market is inscribed on one of Pujol's walls: "The working class, united with the peasants, fights against the exploiters."

I saw Pujol infrequently, but he seemed to me to be a man in spiritual torment. He is an attractive young Indian, with many friends, but the pessimism of his race is deeply rooted in him. The transition from popular art, which is readily marketable, to the fine arts, which are not, is hard to make under the most favorable circumstances. That the Indian Pujol, with a craftsman's background, has made it at all is a notable achievement. Already he has accomplished a good deal, intellectually and technically, but I suppose his ultimate maturity must wait upon a public which will not insist upon having its pictures painted in the unused "best" room.

The small central patio of the market was assigned to Paul O'Higgins, a serious-minded and unpretentious young man who went as a boy from San Francisco to Mexico at the beginning of the mural movement in the 1920's. Well-trained in the technique of fresco as an assistant to Rivera—his portrait appears in two or three of Rivera's murals—he abandoned the Rivera school, at least ideologically, to identify himself with the left-wing painters. His murals in the Abelardo Rodríguez market represent themes which he personally investigated in Russia, but the style of them is Diegoesque. It had proved easier for him to withdraw from his personal attachment to Rivera than to eradicate the aesthetic influence of years of association with him. The spirit of his work has been, however, at once more realistic and more bitter than Rivera's. There is a little stiffness in the ordering of his earlier forms, but his people are strongly individualized. The color scheme for the market frescoes, as originally designed, would have run from somber grays and browns and earth-reds into bright and luminous color, but the completed panels belong only to the bright range, of which the blue tones and values are exceptionally effective.

There were two other community projects to which O'Higgins, although he was a foreigner, was invited to contribute during the last decade. One of them was the decoration of a building occupied by the printers' union, the first structure of its kind to be thus embellished. The newly organized League of Revolutionary Artists and Writers contracted for the murals and assigned O'Higgins to the job of producing them,

along with the painters Fernando Gamboa, Alfredo Zalce and Leopoldo Méndez. The staircase panels produced by O'Higgins and Gamboa rank amongst the best of the political murals in Mexico City. The pictorial victim in this case—the propaganda follows a regular pattern—is the Press, which is represented as indifferent to the interests of the proletariat. There is a good deal of genuinely tragic feeling and plastic force in this work, especially in some real portraits of printing shop workers.

O'Higgins' other major commission was executed in one of the many public schools built in Mexico City in 1932, a suburban primary school named for the unholy Emiliano Zapata and situated in the neighborhood of the Sanctuary of Guadalupe. Like the Orozco murals in the orphanage in Guadalajara, the designs were obviously not intended to be of storybook interest to the very young. One of them is an unpleasant introduction to the exploitation of children in factories, and another, with the inscription "Scarcely art thou born, and thou art already bowed under the weight of tribute," depicts humiliating aspects of Catholic education. In spite of the literary intention of the work it has many fine plastic qualities, and shows extraordinary competence in the fresco technique. The color patterns, chiefly in blues, violets, and earth-browns and reds, are altogether satisfying.

When I last went to see O'Higgins, in the spring of 1940, he was working on a scaffold set up in the auditorium of the technical high school lately built in the new *Colonia Michoacán*, commonly called the "Socialist Suburb." Since this colony, with its comfortable houses and little gardens, is the realization of many a workingman's dreams, it is suitable that O'Higgins' murals should disclose some of the Cárdenas administration's accomplishments as well as its generalized aims. Painted in true fresco, in blacks and grays, in tones of blue and brilliant reds, the design has for its theme the expropriation of petroleum properties by the Mexican government. The parts which O'Higgins had finished when I was there illustrate the presumed causes of the expropriations: violations of labor contracts, unsanitary and dangerous working conditions, corruption in the accumulation of oil-producing properties. The plans for the remainder

39. ENFORCED CESSION OF OIL LANDS

Fresco, Michoacán High School, Mexico City, 1940. Paul O'Higgins

40. THE LITTLE FISH

Fresco detail, Melchor Ocampo School, Mexico City. Julio Castellanos

were probably flexible enough to allow for adaptation to current negotiations between Mexico and the oil companies.

Many of the remaining decorations in the Rodríguez market are dull, but there are five singularly attractive panels by Ramón Alva Guadarrama, who acquired fresco technique as an assistant to Rivera in the Ministry of Education and at Chapingo. They are a little more mature than some rather childlike designs he had already painted in a primary school in the suburb Pro-Hogar, but their charm derives precisely from their naïveté. When Guadarrama attempts to paint in a more sophisticated style, as in a nude Earth giving suck to a child, also in the market, he succeeds in producing only bad Rivera.

The American Greenwood sisters, who seem to have been around a good deal in the course of their years in Mexico—they left an imposing memorial of their visit to the provincial city of Morelia—decorated an entrance and a staircase in the market. They began on the floor level, painted their way upstairs, met at the top and did a panel together. Both of them made pictorial sequences, Marion an agricultural series portraying the progression from seed-planting to kitchen, and Grace the flow of gold from mine to capitalistic coffers. Of the two, Grace Greenwood has the truer feeling for the monumental character of good mural design.

Eight or nine new public schools in Mexico City were decorated during the years 1932 and 1933, some of them by individual painters and others by groups. Perhaps the most successful of this congeries of frescoes are those by Julio Castellanos who, if he had not given up painting for the theater, would clearly have been one of the best painters in Mexico today. In the pre-Diego days, when Manuel Rodríguez Lozano specialized in the sympathetic portraiture of provincial types, Castellanos was his pupil. He developed, under Lozano's influence, a characteristic style which is easily recognizable and yet not mannered. Like Rivera he created a type, an almost archaic figure with an egg-shaped Maya head drawn without interruption of line from the crown of the head to the chin. In the Melchor Ocampo school in suburban Coyoacán, Castellanos produced two lyrical and rhythmical panels of such children at play.

[ 101 ]

His masterpiece, a small oil which was exhibited at the Golden Gate Exposition in 1939 and again in 1940 at the Museum of Modern Art, contains nearly one hundred nudes within its small compass. Called "The Day of San Juan," from the annual Mexican bathing festival, it is, for design, plasticity and virtuosity, one of the choicest of modern Mexican pictures. The "Dialogo," a large somber piece in which a sensitive peasant soldier sits sadly on the edge of the bed of his nude mistress, is better known in its tenderer lithographic form. It is a pity that Castellanos has authored so few of his freshly imagined and sympathetic works.

Children's games likewise furnished themes for the frescoes of one of the most interesting of the younger painters, Jesús Guerrero Galván, in the Chiapas school in the *Colonia de los Alamos*. The characteristic Galván style, of which more will presently be said, was not then formed,—some of the children are suspiciously Diegoesque—but there are indications of the true Galván feeling. In a primary school in the *Colonia de Portales* there is a Galván fresco which contains elements of monumental design, notably in a somewhat irrelevant figure of a woman nursing her child in an open-air schoolroom. But for the most part the work seems to have been done from easel compositions, and to the easel Galván wisely returned.

Some of the younger mural painters were loosely organized, in 1933 and 1934, as the "Group of the Eighteen." Besides Galván there were perhaps seven or eight artists who have achieved more than local reputation: Roberto Reyes Pérez, Gonzalo Paz Pérez, Raúl Anguiano, Enrique Ugarte, Leopoldo Méndez, Alfredo Zalce, Francisco Gutiérrez, and Máximo Pacheco. The Group undertook the joint decoration of one of the public schools, but since each painter composed and painted in his own style the result is hardly homogeneous. On an outside wall of the Polytechnic Institute in the *Colonia Argentina* they made some revolutionary panels of which one bears this arresting inscription: "Let us dynamite the schools and cut off the ears of the teachers."

Alfredo Zalce, who made a somber fresco in a public school at that time, has lately been painting in Duco on the walls of a teachers' college

in Puebla. Although he has used themes acceptable to LEAR, he has made his murals personal by recording some of his own (usually harrowing) observations: a hungry man trying to wrest a bone from a dog; a teacher coolly murdered by a band of *Cristeros* in the name of religion. The finished sections seemed to me to be notable for rich textures and brilliant color, as well as for the personal qualities of design and composition. Zalce is much admired by his young contemporaries, and his studio, presided over by an attractive American wife, is a popular artists' rendezvous.

The most ambitious and probably the most successful frescoes produced by a member of the "Group of the Eighteen," during the short life of that society, are those of Enrique Ugarte in the Teachers' College in Mexico City. Based upon the not entirely original observation of Karl Marx that the "root of man is man himself," this work deals with themes familiar enough in Mexican painting: the landing of the Spaniards, anticlericalism, the Díaz regime, the Revolution. The figures, however, are new plastic forms, monumentally rendered, and there is movement and vitality in the designs. The colors are transparent and bright. Ugarte's frescoes seem to have inspired some of the students in the college to paint, for when I visited the co-operative refectory there, early in 1940, decorations had been blocked out, in expressive line drawings, for a history of mankind. If the painting turns out to be as good as the drawing there ought to be new names to add to the already impressive list of Mexican muralists. A fresh voice would perhaps be welcomed. Even the most sympathetically disposed spectators grow weary of the endless repetition of the revolutionary iconography.

Of all the members of the "Group of the Eighteen" the painter of whom most was expected has perhaps least fulfilled expectations. It has happened tragically often that young Mexican painters of unusual promise have quietly petered out before they have quite established themselves. More often than not, poverty has turned them aside from what seemed to be a fruitful career. Dozens of children who painted precociously well in the open-air schools have been inhibited by indigence from

reaching artistic maturity. On the other hand, the creative fire has sometimes simply not burned strongly enough to overcome Mexican inertia. Perhaps a combination of disabilities has hindered the career of Máximo Pacheco. At the age of fifteen he painted some delightful out-door frescoes, somewhat in the naïve style of Abraham Angel, the tragic young hero of the Mexican movement, and five years later he seemed to have developed an interesting style of his own in interior murals. A few years ago he painted a dull socialist piece for the Teachers' College, and then disappeared into a battered hut on the edge of the city, whence he timidly emerges on days when he has lessons to give.

Pacheco was born in the Otomi pueblo of Huichapan in 1907. He went to Mexico City to study art at the age of eleven, and became a pupil of the muralist Firmín Revueltas, whom he assisted in the Preparatory School encaustic mural. Alva de la Canal was working on his pioneering fresco at the same time, across a narrow passageway, and Pacheco sometimes gave him a hand. When Revueltas got into difficulty with the moody Vasconcelos and was obliged to forfeit his contract, Pacheco went to work with Rivera.

For a time it was thought that he was going to be the messiah of the movement, the eagerly awaited native Mexican Indian painter whose racial intuitions and taste and knowledge would enhance the interior life of the epoch. But Pacheco was horribly poor. The meager profits of a very occasional mural commission could not support the widowed sister who had come, together with her innumerable family, to live with him in his miserable hovel. He was obliged to spend the daylight hours at industrial painting and furniture design.

Still, he painted several easel pieces which the discriminating patroness of Mexican art, Anita Brenner, liked so much that she offered to take them to New York and try to sell them. One of his few completed works is in Mexico City, in the collection of Dr. Ignacio Millan, whose American wife, Verna Carleton Millan, writes sympathetically and accurately about Mexico. "The Fishermen," a large gouache, is an organization of rhythmical figures decoratively preoccupied with the handling of fish,

and is executed in earth-browns, rich, warm greens and pale yellows. This piece undoubtedly creates a taste for more Pachecos; but so do the occasional works of Julio Castellanos, the mystical Francisco Goitia and the unaccountable young Tebo whet appetites which are not likely to be satisfied.

There has been scarcely a year since 1922 in which somebody has not produced murals somewhere in Mexico. A recognized artist can always get a teaching job on the government pay roll and sometimes he is allowed to paint on public walls instead of teaching for his monthly stipend of from fifteen to twenty-five dollars. Trade-unions all over Mexico are progressively becoming patrons of art: witness the new Siqueiros murals; and Xavier Guerrero's recently finished fresco in the clubrooms of the automobile mechanics' union in Guadalajara, a work built around the life of Flores Magón,—a Mexican intellectual who preached socialism during the Díaz regime and soon found himself in exile in California.

But it is one thing to get commissions for murals in Mexico and another to make enough to live on out of them. Rivera has always complained that the costs of material and assistance devour the metrical base-rate of payment. He himself had an income from his painting, he says, only when he drew a salary from a not very luxurious sinecure. The average rate of pay prescribed in the government contracts of 1922 was about eight pesos (then about four dollars) a day, over and above the cost of materials, and out of this sum the painter in charge was expected to pay his assistants. Some of the later contracts were even less favorable. Rivera at one time proposed a flat price of ten pesos a square meter, with extra allowance for helpers. This scheme was tried out, but there suddenly appeared before the public gaze a plague of monumental anatomical details, autopsical hands and feet painted in green and black at ten pesos each. The arrangement was speedily corrected.

Today, except when the painter is expected to produce on his government salary, a contract is usually made for a comprehensive charge, ultimately based on the area to be covered, and the painter-contractor pays the masons, grinders and helpers out of his fee. He generally underesti-

mates the expense and is either out of pocket or abandons the project before it is completed. There are scores of unfinished mural projects in Mexico City at this moment.

I should not like to be thought to generalize unfairly in stating, in answer to a frequently repeated question, what I believe to be the attitude of the Mexican public toward the profusion of murals painted for their enjoyment. I mean only to report what I myself have seen. During the hours I have spent in the *Paraninfo* in Guadalajara, on several occasions, I have seen exactly two persons not of my own company there. Two men came in one day with a guide and stayed about three minutes. Perhaps the chamber is too difficult of entrance: it is habitually locked, the janitor sits in a remote cell at the top of a long staircase, and admission to the auditorium is eventually arranged only with the greatest difficulty. On the other hand, the affable if somewhat inaccessible gentleman who guards the precincts told me that few such applications are made by people outside of the University. The students themselves complain that the decorations interfere with concentration at examination time.

Thousands of people brush by Orozco's frescoes in the staircase of the *Palacio* on their way to and from the government offices, and perhaps they make some unconscious response to them. Still, they always seem to look surprised when anyone actually stops to study them. At the *Hospicio*, some months after Orozco had finished the chapel frescoes, the floor was still dangerously covered with timber from the scaffolding and pocked with puddles of dry cement. A legless youth who passes his time at the chapel door, awaiting an occasional word with visitors, told me that he could remember having seen no more than twenty visitors since Orozco's departure.

In Mexico City you will find on any business day at the Ministry of Education hundreds of people listlessly waiting for interviews with the officials, but invariably they are more interested in what goes on in the patios than in Rivera's frescoes. Of course the murals are included in the professional sight-seeing tours, and you can nearly always see a group of tired tourists being swept along the blocks of corridor by a discursive (and usually inaccurate) guide.

41. ADOLESCENCIA

Ink drawing, 1938. Manuel Rodríguez Lozano

I have already suggested that the little country people think that some of the murals are odd. They also sometimes believe that they are shameful. I have heard hearty, erotic laughter in Chapingo, for example, but for the most part the Indians who drop in, both men and women, will look obliquely at Lupe Marín as pregnant Earth and turn away in embarrassment. In the Public Health building Rivera's sanitary nudes are carefully kept under lock and key, although nothing can be done to protect the public modesty from the undraped allegories in the Ministry of Education staircase.

The sense of *impudicicia* in Mexico strikes the foreigner as being very funny. Practically all the Indians, many ranks of the *mestizos*, the mixed races, and all of the upper-class ladies are curiously modest. At least, they are modest in curious ways. The Indians will sleep stark naked, four or five of them, of all ages, on a single *petate*, perhaps under a single covering, such as the Tarascan mother's red woolen skirt. They hold with no nonsense about needing privacy for copulation. Their reticences outside of the walls of their houses therefore seem not a little inconsistent with their private lives. The middle classes everywhere are likely to behave according to a code of modesty so greatly exaggerated that it becomes lewd, but it is astonishing to find this excess of prudery in the descendants of a race which worshiped phallic images. Perhaps it is possible to explain the modern Indian's sense of shame by his familiar acquaintance with overdressed saints in the churches. So delicate were the perceptions of the ladies and gentlemen who built and decorated the churches and chapels of New Spain that even the Infant Jesus, whom tradition allowed to be represented freely as a naked child, has always in Mexico been carefully covered up. Not even the body of Christ upon the Cross has been spared the humiliation of their false modesty. Frequently this figure, venerable alike in religion and in art, is attired in colored and ruffled drawers.

The paradox is summed up in our houseboy, Pablo, who took care of my Mexican study, where there hung one of Rodríguez Lozano's most beautiful drawings, the "Adolescencia." Young Pablo could have modeled for it; but he, poor boy, born of love out of wedlock and personally not unacquainted with the near sight and feeling of the human form, used

[ 107 ]

to shut his eyes when he dusted the square of glass protecting that well-nigh perfect work of art.

Thus there are expressed in Mexico, as I suppose there are everywhere, a good many attitudes toward the manifold forms of art. There is, along with official patronage, official indifference. The inner patio in the Ministry of Education has become an ugly dumping ground for secondhand trucks. The convent staircase where Roberto Montenegro painted his best murals is a warehouse for discarded office furniture. Great walls have been neglected, misunderstood and even defaced. The painters like to think that many of the scars are accidental, but there has been a good deal of deliberate sabotage. Still, in spite of Rivera's frequently bitter criticisms of the Mexican public, there probably remains a greater body of genuine amateurs of art in Mexico, proportionately, than in most of the countries of the world.

I was not surprised to learn from my barber in Cambridge, for example, that he had not seen the murals in the Widener Library or the Sargent prophets in the Public Library in Boston, and had never walked the few blocks from Brattle Square to the Somerville post office to look at Ross Moffett's "Battle of Concord and Lexington." Yet my barber in Mexico, a man who has to support five children on less than a dollar a day, has made the rounds of the murals in Mexico and talks very well about art. A waiter in a *cantina* in Morelia asked me if I knew what had become of the Greenwood sisters. He knew in detail the murals they had made in the Palace there. Time and again when I have tried to turn up some new painter in the provinces I have been questioned about the city painters, whose names and works are known throughout the Republic by means of the metropolitan rotogravures and the myriad weekly publications devoting a page or two to art. Rivera, when he is vexed because the Mexican people do not buy his pictures—how can they, they have not enough income—does not believe me when I tell him of these encounters. But if I were a Mexican painter I should, if I were not too demanding of money, rather paint in Mexico, at this moment, than in any country I know.

CHAPTER SIX

# A Skipable Chapter on What to Look
# for in Pictures

*There is no mystery about art.*
Jean Charlot, in
*Art from the Mayans to Disney.*

THERE WERE MANY MEXICAN painters who did not join the Syndicate of muralists in 1922, and some of those who did soon withdrew from the public projects in order to return to their studios and their easels. A few were plainly not equipped for mural painting, they simply projected large-scale easel designs upon the walls. Others were not interested in it. One or two have said that they were crowded out of the public competitions by Diego Rivera. Most of the painters who, for one reason or another, went back to easel painting, had this much in common, that they were not interested in the literary and political aspects of painting, nor in the quasi-religious techniques in which community painting had begun to involve them: such as public self-criticism, "sharing," and the group-criticism of their colleagues.

While it is probably true, as Kant wrote, that a solitary man would

[ 109 ]

decorate neither himself nor his house, but requires a community to stimulate him to aesthetic activity, it does not follow that a man must produce works of art jointly with his fellows. Individual Mexican painters have profited greatly from their relationship to the movement which has revitalized the cultural life of their country, but most of them have remained uncompanioned beings who want only to go their own way without interference, and, as far as possible, without subjection to influences. The typical Mexican painter is contemptuous of most of his contemporaries, is interested in solving his own plastic problems in his own way. He may have experienced, in the past, a spiritual attachment to Europe, especially to the school of Paris, but he is busy now working out his own salvation, alone in his own studio.

Apart from the Rivera wing of the mural movement there is, then, no Mexican "school," save from the point of view of the foreigner, who can hardly be expected to deny himself the convenient term. The outside world has seen Mexican art principally in group exhibitions. Moreover, nearly all of the good painters live in Mexico City, and their very congregation there has, in foreign eyes, necessarily constituted a school.

But the artists have formed no colonies, they despise group exhibitions, they cannot agree to sell their works through any single agency. Many of them will not meet others of their kind, some of them have hard words to say of their peers. They are solitary individuals, *solos*; and in thinking of them, and sometimes calling them, *Los Solitos*, out of affection, I confess I am not quite innocent of intention in respect to the pun: for most of them are inclined to behave as though they were indeed "little suns."

I have said that the Mexican painters are severally interested in the problems of painting, and now I should like to approach some of these problems, but rather from the point of view of the spectator, of appreciation of painting, than from that of the artist himself. I should like to ask what it is that we look for when we look at a picture. I should like to ignore, for the moment, much of the the usual critical apparatus, the necessary vocabulary of the specialist, and put a few simple questions.

[ 110 ]

The first question is merely a repetition of Orozco's challenge: "Do you like it?"

Do you like the picture you are looking at? Especially, do you like it enough to want to go back to it? If you are looking at pictures seriously, and see one you do not like, you are not morally required to treat it as though, being stupid, you had missed its importance. You are not obliged to worry about it; although if you have a naturally catholic taste you are likely to examine your conscience to determine who is at fault, you or the painter.

If you like a picture it is probably because it makes you feel something, arouses your emotions so that you respond to it; because, at the very least, it interests you. There is no reason in the world why you should be persuaded to look at a dull work of art. Dullness is the artist's sin against the Holy Ghost.

But it is possible to feel something when you look at a picture and yet be unable to describe what it is that moves you. Picasso told Christian Zervos that his ambition was to paint a picture in such a way that nobody could tell how it was done, so that nothing but emotion would be given off by it. In the experience of many people emotion is given off first of all by the subject. This is perhaps an elementary form of aesthetic experience, but it is, I think, aesthetically crippling to be snobbish about the subject matter of a painting, like Dr. Barnes of Merion, Pennsylvania, for example, who professes not to remember the subjects of most of the pictures in the vast collection he owns.

For myself, I object to being told, by lady guides who recite misrepresentations of nonrepresentational art in a certain New York gallery, that abstraction is the highest form of art. There is no absolute and universal canon by which a particular art form may be so judged. A man who wants good plain representational painting is entitled to have it. Easel pictures are made for the people who will look at them, like them, and possibly buy them: and I have never met a good painter who paints so entirely for himself that he is content to stack up his canvases in the darkness of his studio storeroom, indifferent to appreciation and sales.

[ 111 ]

On the other hand, painters, good painters, generally choose subjects not so much because they want to represent them factually in paint, but because in something they see, or have seen and remembered, there are fascinating suggestions of one or another of the essential elements of their special work. They are attracted by the possibilities of projecting, upon canvas or paper, certain lines, forms, relationships and colors which have been observed in, or suggested by, the physical world.

Hence their emotional attitudes toward their subject matter and toward their work, while it is in progress, are likely to be something very different from those of the ultimate spectator, who will not have looked at the world with the painter's professional eye. Still, if the painter has entered emotionally into the treatment of the materials of his art, chances are that then,—and probably it is only then—the spectator will feel something; not the painter's emotion, but an emotion nevertheless proper to the aesthetic experience of beholding a form of art; an emotion aroused by lines and forms and their relationships, and by the qualities and harmonies of color. In any case, the emotion is what the spectator is after, and if a picture does not give him an authentic emotion the picture does not exist for him.

Now of the qualities of a picture which you like, which awakens interest and feeling, there is much less of importance to be said than you probably think. If you want to go beyond the simple appreciation of the subject matter of a painting and examine the means through which the artist has reached your emotions, there are only a few things you must look for. No special vocabulary is required in order to talk about the painter's professional means, and probably the less said about them the better. A good work of art, as Renoir said, is in the end inexplicable. But it is the curse of our civilization that we have to talk, we cannot let our emotions alone, and when we are looking at pictures and talking about them the best we can do is to try to talk simply and make sense if we can.

Apart from describing the feeling-tones of a picture, such as to note that they are mystical, or romantic, or pessimistic, or gay, most of the things which are to be said about painting from the point of view of the

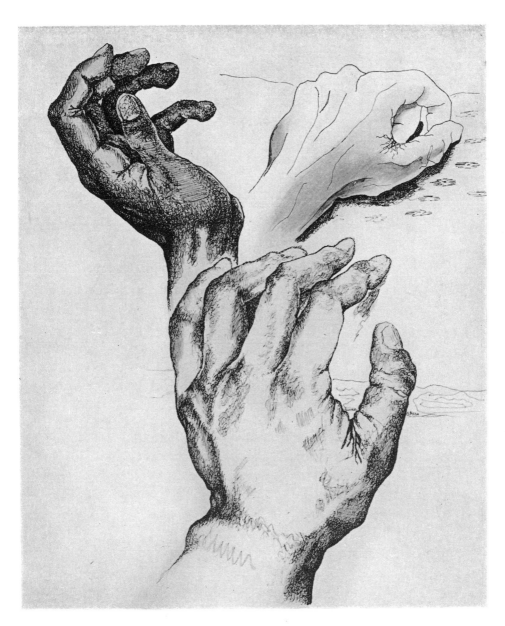

42. HANDS: A STUDY IN LINE

Ink drawing, 1939. Guillermo Meza. From a private collection

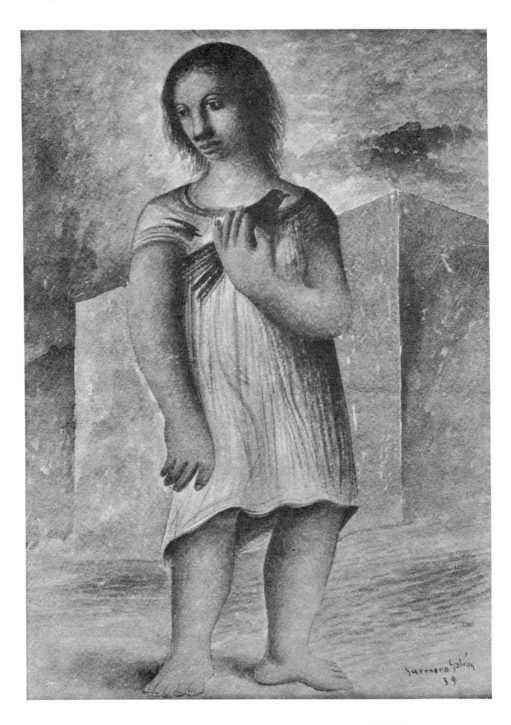

43. GIRL WITH BIRD: A STUDY IN MEXICAN PROPORTION

Water color, 1939. Jesús Guerrero Galván. From the collection of Herman
Shumlin, New York City

spectator have something to do with lines or forms or composition or color. These are the basic materials of the arts which deal with the things that are tangible and malleable, that can be wrought into forms—the plastic arts of painting and sculpture as compared to literature and music.

In discussing the linear aspect of a work of art it is necessary to distinguish between "line" and "lines." Line is essentially the outline of forms. It is not necessarily something which is drawn; frequently it is merely indicated. Some painters draw their designs (with "lines") and fill them with color. In such a case the work is principally linear. Others, like Rouault, draw unmistakable boundary lines between forms or objects, or, like Renoir, simply differentiate their forms by means of color and light.

In fairly flat painting the outlines of figures are sometimes drawn with dark paint, sometimes even with black ink. In round or sculpturesque painting, "line" is an inherent element of contours which are differentiated not by "lines" but by contrasting backgrounds. In other words, the eye does not necessarily demand an actual line of demarcation before it can see where one object leaves off and another begins. Modeling, or merely the modulation of color, may serve to distinguish between forms.

Some painters have used lines as the makers of stained glass use them, to increase the intensity of the vibration of color within the enclosed areas. Cimabue used this device, and Rouault uses it today in exaggerated fashion. However line is employed or indicated, it is of the essence of mature and formal art. Competence in draughtsmanship is a *sine quâ non* of the painter's equipment. At the same time, as Dr. Barnes reminds us, "Line gets power from what it does to what is contained between the lines."

The quality of an indicated line depends upon its expressiveness. Manuel Rodríguez Lozano, a Mexican disciple of Picasso, can draw a line from the top of the head to the fingertips, or from the armpit to the toes, in which every part of the body, in its turn, is adequately expressed. The presence of that quality in a continuous line distinguishes great drawing from casual draughtsmanship.

[ 113 ]

Purity in line-drawing consists in its sure and unfaltering direction, its adequate conveyance of intention. The truth of line does not depend upon its adherence to objective or phenomenal reality. On the contrary, linear distortion is as old as art itself. It is to be found in the art forms of Egypt, the archaic Grecian world and ancient Mexico. True line must obey only the artist's will.

The *form* of a work of art is the sum of the relationships, or the organization, of the parts of the picture. It is a little confusing, perhaps, that the several parts or objects in a painting are likewise called "forms" by the painters, because then the definition of "form" takes on a question-begging aspect: form is the sum of the forms.

I like John D. Graham's definition of a "form" in his *System and Dialectics of Art*: a "consequential mode by means of which an artist authoritatively separates a phenomenon from its setting." Painters very often assemble forms taken from a diversity of settings and give them new and sharper significance in a new setting, in new relationships. Much of the piquancy of Surrealist painting lies in the novelty of relationships between familiar forms.

Forms are likely to be thought of as objects with the appearance of solidity, but it is a mistake to confuse pictorial forms with sculptured forms. The painter must be perfectly free to work within the natural two dimensions of his medium. A plastic form ought rather to be thought of simply as a component part of a picture, functioning as an interesting object in itself and harmoniously related to other forms. Variety in interest is largely determined by the contrasting variety of the several forms. Versatility is attributable to a painter who can exhibit, in a sufficient showing of his work, a variety of forms rather than variations in style. A deliberate variation from a painter's natural style is likely to be merely a *tour de force*.

A painter who is preoccupied with identical forms may end up with a "formula" which will impede his development. The works of El Greco are relatively poor in subject matter—Saint Francis appears in them at least sixty-six times—but there is infinite variety in his forms. Amongst

the Mexican painters there are two or three whose present preoccupations seem to be on the verge of resulting in formulas, but there is no canon for determining just at what moment the forms employed during a given period in a painter's career may be said to have crystallized into a formula. The habitual use of a method of treating forms is a "manner." When a painter has both formula and manner he can be given up for lost.

In considering a plastic composition as a whole, a deliberate painter has probably been concerned with such characteristics of the relationship of forms as proportion, symmetry, asymmetry, and rhythm. Modern painters reject many of the classical canons of proportion and symmetry, of both the several forms and their relationships. In Mexico, for example, there are painters who prefer the usually compressed Maya and Aztec conceptions of human proportions to the seven-heads-to-the-body measurement of the Greeks; just as many painters the world over prefer the sensation of shock generated by asymmetrical designs to the relative restfulness of classical symmetry.

Rhythms occur in repetitions (with variety) of similar forms. The Mexican painter Rufino Tamayo introduced architectural columns to repeat the rhythms of his columnar Tehuantepec women. Francisco Dosamantes, in his invariably rhythmical lithographs, manipulates folds of costume or braided hair into musical patterns.

A particularly absorbing problem in composition is that of ordering the forms on a given surface so that the whole space is interestingly filled. I confess to the idiosyncrasy of being preoccupied, at the moment, with the treatment which painters give to the negative areas of their surfaces, the parts of the picture in which, so to speak, nothing much is going on. It should be the object of the painter to make the negative areas come alive. Representational painters are often neglectful of this element of composition, whereas abstract painters are necessarily conscious of the whole of a given surface. Indeed, it is to the abstract painter, Josef Albers, that I owe my present interest in this aspect of painting.

A picture is not successful in which there is a square inch of dull surface. Some of Degas' celebrated behind-the-scenes oils contain woefully

[ 115 ]

dreary background areas. I have spoken of this weakness in Orozco's earlier frescoes, an infirmity which he has not always overcome save by an overcrowding of forms. In watching the development of Siqueiros' sense of mural pattern, and in observing the amazing progress of a young new painter, Guillermo Meza, I have learned—as painters of course know —how negative areas can be made exciting through variation in textures, vibration of color, and the introduction of transparencies and atmospheric play.

There are many beautiful works of art in which color has not been employed, such as drawings and engravings, black-and-white gouaches and frescoes. But when color is used it must have an integral part in the composition, if only, as in some of Gauguin's pictures, an indispensably decorative part. Color is least likely to have the appearance of necessity when it is simply spread over a drawing. It is easy enough to distinguish this technique when you look at the original painting, but its detection is irresistible in a photograph. In the photographic print the structure of such a picture is likely to be suspiciously too good.

In some of Federico Cantú's drawings color is used very slightly for modeling, the forms being hardly modified by it. Raoul Dufy often slashes a patch of color on his paper and draws forms upon it with pen or brush. These techniques are productive of delightful and sometimes even moving effects. They are not intended for finished masterpieces of art. In truly great painting, color is employed for both drawing and model-ing. One of the finest examples of drawing with paint is found in Renoir's "Les Confidences" in the collection of Dr. Oscar Reinhart, in which it is impossible to detect any point at which "line" is indicated by actual lines. In Mexico, two figure-painters who excel in this mature form of color painting are Federico Cantú, in his oils, and Jesús Guerrero Galván.

This kind of painting, in the long run the most satisfying to most peo-ple, is difficult to reproduce for the reason that both lightness and bright-ness of color, two very different qualities, photograph identically, and so do their opposites, depth of color and shadow or obscurity. From the gray

[ 116 ]

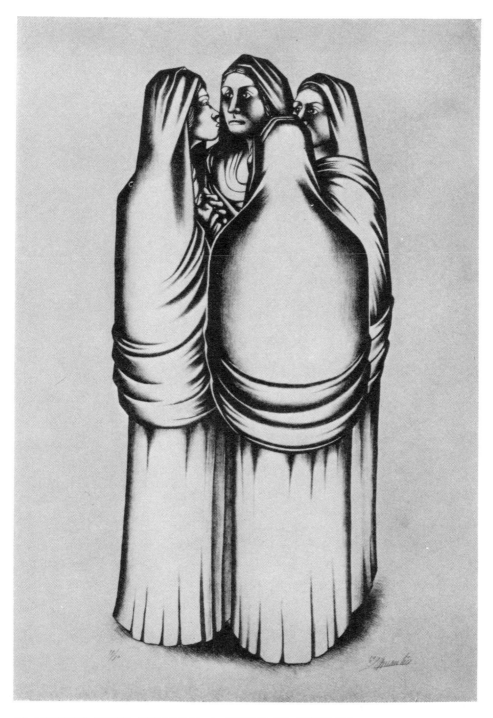

44. WOMEN WITH REBOZOS: A STUDY IN RHYTHM
Lithograph, undated. Francisco Dosamantes. From the author's collection

values of a photograph you cannot tell which areas in the original are light or bright on the one hand, or deep or dark on the other.

There was a fashionable period in the history of painting when color was applied with little attention to line, or deliberately with none. The Impressionists blurred natural line in atmospheric light. It is difficult to get a good idea of a Monet, for example, from a black and white photograph, because the original is essentially a work of color and light. In Mexico there has been very little Impressionistic painting, but there are painters who handle color beautifully and yet show little interest (and sometimes little capacity) in drawing. Tamayo, one of the most celebrated Mexican colorists, does not always produce solid effects in his water colors because of his relative indifference to drawing, as the photographs plainly show; and until quite lately María Izquierdo's works have been valued almost entirely for their rich, varied and thoroughly Mexican color patterns.

In discussing color it is necessary to distinguish between the objective properties of the dried colors as they appear on canvas or paper and the suggestive effects secured by painters in their use of pigment. The spectator may be satisfied when he has trained himself to look for only three objective properties,—value, tone, and intensity. Light and dark and the range between are values; mixtures of color, like blue into green, or blue into yellow are tones; the intensity of color is its purity, its unmixed blueness or redness. These are the terms you will find in the handbooks of the manufacturers of paint, and they are likewise the basic terms of the criticism of art when color is under discussion. Other aspects of color may be introduced into painting by the juxtaposition, contrast and diminution of the several colors. Thus it is correct to speak of the luminosity of color where light is introduced, of low or high key where the general effect is bright, or, on the contrary, obscure. Usually the color patterns are most harmonious when equal values of different colors are used, and when, as in music, the work is executed in a single dominant key. An ascetic palette, in which few colors are used, attains its own beautiful

variety when there is an extensive range of the tones and values of the two or three basic colors.

Two effects which painters look for in applied color are quality and texture. These terms are loosely used, but in the speech of painters, which ought to be the spectator's primary source of understanding, each of these terms has two ordinary connotations. When a painting is said to have "quality," in a general sense, it is usually meant that the colors themselves have such qualities as richness or purity or transparency. But there is also a more technical sense in which painters speak of the quality of a painting or drawing. When Dr. Atl, for example, told me that he had returned to the use of oil paint for the sake of quality he meant that he felt that oil is the best medium for reproducing the qualities of the physical world. He meant that with oils he could produce skies that are more sky-like, trees that are more tree-like and ground that is more earthen.

This use of the term "quality" is confusingly similar to a painter's primary use of the term "texture." Texture in painting is descriptive of surfaces, and perhaps the spectator thinks first of the plastic reproduction of various real or imagined surfaces, as of flesh, or iron, or wood, or fabric. In this sense, a picture is said to be texturally interesting when it contains a variety of textures. But there is also a more abstract use of the term "texture," referring to the look or feel of a painted surface itself, quite apart from any intention to convey a sense of translated textures. The interest which painters feel in surface textures is illustrated in the diversity of technical means employed in modern painting, the use of brushes and knives and fingers and, in extreme form, the pasting of fabrics and papers and threads and the attachment of metallic objects to a painted canvas.

Finally, the spectator looks for unity in every picture, the perfectly harmonious relationship of line, forms and color, organized to endow the work with the crowning excellence of livelihead: not necessarily with physical movement, for stillness may be ultimately more satisfying than motion, but with an interior vitality which suggests that this created thing is instinct with life.

These are the universally cherished contents of the plastic arts. In

45. STILL LIFE: A STUDY IN ORGANIZATION

Oil on canvas, 1937. Rufino Tamayo. From the collection of Mrs. Helen Hall,
New York City

46. WOMAN AND CHILD: A STUDY IN TEXTURES

Water color, 1938. Carlos Orozco Romero. From the collection of Frances
Hammond Helm

Mexico they are subject to local conditioning. That is why it seemed useful to comment upon them here. For example, in the Valley of Mexico, where nearly all the painters live, the atmosphere is uncommonly clear. Natural forms are more substantial than they are in most European countries. This uncommon clarity of line in nature must be expected to have found its reflection in Mexican painting. Mexico also has its own characteristic color patterns, the peculiarity of which only the most painstaking observer can truly reproduce with pigments. Any foreigner can nip into Mexico and paint a picturesque market scene, complete with sombreros, donkeys and bird cages, and yet not produce anything which anybody who knows Mexico will recognize as authentically Mexican. Wholesome and valuable nationalistic art is concerned with more than the immediately visible form, the surface appearance. It discovers and accepts the local variations which time and race and environment have wrought upon the otherwise immutable elements of art.

CHAPTER SEVEN

# Neoclassicism

*Our painters, having departed from the conventional folkloric*
*themes, fully comprehend, it appears, that the subject in itself*
*is of no importance—that the value of a subject is determined*
*by the depth of affection the artist has invested in its definition.*
Guillermo Rivas in *Mexican Life*

I PAID MY FIRST VISIT TO THE
*Galería de Arte Mexicano* in Mexico City
with the express purpose of buying one of
the works of Jesús Guerrero Galván. I had
just seen one in the house of William
Spratling, whose silver shops lend native
dignity to the theatrical town of Taxco. In
fact, I had been scarcely able to look at
anything else in Spratling's not inconsider-
able collection. It was the first Galván can-
vas I had seen, I liked it enormously, and I wanted to own something
like it. Miss Inés Amor, the director of the gallery, had only two Galván
oil paintings to show, at the moment. I took the "Dos Niñas"—Galván's
titles are obdurately unimaginative—because I liked it at first sight. When
I was later able to compare it with photographs of works already dispersed,
and with a few early originals, I found that it had considerable historical

[ 120 ]

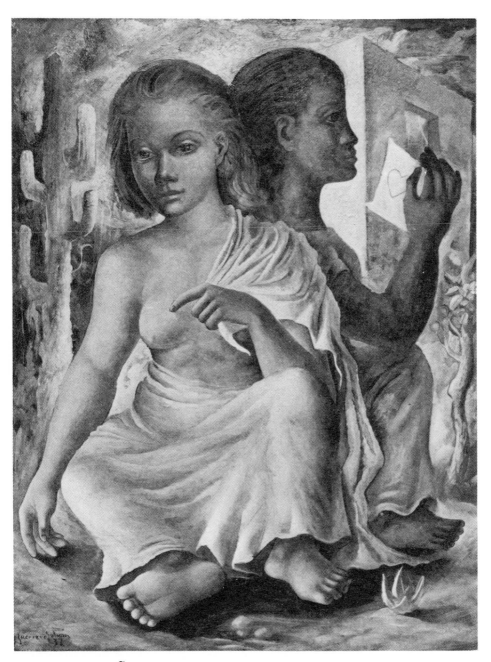

47. LAS DOS NIÑAS

Oil on canvas, 1937. Jesús Guerrero Galván

interest beyond its intrinsic values. A transitional piece of the year 1937, it contains the first traces of the luminous flesh tones which now, since he has come to the attention of a wider public, are invariably associated with Galván. At the same time, the somber qualities of his earlier work have not yet quite disappeared. The other of the two pictures, the "Peasant Children," is now in the Avery Memorial Gallery in Hartford. Miss Amor had set this piece aside, hoping it would one day be purchased for a Mexican Museum of Modern Art, a project which alas! has not been realized. The work is of special interest in that it is Galván's first important oil, a fact of which the gallery will some day be boastful.

Guerrero Galván, who was born in 1910 in Tonalá, in the State of Jalisco, of pure Tarascan stock, looks the very embodiment of the Mexican artist. His refined and sensitive face is thoroughly and nobly Indian; sculpturesque yet mobile. He seems to have been destined from birth to be an artist. At any rate, he began to study art formally when he was only ten years old, and his painting has earned him a living since he was fifteen. His first teacher was a conscientious academician who had been a disciple of Adolphe William Bouguereau, a French painter whose conventional canvases are notable for their surface qualities. When Chucho Galván was still in secondary school he began copying the Zenobias and Venuses of Bouguereau. I have seen some portraits painted when he was ten or twelve years old. Entirely academic in style, they show extraordinary proficiency in draughtsmanship and the handling of pigment. They are rich in color and remarkable for simplicity and linear truthfulness. In short, they are beautifully painted. Galván was born knowing how to handle paint.

When he was about twenty he began to meet other painters in Guadalajara, whence so many Mexican painters have come. He then saw for the first time works of Rivera, Siqueiros and the Jaliscan painters— Orozco, Montenegro and Dr. Atl. He had no means of understanding or judging the new things, but they were sufficiently disturbing to cause him to strike out for himself along lines of which the disciple of Bouguereau could not approve. Galván says that he first saw the heady new art

timidly, but he was encouraged to make his own experiments in modern techniques and design. He has preserved none of those experimental works, but he has shown me photographs of some of them, taken when they were exhibited in the University of Guadalajara in 1932. They appear to have been painfully Mexican in subject matter, but neither very fresh nor original in treatment. The only piece which looked "modern" was a rather flat imitation of Rivera's early mural style.

Emulating Siqueiros and Amado de la Cueva, who had produced some mural fragments in the University art gallery, Galván accepted a commission to paint a wall of his own in one of the University buildings in 1931. Before he could finish the fresco the institution was closed by a student strike, and Galván moved on to Mexico City to try his fortune. There, after two or three further and rather more successful attempts at mural painting in the public schools, he settled down to work alone at his easel, and since 1933 he has been developing his present personal and highly individualistic style, quietly and patiently pursuing his own private objects.

Although there has been change and expansion in his technique since that time, particularly in respect to his use of color, a principle of unity is inherent through the sixty canvases, more or less, which he produced between 1933 and 1940. In the first place, his painting is always poetic. Galván professes no desire to express any particularity or concrete reality of the external world. He sees the world poetically, his attitude toward life and the world is essentially romantic. In his studio, when he shows his new work to friends, the word "poetic" is often on his lips. Only two aspects of painting interest him, the immediate plastic values and the feeling tones. Compared to the muralists, he is a little inclined to talk like a Parnassian; his conscious objects are thoroughly and solely artistic. He is preoccupied with forms and colors and the emotions they give off. He is, I think, hardly aware of the psychological patterns which inform and enhance the undeniably beautiful plastic ordering of his paintings.

Galván has been seriously ill for more of the years of his life than he likes to remember, and he is not entirely rid of his illness now. He is a

[ 122 ]

frail and delicate man whose wasting body burns with professional energy. His native instincts have been refined and spiritualized. Perhaps, from the point of view of his Indian inheritance, he is already on the way to becoming decadent. For so young a painter, he is inordinately interested in the intellectual members of the body, the head and the hands. He admires European facial types and pigmentation. In 1938 he married an ambitious and beautiful fair-haired girl who corresponded to the idealizations of several of his paintings, beginning with the "Dos Niños," and her piquant face and slender figure have appeared in some of his latest pictures. One of these, the "Portrait of Deva," was exhibited at the Golden Gate Exposition in 1939. Deva Galván, who has not long since come with her family from Spain to Mexico, rules vivaciously over a modernistic apartment of her own choice: an apartment by no means incongruously decorated with Galván's collection of objects of Aztec and Tarascan art.

A Mexican poet whom I met in the studio one day said that he thought Galván expressed in his pictures a quality of happiness which he had not personally experienced. For myself, I should describe the psychological state of most of his figures as that of passive tranquillity rather than of active happiness; but there would still remain evidence of psychological conflict between the painter and his works. Undisturbed tranquillity is not a state of mind likely to be induced by Galván's nature, habit of thought or way of life. For all his excessive personal refinement, his grueling efforts, as an artist, to perfect the expression of his ideas of form and color, Galván is still Indian and Mexican. The massive arms and legs of many of his figures are from the Aztec tradition,—they are not, as has been suggested in articles about him, imitative of Picasso's classical period. At many points the claims of his inheritance are in conflict with his acquired predilection for the European culture to which he was introduced in the academic classrooms of Jalisco, and to which marriage and recognition now daily relate him.

Technically, Galván usually knows exactly what he is doing. His plastic effects are deliberate, immaculate, inerrant. Emotionally considered,

his works represent dreams and aspirations whose motivating force is not so amenable to control as the technical processes are. Hence, over and above the solutions of the technical problems which the painter has set himself, there emerge, for the spectator's appreciation (or disparagement), dreamlike and mystical qualities. These have become an intimate part of Galván's personal style, along with his instinctive and cultivated ability to handle paint.

In only two or three paintings are Galván's own dominating feeling states known to have been communicated directly, and not by a process of inversion. During the early months of his wife's pregnancy in 1939 he painted a memorial to his expected son. Originally designed to represent an infant in its mother's womb, the finished work, still called "La Concepción" but actually a study of a clothed child, does not immediately suggest the obstetrical details first present in the painter's mind (although a rose-colored landscape is reminiscent of the preliminary sketches); but there is, in the treatment of a little boy, a quality of tenderness not elsewhere so exquisitely rendered in Galván's painting. It is as though his restless spirit had, in anticipation of tender experience, for the first time come to rest. Even the characteristic plastic values are surer here: rich color and perfected line; substantial form rendered with the profundity and feeling of matchless skill prompted by deep emotion.

That Galván's emotions were directly involved is further intimated by the fact that apart from this single distinguished work he did not produce, for the space of several months, anything of any particular importance. On the contrary, having summed up a phase of human experience in one notable work of art, he painted, in a state of nervous anxiety, a few perfunctory water colors not at all worthy of his gifts.

A Mexican sculptor has described the people in Galván's pictures as being animated by, and enclosed in, profound reflections of the internal world. I repeated this observation to a young painter, an unrecognized disciple of the Dr. Atl school of landscape painting, who replied that Galván's effects could easily be secured by the application of caramel syrup. Now this young man has not, like Galván, achieved any degree of

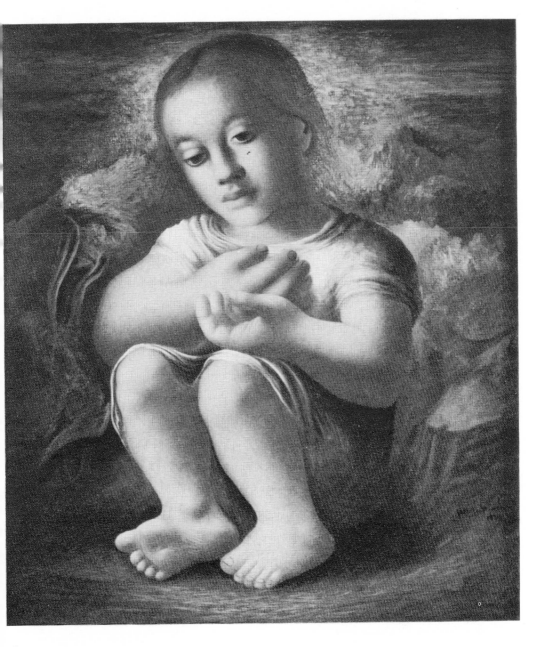

48. LA CONCEPCION

Oil on canvas, 1939. Jesús Guerrero Galván

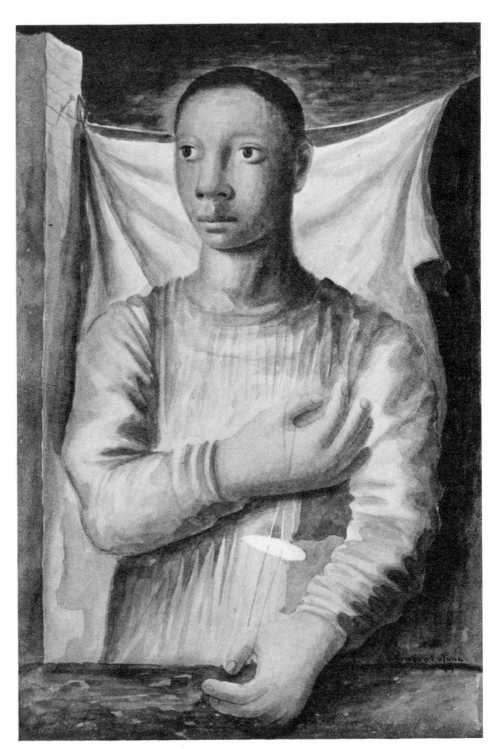

49. EL ZUMBADOR
 Water color, 1939. Jesús Guerrero Galván. From a private collection

success, has not yet found a collecting public (I will not say why I think he has not, I merely preserve his anonymity) and therefore may be convicted of crying sour grapes. Still, ever since Cézanne began to dominate artistic minds there has been a tendency to depreciate virtuosity. The American painter Olin Dows has described this aversion as resulting from a complete misunderstanding of Cézanne, but the phenomenon is recurrent. Galván is a virtuoso, as Rubens and Raphael were virtuosos, and has had to bear the dispraise of people who do not share his interest in the technical excellencies of the pre-Cézanne tradition.

The preciosity of this kind of criticism disturbs neither Galván nor his admirers. A much more serious confession that I am bound to make is that there are quite a few people in Mexico who fear that he has found a fomula which, for all his virtuosity, is likely to spoil him. Now it is true that it is easy to recognize, in subject matter and treatment, anything Galván has painted since 1933; but it is a nice question whether competent observers are likely to be fascinated by the individuality of his works or put off by the evidences of a formula which, according to certain critics, has made them successful and salable. For the reason that there has undeniably been a fine and strong development of form and color over a period of seven years it cannot be said, at any rate, that Galván has been working on the basis of some glib and invariable formula.

Since 1937 his textures have become more and more diverse and truthful, his colors more transparent, his atmospheric effects lighter, his skin-characters more translucent. All of these things indicate steady growth, an increasing mastery of plastic resources. And for two additional reasons I think it is not quite fair, at this early date, to rebuke Galván with the criticism that he is already lost in a formula and a manner: his more or less "straight" portrait style will probably check the excesses of his appeal to ancient Mexican art in the imaginative figure studies; and his water-color technique may be counted on to influence his oil painting in the direction of flexibility, without the loss of lucidity.

Still, I am willing to agree with a friend of mine, himself one of the

best Mexican painters and an admirer of Galván's work, that he has come upon a dangerous period. It was a little discouraging to his friends when he produced almost simultaneously, at the end of 1939, one of his freest, most natural portraits, and, as one of two figures in a large canvas shown in the "Twenty Centuries" exhibition in New York, a rather wooden little girl, all massive arms and legs, who dated back, in style, to 1936. The better piece, the "Portrait of Sheila," now in the collection of Mr. and Mrs. Henry M. Winter of New York, is a sensitive study of a contemporary young woman (actually another Deva) with flowing hair of rich tones of brown into pink. Set against a background vibrant with an infinite variety of values and tones of blue, she wears a loosely-wrapped shawl of the deepest reds Galván has yet produced. The face still shows traces of the painter's romantic attachment to the Italians, particularly in the high lights, but the features, broadly speaking, are wrought in Mexican terms; and the otherworldliness of the drawing and the mystical expressiveness of the portrait are uniquely the artist's own. It is precisely because this little masterpiece is so satisfying that one is disturbed to discover that Galván could, at about the same time, have struck several years off the course of his development to produce another of his stereotyped little girls.

I have intimated that Galván's pictures do not go begging. Although he has not yet joined the procession of successful Mexican painters to New York, his work has been shown in group exhibitions and one-man shows in both North and South America. Several canvases have found their way into important public galleries, but a few private collectors who have had an opportunity to follow the course of his career have so far acquired most of his works. A reproduction of another American-owned Galván, from the collection of Mr. and Mrs. R. D. Cahall of Gambier, Ohio, may be seen in the summer 1940 number of the enterprising *Kenyon Review*.

Since Galván paints slowly, producing no more than eight or ten canvases a year, besides the occasional freely rendered water colors, the

picture market is not likely soon to become glutted with the work of this new young master.

It was, I think, on my second visit to Miss Amor's gallery that I first saw the work of Federico Cantú, who had at that time left a fairly comprehensive collection of paintings and drawings there. He was not then quite established, as he has since become, in art circles in New York.

I first chose for myself one of his small, rare landscapes, a Barbizonesque piece painted early in 1938. It looked as though it had been taken from the French, not the Mexican countryside. Except during the dust storms of February and March —

*febrero loco*
*marzo otro poco—*

the Barbizon techniques would hardly be suitable for recording the Mexican landscape with its usually clear forms and sharp atmosphere. Cantú has lived a number of years in France, and Mexican critics have often compared his landscapes to Corot's; but they seem to me to be bolder and stronger than the French painter's. They have romantic quality and elusive tones, to be sure, but they do not quite shimmer off the canvas.

In the United States Cantú has become more generally known for his washed drawings, his monotypes, and the figure studies and portraits in oil. The drawings prove him to be as much a master of line as any of his contemporaries. When you look at them—unfortunately there are not many—it is easy to nod and say "Picasso." When I showed two or three of them to Diego Rivera he said, "Cantú is Picasso *para los pobres*,"— for the poor. Perhaps they do suggest the Picasso of the harlequins, although I should think that it is mood rather than line which recalls Picasso. The line is intensely personal.

The drawing that I wanted most was made in black ink and washed in faded, grayish-green water color. It shows a young man pulling a cork out of a bottle. He wears an absurd tall hat and a shirt buttoned with two buttons. He is barefooted and sits on a box. The piece could hardly

be simpler, or yet more movingly drawn. But it was not for sale. It was, Miss Amor said, probably the only thing in the gallery not offered for sale. I suppose that, being thwarted, I wanted it then more than anything else the gallery contained. Six months later it hung on the walls of my house in one of the *Calles de Liverpool*,—but not because I had been able to buy it. Miss Amor gave it to me for my birthday. Some day she may have to settle with Cantú, an ordinarily pleasant man who gave it to her, but now it is mine, and I cannot think of anything for which I would willingly exchange it. I have only a brace of Picasso drawings myself, but if I were called upon to sacrifice something from my portfolio for my country I think I should give up one of these before I would part with the man with the corkscrew.

Most of the painters and critics of Mexico concede that Cantú is one of the most accomplished painters of his generation. It may be that until he came home from Europe he was more sensitive to foreign influences than a mature painter should be, but now he is entering into his maturity with an unmistakably personal style. He is no longer under the spell of any European contemporary; although he is thoroughly modern in his handling of paint, his ultimate sources belong to an older tradition. Here and there in his forms are to be found mediated glimpses of El Greco and the Pre-Raphaelites, and of Botticelli in mood and finish. Like Galván, Cantú went through a period of absorption in Italian painting. Galván's spiritual ancestor happened to be Leonardo da Vinci, whose treatment of masses was weighty, as in the ancient Mexican plastic tradition; while Cantú's Italianism, derived from Botticelli, has produced more buoyant forms and lighter moods.

Cantú's typical figure piece in oil is a finely painted nude set against an interesting and colorful background. Sometimes his models are translated naturally, without distortion and in relaxed positions. At other times they come out highly mannered, with pillared necks after Dante Gabriel Rossetti; exaggerated breasts, wide thighs and tapered arms and legs.

In 1938 a discerning American woman stopped on in Mexico beyond

[ 128 ]

50. EL DESTAPADOR

Ink drawing with water color, 1935. Federico Cantú

51. SACRED AND PROFANE LOVE

Oil on canvas, 1937. Federico Cantú. From a private collection

the conventional ten days in order to sit to Cantú for her portrait. When the work was exhibited at home some of her family and friends wanted to be painted too, with the result that the portraitist had a sufficient number of commissions to keep him busy in the United States for some months. The portraits, perhaps, are more "modern" than the studies, in that while they are polished and fastidious, they are looser and convey less of virtuosity.

Choice examples of the whole range of Cantú's work were assembled by Miss Margaret Ruth McKinlay for a Mexican show at R. H. Macy's New York store in the early summer of 1940, one of the very few comprehensive collections of Mexican art of high quality ever exhibited in the United States. There I counted five stylistic variations, running from the drawings through the monotypes, into the three types of handling in the oils: landscapes, figure pieces and straight portraiture,—a sufficient demonstration of a painter's versatility. The first adequate exhibition of Cantú's paintings had been made in New York only a year earlier, at the Charles Morgan galleries. At that time the influence of El Greco was noted here and there in the press, "El Greco" being at the moment the reportorial shorthand symbol for distortion. At the same time, most of the metropolitan critics were quick to detect many elements of individuality both of theme and technique. Cantú, almost alone amongst the younger Mexicans, makes an occasional excursion into the religious tradition. New York saw at that time such pieces as his "Annunciation," a design which is at once elegant and warmly human; and his "Last Supper," into which he had introduced (perhaps from another Gospel supper) some attendant women. In the Swedish legation in Mexico City there hangs a Cantú "Crucifixion" which in both drawing and lighting is reminiscent of El Greco, although the flesh characters are Cantú's own.

Since Cantú does not seem to require immediate inspiration from the Mexican scene, and is more interested in paint than in subject matter, he has taken up his residence in New York. It is hardly likely that his long absence from home will do him any particular harm. At any rate, since he is only thirty-two years old, he has plenty of time to try to adapt

himself to a foreign *milieu* before he returns to settle down in his native land.

In the early days of the Mexican revival two painters went out from Mexico City to paint the provincial scene, remote from the passing phases of political intrigue and artistic revolution: Manuel Rodríguez Lozano, who was then in his early twenties, and his young pupil, Abraham Angel, still in his teens. It is easy to understand why Lozano took no part in the mural movement in the capital. He was temperamentally ill-suited for friendship with Diego Rivera. Each was contemptuous of the private life as well as the aesthetic objects of the other. There are many indications that Lozano, for his part, felt antagonistic to his older contemporary from the beginning of Rivera's assumption of leadership of the mural movement. He announced, upon the completion of Diego's Italianate golden encaustic in the Preparatory School, that Rivera was a corruptor of art. He was, like other painters who had begun to experiment with local color while Rivera was abroad, resentful of the returning exile's widely publicized "discovery" of Mexico. For a time he became more deliberately Mexican in protest against Rivera's artificial Mexicanism.

Like the sons of all good Mexican families of former days, Rodríguez Lozano went early to Europe. In France in 1914, under the influence of the Paris school, he made a solemn profession of art. Like Dr. Atl, he had never worked in the Academy at home. Now that the old Academy of San Carlos is the University School of Plastic Arts he is, in his turn, its director, an office which he administers with fresh distinction: although people say that his pupils come out like so many little Lozanos. The painter himself, in his Paris days, especially admired Picasso, who took the pains to explain to him his intention to destroy painting in order to produce an entirely new creation. Rodríguez Lozano is by no means a crude imitator of Picasso, but it is obvious that the Spaniard has influenced his work profoundly, particularly in the basic and disciplinary field of draughtsmanship. Although his drawings are unpretentious and have been infrequently exhibited, they are as remarkable for beauty of line as

[ 130 ]

52. SELF-PORTRAIT

Oil on canvas, 1938. Federico Cantú. By permission of the Galería de Arte
Mexicano, Mexico City

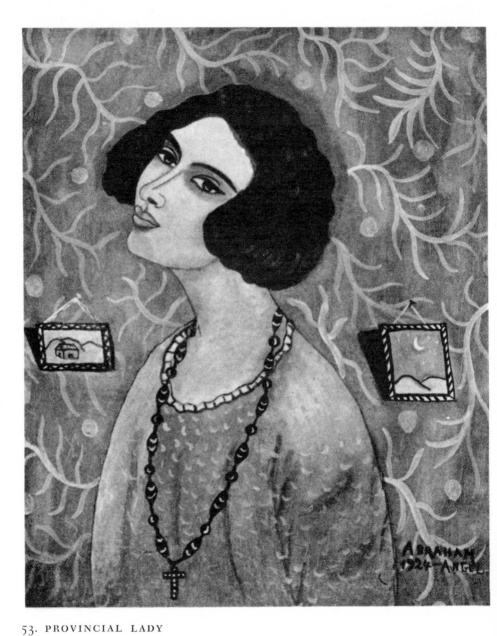

53. PROVINCIAL LADY

Tempera on board, 1924. Abraham Angel. By permission of the Galería de Arte Mexicano, Mexico City

anything to be seen in Mexico today. There is also a slight suggestion of Picasso's Classical period in certain monumental figures in some of Lozano's recent canvases, although the Mexican artist's women are Mexican in type and are painted in somber colors,—browns, grays and grayish greens, instead of Picasso's icy pinks. They are more severe than Picasso's women, and drawn, perhaps, with less emotion, but they are comparable to their Parisian sisters in simplicity and purity of line.

After wandering about in Europe for five or six years Lozano went home to paint. In the ateliers of Paris he had learned more about life than about painting. Unlike Rivera, who worked hard in Europe, Lozano was scarcely able to work at all. He liked Bohemian manners, but he missed the light, the climate, the atmosphere of Mexico. Perhaps his latest imaginative work, a series of studies of nudes at the seaside, would not be immediately recognized, in a foreign country, as particularly Mexican, but Lozano is thoroughly at home in his own country. It may be that he has translated factual colors into a color idiom of his own, but his work remains more Mexican in feeling than Cantú's, for example, ever was.

Upon his return from Europe, along with Montenegro and Adolfo Best Maugard, and somewhat earlier than Rivera, Lozano went straightway into the highways and byways of Mexican life in search of popular motifs. Abraham Angel, who as a boy of fifteen was one of Best Maugard's staff of experimental teachers, joined him. These two painters, together with Rufino Tamayo and Julio Castellanos, and another small group of artists who painted independently in faraway Aguascalientes, were, after Dr. Atl, the real pioneers of the Mexican movement. They were painting Mexico when Rivera fixed stars in the deep blue sky of his Italian allegory and Orozco composed his nude Madonna.

In 1922 and 1923 Lozano and Angel interpreted provincial life according to a simple model conceived first of all by the younger painter. In these works there are no picturesque peons in *huaraches*, white cotton pantaloons and convenient face-obscuring sombreros. Instead, there are unaffected and sympathetic portraits of comely village girls and their

sweethearts, provincial young people in European dress—although not uncommonly barefoot—set in landscapes or chambers unmistakably Mexican in design and color. The subjects are as far removed as possible from the innumerable stolid, indistinguishable (and undistinguished) Indians painted by adherents of the Rivera school. When the provincial idyl was over, Lozano returned to the classical style to which by nature he had originally been attracted. Abraham Angel, who finished only a few of his simple and persuasive canvases, died before he was twenty. His touching picture, "The Betrothed," from the collection of Miguel Covarrubias, was faithfully reproduced in *Vogue,* June 15, 1940.

From 1920 to 1929 Lozano painted principally on cardboard, hence he refers to that era as his Cartoon period. At that time he used bright colors from a wide palette. Most of the work of the next few years, a period of transition, consisted of a group of seventeen small paintings which hang in consecutive panels in the town house of Señor Francisco Sergio Iturbe in Mexico City. The theme of this series, mortality, as old a subject as the history of Mexican art, is taken from one of Señor Iturbe's poems. In a frieze running across the walls above the panels is the quotation: "Elle est morte un jour d'été près de l'hiver. Elle est morte quand les feuilles tombaient et à l'horizon le soleil se levait. Que la lumière l'éclaire maintenant qu'elle est partie pour toujours."

The first nine panels, some of them painted in the bright unmixed colors of *retablos,* some in contrasting monotones, show chambers of death. Little quivering figures gather about the bodies of the dead. A second series of seven paintings compares in detail the degrees of pessimistic impassivity achieved by the Indian mourners. These pieces are in no way morbid. They are simply impersonal, as impersonal as death itself.

Since 1933 Lozano has been painting and drawing in a style that may definitely be called classical. In the drawings his line carefully records both color and depth, and differentiates between bone and flesh, between wrist and thigh, all with the most subtle simplicity. He has drawn a series of bullfighting nudes in which he has reduced to their meagerest essence

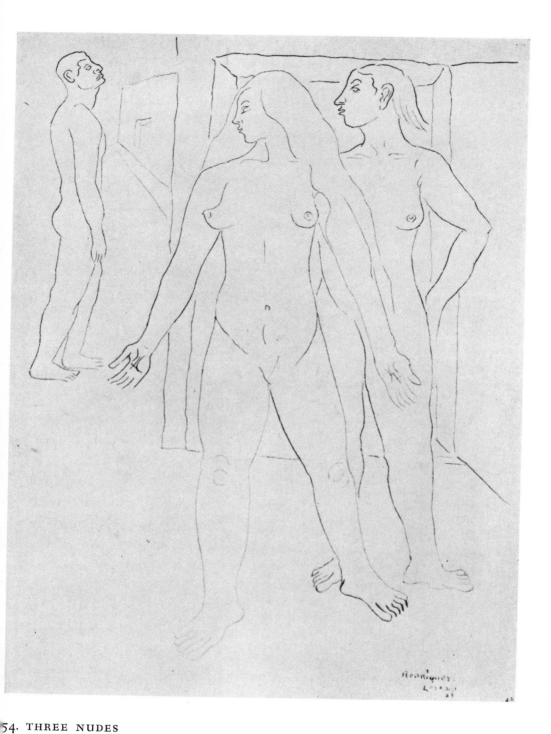

54. THREE NUDES

Ink drawing, 1937. Manuel Rodríguez Lozano. From the painter's
collection

55. PORTRAIT OF A PAINTER

Oil on canvas, undated. Manuel Rodríguez Lozano. From the painter's collection

the traditional forms of the bull ring. There are also some rhythmical and rather exotic drawings of young men and mature women, in vertical designs reminiscent of Etruscan friezes.

Lozano is much in demand in Mexico as a portrait painter, and for good reason. His portraits are uncomplicated transliterations of personality, simply and interestingly designed, studiously painted, and arresting in their color patterns. Of the purely decorative paintings there have been two series within the last two or three years. The immense canvases of the first are designed with monumental figures painted in the colors of fresco. They are intended to be let into walls, to function architecturally. The smaller panels of the second series show stylistically composed groups of nudes by the seaside. These figures, which are only slightly modeled, are painted with soft pastel colors taken from Lozano's increasingly ascetic palette.

Lozano lives in a commodious apartment containing an impressive succession of tall, sunny, freshly scrubbed rooms, decorated, save for a drawing which Picasso gave him, and a few neatly framed photographs of friends, with the work of his own hands. There I have spent many hypnotic moments in the presence of unhurried men and lovely women who, on their quiet canvases, wander naked and dreaming through an enchanted world.

Working (when he works) in Lozano's studio, there is a painter who has attracted attention in Mexico rather for the finished quality of his productions, particularly his drawings, than for its all too slender quantity. He is a youth who, since he became a protégé of Lozano, has called himself Tebo. Born in Mexico City in 1912, the son of a Nahua Indian peon who went to the capital from Querétaro during the Revolution, and baptized with the name Angel Torres Jaramillo, he took a pseudonym which does not, like Dr. Atl's, mean anything. It is, however, easy to remember, and serves a certain useful purpose in that it invites inquiries.

When Tebo was twelve years old his father, no longer able to give him the kind of clothing he required for school even in a squalid neighbor-

hood, sent him to work on a farm on the outskirts of the city. After a few years of farming he went to Lozano's studio as a *mozo*, an errand boy and helper. When he first shyly reported to his family that he had begun to paint, their only interest was in knowing whether he would make as much money as he had made in the fields. To this day they think he is a little *loco*.

Lozano, a born teacher, could not rest until Tebo began to draw and paint. Tebo told me—and I was reminded of Rivera at the feet of Velasco—that Lozano taught him that observation is the beginning of the artist's work, and annotated observation, with brush or pencil, the artist's culture. Lozano persuaded his pupil to look for differences as well as likenesses amongst men. He encouraged him in what seemed to be a natural style of slow and painstaking drawing and painting. At length, in 1937, Lozano wrote in *Letras de México* that he thought Tebo was as gifted a painter as Dalí. He said he would not be afraid to compare him, as an analytic painter, to many a great Dutch artist; although he recognized that the qualities of repose and equilibrium which distinguish Tebo's art are purely Indian. Thus was Tebo launched upon the world. Then something happened. Within a few months his impulse seemed to peter out.

I felt the greatest curiosity about this young man when I met him, saw some of his drawings, and heard something of his story. I knew that he had received practically no formal education, and I knew also that in the twelve years he had lived and worked in Lozano's studio he had produced drawings which Renoir would not have been ashamed to sign. I could not understand how this gift had developed in the first place, nor how, having matured so slowly, it should so soon have begun to fail. For a long time I seemed to be unable to have any satisfying talk with him. I was not sure whether he was reticent or simply inarticulate. Then one night, after a casual meeting in the street and a visit to the cinema, we returned together to my study for sandwiches and a bottle of claret. In the quiet of the night he talked as I had not believed he could talk: about his bleak boyhood, his efforts later in the city to develop his interior

[ 134 ]

### 56a. NUDE STUDY

Pencil drawing, 1934. Tebo. From the author's collection

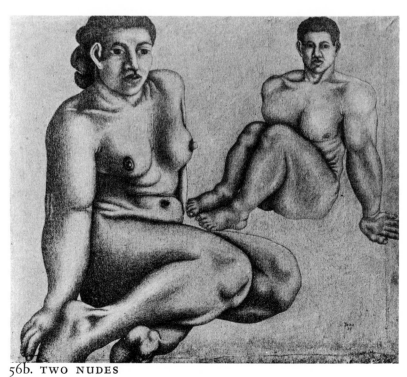

### 56b. TWO NUDES

Oil on canvas, 1934. Tebo. From a private collection

life. He told me about tensions which had developed during secret attempts to live now according to the wisdom of Socrates, and now according to the teaching of Christ. Like an older Mexican mystic, Francisco Goitia, he has had impulses to cultivate the life of the spirit. He has tried, he said, to reproduce in his representations of the exterior world some suggestion of the spiritual universe which, according to his perceptions, animates the world we see. Altogether, it was an absorbing story of the self-cultivation of natural sensibility.

I asked him what books he had been reading. It appeared that he had read practically nothing at all. I asked him why he had produced so little. He said that he had felt obliged to take time to repair, by study, the deficiencies of his intellectual development, and explained that he is at best, by nature, a laborious workman. But I could not help feeling, in the end, that like the long silent Goitia, Tebo has a native disinclination to work beyond the need of bread and shelter. Indian mysticism is akin to idle daydreaming. The need for interior satisfactions is not so continuously pressing as to create professional attitudes toward work.

Sometimes Tebo seemed to be a little like one of the entranced young men in a Lozano canvas. Before he can live and act in response to the genius that is undeniably in him he must be raised from his sleep.

# CHAPTER EIGHT

# Mexicanism

*Tonehuiztica tipano*
*ipan inin Tlalticpactli,*
*nochi tlami nochi pano*
*que mextli ca ilhuicactli.*

*In this life Fate gives us*
*Bitterness for bread.*
*All delight, all sweetness*
*Die when we are dead.*
From some verses in the Nahuatl language
by Enrique Villamil

AMONGST THE YOUNGER Mexican painters who discovered, when Rivera returned from Europe, that he was not the man to lead the kind of revolution they had dreamed about, were Rufino Tamayo, Agustín Lazo, and Julio Castellanos. Tamayo, the most candid member of the group, insisted that nothing was so important to a Mexican painter as the bona fide Mexican plastic tradition. Subject, he said, scarcely mattered. Indeed, he thought it would be a good thing to univer-

salize Mexican aesthetics by treating a diversity of subjects, both local and foreign. He was critical of Rivera for ignoring the interior culture of Mexico, the tradition handed down from ancient times, in favor of a superficial and exterior view of the national scene.

The young men who had inherited or achieved some degree of urbanity resented Rivera's representation of Mexico as being, however colorful, still a semi-barbarous State. The charges they made against him early in the twenties were sufficiently devastating. They said he was un-Mexican, old-fashioned, and picturesquely untruthful about contemporary life. They accused him of turning revolutionary painting into a political and journalistic exercise. Political or journalistic painting, academically rendered, was simply more than they could bear.

Rufino Tamayo, the leader of the anti-Rivera forces, was born in Oaxaca in 1900 of a Zapotecan Indian family. When his parents died in 1907 he was adopted by an aunt who kept a fuel and fruit shop in Mexico City. When the aunt discovered that Rufino was slyly spending a good deal of his time in evening art classes, she withdrew him from school and put him to work as a delivery boy. She promised to make a good prosperous Catholic business man out of him. Terrorized by the thought of being either a good Catholic or a man of affairs, he continued to work surreptitiously at his true vocation. As soon as he was able to support himself, however meanly, he gave up his aunt and her business and her Church as well. There followed long, formative days amongst the archaeological treasures of the National Museum, wherein are hoarded many of the shapes and forms upon which Tamayo's early designs were based.

In 1926 Tamayo held his first exhibition in a vacant shop in the Avenida Madero in Mexico City, and in the same year exhibited oils, water colors, drawings and woodcuts at the Weyhe Galleries in New York. When he went to New York to deliver his pictures he saw things he had not dreamed of. He had encountered modern French painting only in books, in half-tone reproductions. He felt an immediate attraction to the French masters and wanted more than ever to see Mexican painting take on universal qualities. In some of the oils of that time, the first

[ 137 ]

Dark period, he had already experimented with universal forms, but the water colors, upon which Tamayo's reputation has largely been based, still generally lay well within the Mexican frontiers. At the same time, he insisted that he did not want, as he was presently accused, to make Mexican painting French.

A year later he took new pictures to the Art Centre in New York. The reviewers offended him. Some of them spoke of the influence of Rivera and Charlot upon him,—probably because those were the names they knew best at that time. Today there are American writers who can look at Mexican art without detecting the hand of Rivera, but in those days it seems to have been a mark of erudition to have had a bowing acquaintance with any Mexican painter. Tamayo was further annoyed because others called him a primitive, whereas he was trying desperately to be sophisticated. On the other hand, he was pleased by the comparative absence of detection of influences from Europe.

Tamayo's first Bright period was inaugurated in 1929 at a new gallery, the *Galería de Arte Moderno*, under the direction of the painters Carlos Mérida and Carlos Orozco Romero. There were still-lifes, landscapes and some figure studies, all of them with a new poetic quality and yet not literary. Mexican critics compared Tamayo with Braque, but one of them wrote that his work conveyed a *"mexicanismo amplio y universal."* That is to say, it was recognized that he had begun to free himself from the limitations of ethnical traditions without losing his racial characteristics and techniques.

Other exhibitions of the new period were held in New York and San Francisco. At the Levy Gallery in New York in 1931 Tamayo was shown in interesting contrast to Joaquín Clausel, an older Mexican painter, French-trained, a pupil of Pissarro. John Levy wrote in the catalogue that the peculiar qualities of Mexican art were present in Tamayo's work, particularly in his colors,—Tamayo was then using earth-reds, dull greens, purple and chrome yellow—and curiously absent from Clausel's. Clausel, of course, had painted the Valley of Mexico to look untruthfully like the Valley of the Loire. Henry McBride, who later became one of

57. TEHUANAS

Oil on canvas, 1938. Rufino Tamayo

Tamayo's warmest supporters, at that time complained that his painting was farther from life than Rivera's and Orozco's: a criticism which, even if it had been accurate, would have been quite beside the point.

Tamayo's early experiences with criticism are fairly characteristic of the disabilities the young Mexican painters had to put up with for some years because they were neither Orozco nor Rivera. But better times were ahead. In 1935 the people of San Francisco were informed that not all Mexican painting was journalistic. Glenn Wessels was the astute vehicle of this information, upon the occasion of the showing of the last water colors and gouaches from Tamayo's first Bright period, at the Paul Elder Gallery. These works more nearly realized the painter's aesthetic conceptions than anything he had done. They were painted with complete technical freedom, out of pure delight in plastic expression. They were detached in mood, contained only pictorial ideas, and were rhythmical and lively. A reporter from the San Francisco *News* caustically made a present of Tamayo to the Surrealists. That this writer had missed the boat was ably pointed out by Ralph Flint in the New York *Sun*, when Tamayo had an exhibition immediately after Dalí in the Julian Levy Gallery. Tamayo had a flirtation with Cubism for a time, but he has never gone in for Surrealism.

At an exhibition in Mexico City commemorating the tenth anniversary of his first Mexican show, Tamayo was finally received as a mature artist who had amply illustrated his theory of Mexican art. For forms he had gone to the sources of the Mexican tradition; for color he had gone to the Mexican people. He had observed what colors the Indian women use in their dress, with what colors men paint their houses. These were the colors he used on his palette, with correspondingly diminishing range.

It is perhaps difficult for Americans to understand Tamayo's increasing asceticism in the use of pigment. Coming almost invariably from drab and dirty and colorless surroundings, American visitors to Mexico are struck by the lavish color of the South. But the fact is, that while there is an abundance of color wherever the eye comes to rest, the palette, so

to speak, in any given area (if we except the natural landscape and planted gardens) is delicately—and traditionally—restricted.

Out in the country the women of any region conservatively dress very much alike, within a traditionally narrow range of color. In one place they may choose between black or red for their skirts; in another, between blue or black. For their *rebozos*, or shawls, they are permitted freedom in fabrics, not in color. In the towns most women wear only black. The *sarapes* which the Indian men wear over their white cotton tunics or carry over their shoulders are woven according to a traditional color scheme. The houses in most small pueblos are of either unpainted adobe or plain whitewashed surface. In the larger towns there is little range of hue in the streets beyond light blue, pale pink and tan.

Now Tamayo, better than any painter I know, has made his later paintings correspond to this very subtle actuality. He can mix as many colors as you like in the course of painting a series of twenty gouaches or water colors, but only four or five, and sometimes only two or three,—freely ranging in values, to be sure—appear in a single picture. It is for this reason, as well as for the universally acclaimed quality of his color, that I believe Tamayo is one of the two or three greatest colorists in Mexico.

There are many ideas in the whole complex of Tamayo's theory of Mexican plastic art, of which, after color, the most significant are his notions of proportion and atmosphere. Greek proportion does not work in Mexico. Not only is it sculpturally wrong, but what is worse, it is psychologically wrong. Michelangelo discovered that Greek proportion was not artistically true. El Greco greatly distorted and exaggerated anatomical forms for emotional effect, if not in the interest of psychological truth. So in the ancient cultures of Mexico—the northern kingdom of the Mayas seems to be the only exception—proportion was psychologically as well as scientifically estimated. The truly Mexican painter is therefore likely to learn proportion not from Greek art but from Mexican archaeology.

Tamayo again is typically Mexican in sensing the profound tragedy of the atmosphere of his country. A few painters, like Antonio Ruiz and María Izquierdo, think that the tragic character of Mexican life, if it has

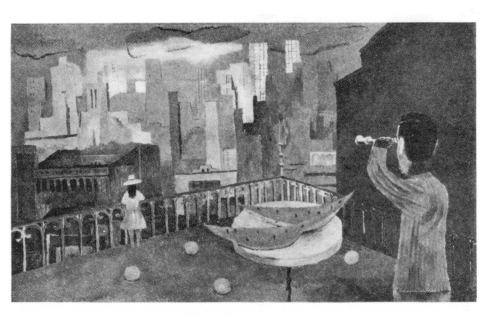

58a. NEW YORK FROM A TERRACE

Oil on canvas, 1938. Rufino Tamayo

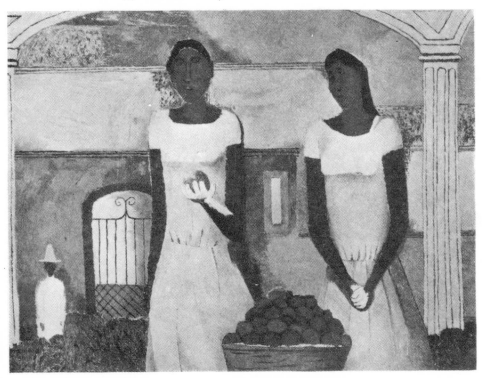

58b. THE FRUIT SELLERS

Oil on canvas, 1938. Rufino Tamayo. From the painter's collection

not been exaggerated, has at least, in its transmutation into paint, dimmed the comic balance; but if a painter feels that the tragedy of Mexico has been heightened to the point of obscuring the comedy, he will choose the subjects which match his perceptions. So it is that Gabriel Fernández Ledesma's most mature painting is most somber. So it is that Tamayo is not content to paint bright and beautiful landscapes.

Dr. Atl has been painting pleasant *paisajes* all his life, but it might be observed that they are not particularly Mexican. Popocatépetl, either in color or in black and white, unless it is projected between the leaves of a cactus plant, could equally well be in Alaska, Japan or Switzerland. It is significant that there have been no Atl disciples who have produced anything with Mexican qualities. It is the people of Mexico who furnish the peculiar elements of the atmosphere of the country, so that if a painter is going to use Mexican subjects at all, as well as Mexican technique, it will be the people, in their activities and in their natural surroundings, that he will be obliged to paint. Most of these activities are melancholy, most of the settings are sad. All of which authentic conceptions began to be richly wrought into Tamayo's painting in the 1930's.

Naturally enough, the refinement of Tamayo's techniques has not given invariable pleasure. Ralph Flint wrote in the *Sun* in January, 1937, concerning some of Tamayo's monochrome designs, that "there were just enough color accents to keep them from fading out." On the other hand, Henry McBride said that Tamayo was more subtle and natural in the use of color than Rivera and Orozco: those heavenly poles again, the Arctic and Antarctic of criticism. He was enthusiastic enough to rank Tamayo aesthetically at the top of the whole group of Mexican painters, a judgment in which a correspondent of *Art Fronts* agreed. By this time Tamayo was in the middle of his second Dark period, using burnt black, acid yellows, grays, red-browns and blue-whites.

Some of Tamayo's best oils are still-lifes, and practically all of these are compounded of Mexican objects and familiar European still-life forms: bananas and pineapples and watermelons combined with alarm clocks, banjos and striped table cloths. The best water colors are the studies of the strong, still women of Oaxaca.

Tamayo has recently said that in his newest pictures, shown by his New York dealer, Valentine, in 1940 and late in 1939, he thought he had found his most personal colors and designs. A new Light period seems to have developed: psychologically, perhaps, rather than deliberately. The color is light; incisive without being bright. The palette is restricted to three or four colors, with their tones and combinations. The subjects are simple, amazingly simple when compared to the big organizations of the first Levy exhibition. There is less of caprice and brittle sophistication than in previous Valentine exhibitions of tree and figure pieces, of ice-cream cones and liquor bottles. This vehement young painter has disciplined himself through rigorously ascetic practice. He has, in a phrase of the Spanish painter José Moreno Villa, "bound the fire."

The future of Tamayo will be related very nearly to his passion for New York, where he spends a large part of each year, teaching in the Dalton school. He has offended old friends in Mexico by telling them that his most intimate companions now are in New York. Several years ago he received a commission to do important murals for the entrance to the patio of the National Museum, but since that time he has not been in Mexico long enough to finish them. A certain want of tact having alienated some of Tamayo's friends amongst the painters and in the government, there is no doubt that much of the sharp criticism of his work in Mexico (not that it has spoiled his sales) has been inspired by feelings generated by matters irrelevant to his painting.

More serious than the effect upon his social and professional position in Mexico is the influence that long absence from his own country is bound to have upon his art. He paints uneasily in New York.

"Tamayo is a welcome visitor to New York," Henry McBride wrote not long ago, "but for his own sake he must not stay too long. A singer never quite becomes eloquent when celebrating other people's possessions."

Of the two most distinguished women painters in Mexico, María Izquierdo and Frida Kahlo, the former is the more deliberately and ob-

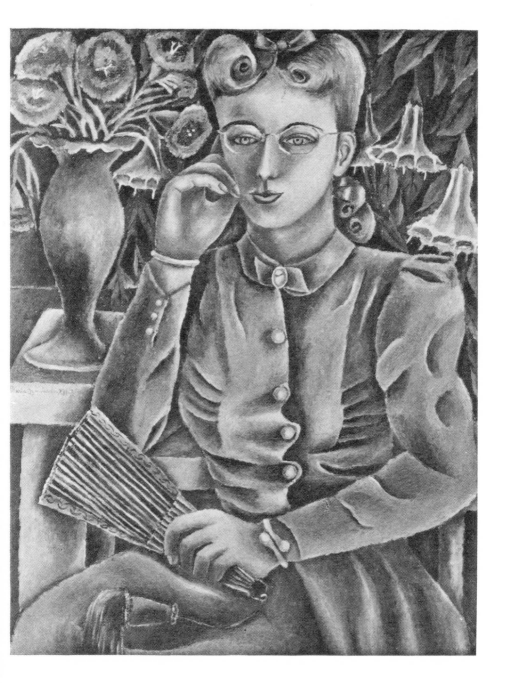

59. PORTRAIT OF CATHIE
Oil on canvas, 1940. María Izquierdo

jectively devoted to *mexicanismo*. Frida Kahlo was a city girl, María Izquierdo grew up in the provinces. María remembers her childhood as a kind of diurnal penance of six o'clock Masses and solitary, friendless hours in a garden which rarely flowered. Many of the Masses, she was told, were celebrated for the repose of the souls of her parents: her mother, a Tarascan Indian, who had died in 1907 when María was in swaddling clothes; and her father, a *mestizo* laborer, who quickly joined his wife in the grave. María lived with her grandmother and an aunt, excessively religious ladies whose life, according to the custom of that time, daily revolved about the disciplines of the Church. The only xcitement which seems ever to have interrupted the pious grandmother's round of prayers and the small granddaughter's obligatory meditations on mortality was occasioned by the infrequent visits of another aunt who was a nun.

When María was thirteen she was precipitately married to a man altogether unknown to her and much older than herself, a husband chosen by the family in expectation of the grandmother's impending death. María quickly discovered that she had been married into a Mexican matriarchy. The matriarch and the spinster daughters by whom she was amply companioned were not unkind to her. They were merely elderly or middle-aged dames, and very conventional. As time went on, María became inescapably bored.

About 1927 she joined a class in polite painting, largely attended by light-minded young women who wished to spend an hour or two in the week in a livelier spot than the bosom of the family and the Church. For a year she worked industriously at painting satin sofa cushions. The ladies of the household entirely approved of this harmless activity and greatly admired her handiwork. But it was not long before María discovered that painting meant a good deal more to her than an occasional afternoon of escape from tedium. She decided to become a professional painter and entered the National Academy. If family enthusiasm waned, nevertheless middle-aged tolerance allowed her to set up a small studio in the family house.

When Diego Rivera became the iconoclastic director of the Academy

for a brief time in 1926 he saw some of María's portraits and still-lifes. He liked them because they were original, and although he had begun to experiment with an elaborate new curriculum in the Academy, he encouraged her to stay in her studio and paint alone. For a year she worked by herself. She was, she says, wholly ignorant of original works of art, in which Mexico is poor in any case, and had seen few published reproductions. Without instruction she went on producing pictures in her own primitive and personal style.

At the end of the year Rivera organized an exhibit of her work in Mexico City, and wrote for *Mexican Life* a sympathetic although not an extravagant account of it. He spoke of the "proud yet modest" richness of her coloring, a phrase still apt today, and of the tranquil and impenetrable expressions of her portraits. Judging by the photographs, these seem to have partaken of the unstudied impersonality of Mexican colonial portraiture. María's current portraits are mature studies in interpretation, although they are still decorative and unmistakably Mexican.

María Izquierdo is today a luxuriously pretty woman, as pretty as the grown-up niece in her picture "Mis Sobrinas," shown at the Museum of Modern Art in New York in 1940. It is no wonder that she was discovered, ten years ago, to be too attractive to be allowed to live indefinitely in conventual seclusion. Not long after her first exhibit she left home for the more diverting life of the independent studio. Her husband's female relations feared for her morals, her Bohemian friends were anxious about her art. The fears of her friends, at least, were realized. For two or three years María painted imitatively, especially in the current angular style of Rufino Tamayo, of whom she saw a good deal in those days. The pictures produced in the new freedom did not immediately enhance her reputation. The qualities of Tamayo's paintings are so subtle, so dependent upon personal designs and colors, that an imitation of them is likely to have radically diminished values. But Tamayo taught her to use water color and gouache, media in which she has since produced some of her best work. Fortunately he did not try to modify her lavish, decora-

60a. BAREBACK RIDERS

  Water color, 1939. María Izquierdo

60b. CIRCUS PONIES

  Gouache, 1940. María Izquierdo

tive and feminine use of color. After her escape from an alien cloister María took care not to rear up another prison for her gifts.

Since 1932 María, like the young man in Housman's quatrains, has been quite herself again. Outside influences are rarely detectable in her paintings now. She shares her brightly decorated studio with a new husband, Raúl Uribe, a fine draughtsman from Chile, and under his direction she has been sketching conscientiously. Her portraits have become rounder and more sophisticated in design and color, although they remain thoroughly personal. The portraiture shows not a little perception of personality and depth of understanding. The subjects are set against colorful and mirthful backgrounds of animals and flowers. The oldest niece in the "Mis Sobrinas" wears a violet-toned rose tunic in which María often presides at tea, the two little girls are in red and yellow; a Rousseauesque background is filled with orchids and daisies. This work continues the nearly rounded style of the "Portrait of Cathie," the first picture in the new manner. Of slightly earlier date, in somewhat flatter drawing, are a well-known self-portrait and the exotic "Portrait of Tamara," in the collection of the subject, Mrs. Schee of Taxco.

In María's animated gouaches, mostly taken from the provincial circuses, there is a good deal of free and humorous rendering of honest and sincere observation. This is the work of an uninhibited human spirit,—not ladylike, as the painting of Marie Laurencin and Suzanne Eisendieck is ladylike, yet entirely womanly. There are no ascetic restraints in María's use of color, there is abandon in her designs.

The persistence of her naïve and primitive style has obscured the generally undisclosed and rather surprising fact that María Izquierdo is a sound scholar in the field of painting. She has made many experiments with the traditional techniques of oil painting and has successfully published some of her results. She manufactures her own glues from the formulas of Cennino Cennini. She prepares her own mahogany boards for wood-painting by soaking them in hot water, drying them in hot air, washing them with a corrosive sublimate, and coating them with oil on both surfaces. She follows Cennini again in polishing gesso surfaces with

small iron rods until they take on the appearance of ivory. In working up linen canvas she covers both surfaces with three or four coatings of light blue, followed by an application of a paste of flour, walnut oil and white lead. When she uses the gelatine formula with Spanish white, she uses honey instead of glycerine to keep her oil colors bright.

María Izquierdo was the first Mexican woman to make a one-man exhibition in New York: at the Art Centre, in 1929. Other individual showings of her paintings have been held in Paris, in 1937, and in Hollywood and Santiago, Chile, in 1938. Her works have been bought for museums and private collections in England, France, and the United States, India and Chile. Her self-portrait was hung at the World's Fair in New York in 1939.

Raúl Uribe, María Izquierdo's husband, a Chilean by birth, is rapidly becoming a typical exponent of Mexicanism in art. Born in 1912, of a cultivated South American family of unmixed Spanish blood, he is one of a very few Latin-American painters who can write A.B. after his name; and a fine intelligence informs his work. While he was still a member of the University of Chile he went to night classes in the Academy of Fine Arts in Santiago, at a time when the teachers were much influenced by Van Gogh and Picasso. Uribe and his friends first imitated Picasso's Cubistic works and proceeded thence to their own experiments in Surrealism. Dissatisfied with these imitative efforts, Uribe made a comprehensive exhibition of his work in Santiago, in 1936, and sailed for Mexico, the only country in the Western World which seemed to him to have anything of genuine plastic importance going on in it. He now feels perfectly at home in the Mexican atmosphere, and his work is beginning to be favorably known amongst the Mexicans.

Uribe's style is humanistic and personal. He paints children at games, and men and women in everyday attitudes. His treatment of observed life is tender yet strong, his palette is becoming increasingly warm. The water colors which he brought from Chile were cold, particularly in the blue and green areas; but when he began to appreciate the warmth of the

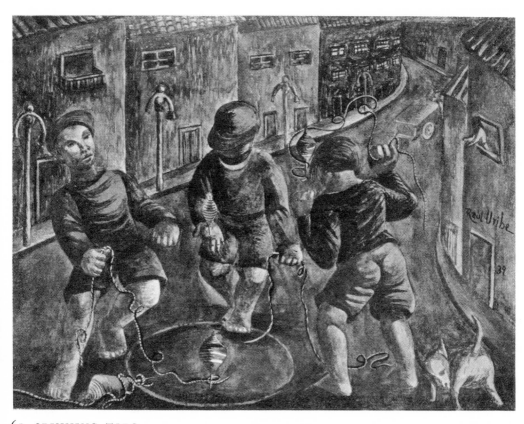

61. SPINNING TOPS

Water color, 1939. Raúl Uribe. From the author's collection

blues and greens of Mexico he experimented with new values of his favorite colors. His preoccupation with modeling has led only recently to his use of oil paint, and he proposes now to work more extensively in that medium. The designs of the new oils are not unlike those of the water colors, but the color is in higher key.

There appears in most of Uribe's pictures, as a kind of secondary signature, a perky dog. A choice souvenir of Mexico in my house at home is a straw basket decorated with Raúl's dog and some of María's birds and flowers. When they came to breakfast with my wife and me on the sorrowful morning of our departure from Mexico City they brought it to us, filled with candy flowers and candied fruits.

A good deal of modern Mexican painting is a little formidable, as it probably should be, because the life of the poor, with which it has been chiefly concerned, is distinctly grim. I have talked to Indian painters who are still near enough to the life of the rural villages to be able to describe the utter dreariness, the forlorn depravity, of the life of the Indian countryman. There are few high lights in such a life. Economic necessity has restrained impulses to happiness. The houses are drab and dark and, in the Valley of Mexico, terribly cold. The sexual life of the people in the rude cold houses is dark and sullen, animal-like, wanting grace and beauty. Children, if they are sensitive, grow up in horror of it; if their feelings are blunter, they become cynical. The *fiestas* which outwardly give color to the Mexican scene merely afford the men of the village protracted seasons for drinking. Only in drink do they find relief from the terrifying urgencies of their lives. Even in the dancing there is little sign of gaiety. Of perhaps twenty regional dances with which I am familiar, I have seen only one, the dance of the Little Old Men of the Tarascan Indians, which provoked mirth amongst dancers and spectators alike.

Painters who have come up out of such a way of life are likely to have missed the comic overtones which an outsider occasionally may have caught. If there is little joy in the heart, life cannot be described joyously.

[ 147 ]

Yet in the midst of the depressing events of daily life many things happen which look funny to the spectator. The comedy may approach tragedy pretty closely, as indeed high comedy invariably does. The highest form of comedy, as George Meredith explains in his essay, "On the Idea of Comedy and the Uses of the Comic Spirit," is that which partakes of, while it yet relieves, a tragic atmosphere. The fool in *King Lear* is a comic creature, but he is not joyous. So the little *campesinos* of Mexico may have small experience of fun while they are yet involved in comic situations. Still, the comic situation is recurrent in Mexican life, and Mexican art would be poor indeed if it were not represented there.

Raúl Uribe paints the children of Mexico at a time before tragic destiny overtakes them. María Izquierdo paints the carnival scene in its outward gaiety and relieves the spectator from the necessity of beholding the gloomy, impassive faces of the people who go to the circus. Antonio Ruiz, a city man of Spanish stock, inheritor of a bright and optimistic nature, gifted with a keen intelligence and a great capacity for sensuous enjoyment,—and withal one of the very best painters in Mexico—sees the comedy without losing sight of the tragedy. The somber side of the Mexican scene seeps through his ironic presentation of the comic spirit. In the present phase of his painting he does not pretend that the countryman is a gay or lighthearted fellow, but he has seen him, objectively, in hilarious circumstances.

In one of Ruiz' pictures a couple of little pueblo Indians stop to gaze at the blonde wax manikins in a city shopwindow. The contrast is so preposterous: the awe-struck wife in her *rebozo*, the gaping young farmer in blue jeans, both of them looking as though they had unexpectedly come upon some modernistic shrine; and inside the illuminated window, posturing figurines in a variety of imported, abbreviated costumes designed for use at a seaside resort,—that even one of the wax models, sharing in the general astonishment, loses her manufactured composure in a returning stare of appraisal.

Ruiz, who was born in Mexico City in 1897, says that he wishes a little Indian blood had run in the veins of his parents so that there might

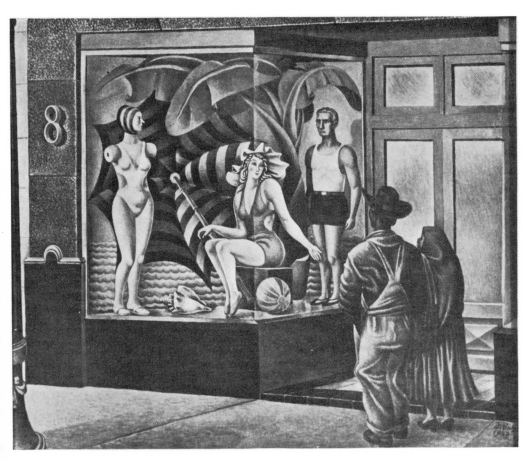

62. THE SHOP-WINDOW

Oil on canvas, 1937. Antonio Ruiz. From the painter's collection

have been introduced into his moderate disposition something of the complexity such a mixture invariably occasions. Few of the Mexican painters grew up in a more polished environment than that of his childhood. His grandfather was a painter, his father a physician, and his mother a concert pianist. Hence Ruiz early became accustomed to a various society. His sophistication is apparent in the controlled and dissimulative treatment of subjects which a less civilized painter might have handled representationally and without humor. Indeed, the not infrequent likening of Ruiz to Rousseau seems to miss the distinction that the paintings of Ruiz are the drolleries of a witty and acute observer, whereas those of Rousseau are genuinely primitive.

When Rodríguez Lozano succeeded Adolfo Best Maugard as director of drawing in the Ministry of Education he instructed the teachers, of whom Ruiz was one, to give coaching in forms, and for subject matter to allow the children to paint and draw whatever they liked. The children painted what they saw at home, and Ruiz learned from his pupils how to look at the Mexican scene: not, like some of the French-trained painters, with the eyes of a delighted stranger, but intimately, sympathetically and humorously.

Because he was occupied with his teaching when Diego Rivera came home, Ruiz took no part in the mural movement sponsored by Vasconcelos. In later years he made, in a building occupied by the union of moving-picture operators in Mexico City, a strong, freely composed mural done in egg tempera, with amusing details that nobody but Antonio Ruiz could have painted. But it is in the small, not to say tiny, canvases that the caprices and brilliant technique of Ruiz are most effectively displayed. He is essentially an easel painter, not a muralist filling in time between commissions.

Ruiz himself does not divide his life as a painter into periods. He paints so slowly, producing no more than three or four pictures a year, that before one is done another has begun to grow out of it. The whole of his work in retrospect seems to follow a more or less continuous plan.

In a private collection in Guadalajara there is an early canvas of a

[ 149 ]

boy sleeping in a garden, of which the precisely painted plant forms inevitably do suggest Rousseau. The remaining matter is treated in the loose style of fresco painting, the figure being modeled large and round. From the same year comes a piece called "Woman Ironing," exhibited at the Art Centre in New York in 1928 and now in a New York collection. It contains a nearly life-sized figure in a setting in which the characteristic brush work of the later Ruiz *miniaturas* is clearly discernible: the graining of a wooden chair and an ironing board, the texture of a plaid apron, the folds of freshly ironed bath towels. There is still, however, a good deal of free movement; the composition and treatment are not yet minutely planned in the Flemish manner. Amongst the first of the miniature canvases was the "Marionettes," a transition piece which attracted critical attention at the Golden Gate Exposition in 1939. The figures in this work are small, but they are broadly treated. The "Fiesta Deportiva" is one of the first masterpieces of the mature Ruiz style, with its firm painting, tight design and subtle modulation of line and color.

I first met Ruiz when Miss Inés Amor brought him to my house in Cuernavaca one day. Roberto Montenegro came to lunch and made jokes about Antonio's little pictures. He called them *tarjetas*, postal cards; and indeed the "Fiesta Deportiva," which is no smaller than any of the last half dozen of the Ruiz canvases, measures only 16½ x 14½ inches. The paintings are as unpretentious as their author, who lives in a tidy blue and white house on a sunny colonial street near the shrine of Guadalupe. Ruiz is not a member of an art colony, although his artist friend, Gabriel Fernández Ledesma, lives near by. His wife is a modest, aristocratic lady, his children are intelligent and well mannered, and he paints, in his upstairs studio, to the accompaniment of a tinkling French music box: in short, everything around him is as neat and bright as one of his own works.

Ruiz is a serious professional painter who gets fun out of life and mature pleasure out of painting. He thinks the art of painting requires the solution of as many intellectual problems as are to be found in any other activity of man. He says that an artist must labor as earnestly to produce

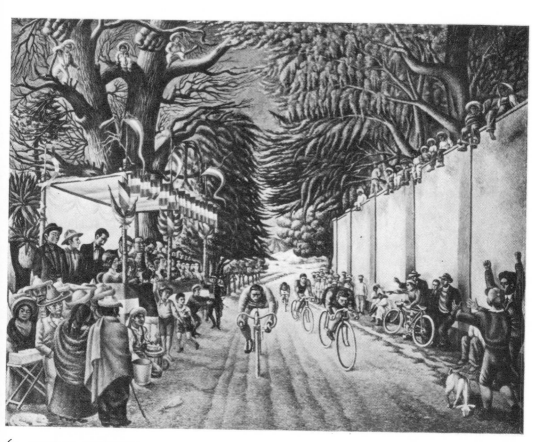

63. FIESTA DEPORTIVA

Oil on canvas, 1938. Antonio Ruiz

a good picture as an automotive engineer designing a new engine. Hence there is dignity and order in his workmanship, tight thought as well as careful painting. He is indifferent to the Impressionists because they were intellectually untidy. When he was a youth in Paris he disliked Montmartre because it stood for waste and affectation and disorder. Although there is no surface trace of the influence of Cézanne and Renoir in his painting, Ruiz respects them for precisely the qualities of mind and character which he himself possesses.

It was indicative of the man when he said one day, while I was making notes about his career over a dish of pigeons, "I have not tried to make my life interesting. I do not give a damn about my life. I try to make my painting interesting." And that is exactly what he does. Every inch of surface he covers is interesting, a fact which alone would distinguish a Ruiz canvas in many parts of the world today.

Although a recent book about certain phases of modern Mexican art lamentably failed to mention Antonio Ruiz, this artist has not at all escaped the attention of painters and collectors both at home and abroad. When his "Street Meeting," a sly commentary on a political demonstration, was shown at the Museum of Modern Art, it even occasioned the linking of his name in the newspapers with the names of the Heavenly Twins. If he has not yet had a wide popular success it is because he is a slow painter and has not produced a great number of pictures. In fact, he has never been able to accumulate at any one time a sufficient number of canvases for an impressive exhibition.

To buy one of his pictures today is a little like adopting a baby from a fashionable orphanage. It is a ceremonious occasion. There must be references and exchanges of good will. Ruiz learns to love his canvases through a long period of gestation and does not part with them lightly. His salary as Professor of Scenography in the University of Mexico gives him a *tente-en-pie*. His painting is therefore not so much a means of livelihood—although he is no amateur—as it is a way of life. You may have Diego Rivera's word for it that a collection of Mexican pictures is

far from complete without a painting by Antonio Ruiz, however hard it is to come by.

Of all the *Solitos*, the most solitary, as well as the most mysterious and inaccessible, is Francisco Goitia. He and his works are so far removed from the public view that few people realize that his genius is no less creative, if his capacity for sustained effort has been slighter, than that of the greatest Mexican painters.

I tried for many weeks to meet Goitia. Miss Amor wrote to him several times in an effort to make an appointment for me, but no response ever came. At length we set out one morning, on the vigil of the Day of the Dead, to find him in Xochimilco. As we drew into the village plaza I began to understand why Goitia had so long lived in retirement there. I had been to Xochimilco before, but only amongst the floating gardens in tourist season. Today I was seeing the real life of the place, only that its tone was heightened by reason of the impending holidays. The plaza was filled with flowers, tens of thousands of marigolds and yellow chrysanthemums for the decoration of churchyard and burial ground. Merchants drove up in trucks to carry away mountains of flowers to the cemeteries in Mexico City. Fallen petals covered the village with a golden carpet, ready for the footsteps of the dead.

Passing through a throng of buyers and sellers of flowers, we came upon the address we had been looking for. The block of buildings to which it pertained was in process of destruction, to make room for a village improvement long advocated by Goitia himself. We looked for the *maestro* in the public schools. Everybody knew him, but it was a couple of hours before we found anybody who knew where he lived. At length we were directed to a shabby settlement on the outskirts of Xochimilco. We followed a railroad track, walking the ties until we reached a crude hut which was sided with irregular and gaping boards and roofed with corrugated tin. This was the abode of a painter who before the Revolution had been a familiar and welcome figure in the most distinguished artistic circles in Europe.

[ 152 ]

There we learned how to find Goitia in Xochimilco. Wearily returning to the town, we discovered him in the midst of a class of drawing. He was teaching perhaps fifty ragged and unlikely looking children. I was immediately impressed by the serene expression of this comely man of fifty-seven-or-eight, and by his dignified and modest bearing. We asked him if he could show us some new pictures. He seemed to be regretful that he had painted practically nothing since he had been commissioned by the Minister of Education, twenty years ago, to record the types and customs of the people of San Juan Teotihuacán and of Oaxaca. But he said that he was beginning to feel the need to paint again, and proposed to spend the forthcoming winter at his easel. He promised to come into the city to visit me the following week end.

Thus I had my first glimpse of this mystical Indian painter, this Saint Francis of Xochimilco, at the season nearest to the hearts of the people to whom he has dedicated his life; whose lowering emotions he has portrayed with unequaled power and sincerity.

Francisco Goitia was born in 1882 on a farm in the State of Zacatecas, where Indian tribes have intermarried for many generations. He went for a little while to a grammar school, but when he was about ten years old it was necessary for him to go to work on the *hacienda* where his father was a peon. He wanted to go to Mexico City to the army school, but his father would not consent to this project. Then, perhaps as much to his own astonishment as to his father's, he asked if he could study painting. He had seen no art forms, apart from the popular arts of his people, but he had grown up in a beautiful countryside, and his feeling for nature, for the woods and streams of the *hacienda*, had stirred in him a half-formed desire to draw and paint.

Just before the end of the nineteenth century his father at length permitted him to go up to the City. At the Academy he became a pupil of Germán Gedovius, a German-trained artist who taught well and painted indifferently. There he remained for five years, with intervals on the farm, and in 1904 Gedovius sent him to Europe on a government stipend. For all his five years in the Academy he was still practically ignorant of

the history of art. He had acquired no standards of judgment and was still ill-equipped to visit the European art galleries, except for the natural refinement of his untutored taste.

In Barcelona Goitia became the first pupil of a new teacher, Francisco Galí, who kept him at the drawing board for three years. Spanish collectors began to buy his drawings, and critics favorably noticed the few paintings he exhibited without his teacher's approval. When the officials at home read that he was being called a Mexican Catalan they agreed to continue his allowance. He went to Italy to study the frescoes, and when the fresco revival occurred in Mexico he was not sympathetic with it. He felt that a technique historically identified with Italian architecture was not suitable for new public buildings at home.

Goitia had his first glimpse of French painting during an international exhibition of art in Italy in 1911. Two pictures of his own hung in that exposition, as many as any painter, living or dead, was represented by. The critics wondered at their thoroughly Italian style. Goitia remembered how Galí had warned him of his dangerous capacity to assimilate, and he decided it was time for him to go home. Meanwhile he had learned to paint, acquired a reputation and achieved a flattering financial success.

Upon his return to Mexico Goitia was plunged at once into the Revolution, a phase of which was fought hotly over the district in which his family lived. He became a member of the staff of General Angela, and while he was in the army he produced three pictures which have become famous in Mexico: the "Revolutionary Ball," a luminous oil; a landscape of white trees against a vibrant blue sky; and a gouache study called "The Hanged Man," a gruesome *calavera* in a torn jacket, inescapably reminiscent of Goya. With these three pictures under his arm he went to Mexico City, after the withdrawal of Pancho Villa, and secured a government commission to go out and paint the "soul" of the Mexican tribes. He moved on to Xochimilco, where the purest Aztec types are to be found, and thence, for a short interval, to Oaxaca, where he produced his masterpiece, the "Tata Jesucristo," in which the world's grief is painted into the figures of two weeping women at a wake. This work, which has

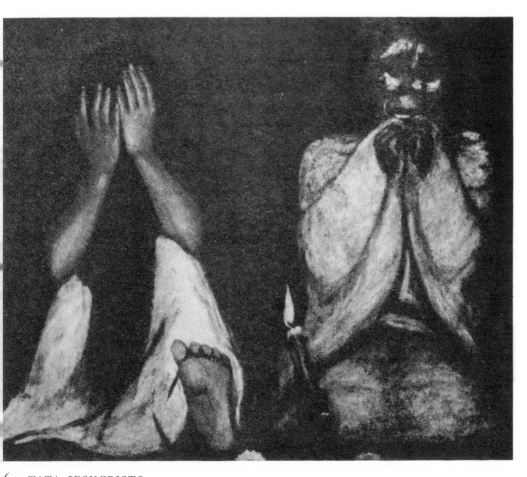

64. TATA JESUCRISTO

Oil on canvas, undated. Francisco Goitia. From the collection of the Ministry of Public Education, Mexico City

been shown over and over again, still drew almost invariable comment in accounts of the "Twenty Centuries" exhibition in New York in 1940.

When the hammer-and-sickle school of painting took possession of the new art movement Goitia withdrew from the public view. He returned without government subsidy to Xochimilco and took up his life there amongst the people. Most of his work, once visible, upon polite inquiry, in the Ministry of Education in Mexico City, has mysteriously disappeared, and Goitia has painted pitifully little during the last fifteen years by way of making up the loss of his former work. He has been bent upon the cultivation of a way of life. Like Gerard Manley Hopkins, who needed a superior in religion to recall him to the practice of poetry, or Michelangelo, who required the nagging insistence of Julius II to gather up his disinclinations, Goitia needs a persistent patron to recall him from his mystic contemplations (and perhaps from his Indian postponements) to the easel.

I should like to add this note: that when the manuscript of this book was nearly ready to be delivered to the publishers I received a letter from Goitia asking to be excused for his failure to paint something new for me to reproduce. The letter expressed inability, ineptitude and despair. Poor harassed man! I should never have disturbed him. He begged to be omitted from the book. "Why," said he, "since I do not paint, must I still be called a painter?"

In conversations and correspondence with American friends I have encountered two recurrent questions. Once people have got over the astonishment of discovering how many good painters there are in Mexico and have acquired a little fluency in reciting their names, they usually want to know what the Mexican Indian painter is like, and why it is that some of the pictures coming from Mexico to be exhibited in the United States appear to be less Mexican than the work of many American artists who paint in Mexico,—the Americans of the school of Taxco, for instance.

It will have been observed by this time how impossible it is to generalize about the Mexican Indian painters. Pacheco, Tebo and Goitia have behaved about as the foreigner would probably have expected them to. They are creatures of the pessimistic indifference to accomplishment which characterizes their race. On the other hand, Galván, Tamayo and Carlos Mérida are no less "Indian," for all their greater culture and sophistication; yet they are ambitious, industrious and disciplined.

I have also tried to explain that what many Mexican painters mean by "Mexicanism" is something that goes deeper into the life of the Mexican people than a reportorial representation, in plastic forms, of the outward scene. If you wanted to buy a picture which would show you, for example, how the plaza in Taxco would appear to you if you were to step out onto it from an automobile, you would do well to buy the work of some American painter who hangs around in one of the bars overlooking the plaza and specializes in that kind of thing. He could tell you exactly what it looks like at first glance. Even Diego Rivera could accommodate you with a water color of a flower girl or a man carrying a bunch of calla lilies over his back, if you wanted (say) a souvenir of a day in the floating gardens of Xochimilco. Because serious Mexican painters try to reach beyond these externals they are sometimes scolded for not being Mexican. When it comes to exhibitions and sales they find that easily recognizable pictures containing sombreros, straw mats and cute babies are preferred by the general public above their own profounder commentaries.

In the long run it would not matter particularly whether the public, critical or otherwise, recognized the racial and national characteristics of their serious works of art, but at the moment the Mexican painters are proud to be identified with what is probably the most vital national movement in the artistic world, and they are unhappy when they are said to be un-Mexican.

## CHAPTER NINE

# Abstraction, Somnambulism and Surrealism

*Modern painting has ceased to copy nature, the better to have*
*a nature of its own.*

José Gorostiza

I WENT ONE NIGHT WITH A
company of painters to see a midnight per-
formance, at the Fabregas, of a ballet
danced by Anna Sokolov's Mexican group.
It was a gala occasion. All of the refugee
intellectuals were there because two of
their number had written the book and
the music of the ballet. The painters were
there because the posters, programs and
sets had been produced by colleagues.
Antonio Ruiz designed the costumes and painted the decor, Lozano made
the posters.

In the center of an otherwise vacant row of stalls in the orchestra pit
there sat, waiting for the tardy members of his theater party, one of the
handsomest men in Mexico. When we filed into our box he looked up
and waved to us.

"There is Carlitos," said one of my companions, "looking as though
he had got plump on abstractions."

Carlos Mérida is not Mexican by birth but he is, rather more than Jean Charlot, Mexican in genre. He was, indeed, the first painter to exhibit in Mexico work of indigenously Latin-American character. He was born in Guatemala in 1893. His father was of pure Maya stock from the Maya-Quiché district, and his mother was a Zapotecan Indian with a single remote priestly ancestor from Spain. Hence his origins are not unlike those of Indian painters born in Mexico; except that his immediate family was in possession of ampler means. He seems to have begun to walk, talk, paint, and play the piano at about the same time. At the age of ten, with a show of precocity not uncommon in the southern countries, he decided to make his vocation in music.

For six years he worked assiduously at piano, musical theory and composition. Then he picked up a catarrhal infection which resulted in an incurable degree of deafness. To comfort himself for the loss of a promising career he took up painting again. He often speaks of his work in musical terms. Even the titles of his pictures sometimes show that he has been thinking in terms of musical composition: for example, "Ten Variations on an Ancient Maya Motive" and "Ten Plastic Inventions on the Theme of Love," the work of 1939.

In 1910 Mérida went with a Guatemalan companion to Paris, lived in the Latin quarter, went about to cafés and smoked marihuana cigarettes with Amadeo Modigliani. He and his friend had read together, in Guatemala, some books about Impressionism and Cubism, and had gone to Paris to see for themselves what was going on. They had the misfortune, as more than one Mexican painter has had in his time, to meet European artists in cafés rather than studios. They were bewildered and shocked by the egotism and brittleness of the talk they heard there. Mérida's companion, in a fit of depression, killed himself. Fresh from Catholic schools, Carlos was afraid to commit suicide, although he says he wanted to. Determined to recover his equilibrium in work, he went for lessons to Modigliani, Van Dongen and the Spanish painter, Angel de Camarasa. With the thought of his friend's death always fresh in his mind, he

worked furiously at the production, so he says, of reflections of the works of his teachers.

For a reason which was never explained to him he was arrested by the United States military police in New York, on his way back to Guatemala, and detained until diplomatic forces intervened to free him. He spent the years of the first World War at home, making decorative pictures on Guatemalan folkloric themes and experimenting with the color harmonies which distinguish his painting today. Curiously enough, he seems to have rediscovered Maya color patterns by himself, before he had seen Maya painting. There are no frescoes in the ancient Quiché ruins near his home, and he did not see the illuminated codices until he went to Mexico. Mérida now depreciates his early Guatemalan paintings, but in 1919 he took them to Mexico City, many months before Rivera's return, and gave the Mexican public its first glance at the prolegomena of a new racial movement which within two years revolutionized the character of painting in the Republic.

When Rivera was commissioned to paint his encaustic mural in the *Anfiteatro Bolívar*, Mérida was assigned to assist him, along with Jean Charlot, Luis Escobar, Xavier Guerrero and Amado de la Cueva, and upon the completion of this work he shared honors with the *maestro* at a fiesta given by the Syndicate. Vasconcelos gave him a wall of his own in the children's library at the Ministry of Education. For this space he designed a Latin version of the story of Little Red Ridinghood, in the stylized manner of his first Mexican water colors. But his real interest had already developed in the direction of nonobjective art, and he soon drifted away from the Syndicate to the easel. After a New York exhibition in 1926 he went to Paris to observe new tendencies, and returned to Mexico in 1929 to begin his life's work in personal, plastic painting.

Inspired by the artistic tradition which his native country shares with Mexico, particularly by the sculptured forms in the ruins in which his own province abounds, he began to paint Maya profiles and figures in water color and oil, using a severely narrow palette. Like Tamayo, Mérida is master of a boundless color range, but in each painting he keeps

[ 159 ]

his color harmonies under strict control. One of the first of Mérida's paintings of permanent value, now in the Armitage collection in Los Angeles, represents two liquid masked nudes in gray, vermilion and blue.

About 1932 Mérida began to make what he now calls a detour into abstraction. He had admired, during his visit to Paris, the work of Klee and Miro, although he was convinced there was no authentic basis for it in the history of European art. He knew of no tradition of abstraction this side of classical antiquity, except at home. The new techniques of the abstract painters nevertheless fascinated him. He set to work to employ them, in relation to designs based on the Maya art forms which had never quite disappeared from a living tradition handed down by Indian craftsmen. Many of his forms, Mérida confesses, have come to him through the medium of relatively recent Tarascan ceramics.

Except for one or two intervals of documentary painting, Mérida went on to refine his abstractions until about 1937, when he discovered he could go no farther. There was, for him, nothing more to paint. The first folio of documents was produced between 1932 and 1934, when he was director of a school of dancing opened by the government in Mexico City for the purpose of exhibiting, preserving and recording the historical dances of the Indians. Mérida's records, which are bound to be of permanent historical value, took the form of colored lithographs. The first set, printed in Mexico and issued by F.A.R. Publishers, Ltd., of New York, contains characteristic costumes and postures from ten popular and colorful native dances: amongst them such favorites as the Plume Dance of Oaxaca; the Pascola and the Deer, traditional amongst the Yaquis; the Umbrella Men of Tlaxcala; the Dance of the Moors from Lake Patzcuaro. A second set, published in Mexico in January, 1940, under the title *Carnival in Mexico*, represents costumes worn at regional fiestas: masks of death and the devil, of realistic and imaginary animals; and the exotic dress worn in dances based upon colonial legends.

A retrospective show of Mérida's work since 1924 is badly needed. It is not now possible to see in any one place anything like a complete view of it, because practically everything he painted up through 1937, when

65. ABSTRACTION

Water color, 1932. Carlos Mérida. From the Weldon Collection,
New York City

he left off doing pure abstractions, has been sold and widely dispersed. Fine examples are to be found, however, in the Rockefeller, Murphy and Rice collections in New York, the Jacques collection in Philadelphia, the Myers collection in San Francisco, the important Arensberg collection of modern art in Hollywood, and in the Art Museum of San Francisco. A Swedish collector found the San Francisco piece so fascinating that he recently went to Mexico City for the express purpose of meeting Mérida and seeing more of his work.

Twenty pictures of the new period which began in 1937 when, as Mérida says, he found his "own way," were shown in New York and Mexico City in 1939, and in San Antonio early in 1940. In these works the artist believes he has succeeded in painting as a Maya Indian might conceivably paint in our time. Yet the style is by no means archaic. On the contrary, it is enormously creative. Each begins with a recognizable if not thoroughly representational theme, a kind of amoebic form suggestive of human personality, which is then developed and contrasted with counter-themes. The rhythms suggest Maya sculpture and relief. The color patterns are harmonious and musical. There is no conventional linear perspective, but depth and variation of plane are indicated by the ebb and flow of color and by the thinning and thickening of line.

Mérida stands, at the moment, so entirely alone in the Western Hemisphere that it is not to be wondered at if his works have required studious examination before arousing sympathy. He has, I have been glad to say to Mexican friends, been conscientiously exhibited and written about in the United States. When he first began to show in New York a few writers were sufficiently confused to report that they could discover little plastic feeling in his painting. Presently, however, discerning critics began to observe that here were works compounded only of pure plastic beauty, first of color, then of line and formal relationships.

Margaret Breuning, who early undertook the appreciative study of Mexican art, was one of the first critics to congratulate Mérida. She perceived in his paintings, she wrote in the New York *Evening Post*, "an echo of Mayan symbolism, as though some of their curious temple carv-

ings were transcribed in a vernacular which we could understand."
Carleton Beals, Edward Alden Jewell, Carlyle Burrows and Henry
McBride all wrote about him with insight and understanding. Walter
Pach, the most *simpatico* of Americans in the eyes of Mexican artists,
pioneered—as is his wont—in the discovery of Mérida.

Even California paid him the compliment, without compensation or
acknowledgment, of projecting, in large murals in the foyer of a Beverly
Hills moving-picture palace, a set of water colors which had been pub-
lished, with a preface by André Salmon, in Paris. The California news-
papers were a little more reluctant in being persuaded to see what
Mérida was doing. It is amusing to read the San Francisco papers about
his exhibition at the East-West Galleries in 1934. The *Chronicle* dis-
played this caption over the reproduction of one of his pieces: "It's Art
But Is It Beautiful?" The first appreciative reviewer on the Coast was, I
believe, Arthur Millier of the Los Angeles *Times*. This honest and
candid critic said that he did not profess to understand abstract art—
hardly anybody did in those days, although many people pretended to—
but he believed he knew distinguished painting when he saw it, and
he saw marks of distinguished painting in Mérida's abstractions.

One of the latest evidences that Mérida is finding a public for his
superb if somewhat difficult painting is the reproduction of one of his
most colorful and complicated pictures by the audacious editors of *What's
New*, the house organ of the Abbott Laboratories in Chicago, on the
cover of their November, 1939, issue. It is a thematic gouache called
"Projection of a Mayan Hunting Party."

Mérida will be of permanent importance in the history of Pan-Amer-
ican art because of the part he has played in the rebirth of the culture of
his ancestors, a culture largely unknown before his time to anybody but
the archaeologists, and now richly renewed with the forms he has re-
created out of it for the advancement of the aesthetic taste of the modern
world.

There has been a good deal of talk in Mexico lately about the propriety

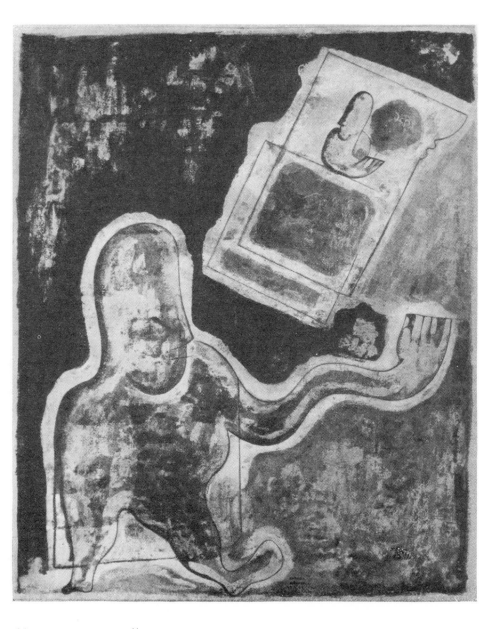

66. ONE OF THE "TEN PLASTIC INVENTIONS ON THE THEME OF LOVE"

Water color, 1939. Carlos Mérida. From the collection of Mrs. Katharine Kuh of Chicago

of the use of the term "Surrealism" in discussing Mexican art. The phenomena which go by that name there are in no sense derivative from their European prototypes. For one thing, the art forms called Surrealistic in Mexico are generally more genuinely imaginative and less intellectual than those of Parisian provenance. Recently exhibited Surrealistic importations from Europe cannot be treated as representative of the best work of the school—certainly the most distinguished paintings of Salvador Dalí, Max Ernst and Yves Tanguy have not been amongst them—but when a collection of them was exhibited in Mexico City in January, 1940, along with the work of six or eight Mexican painters, the Mexican things outshone them in originality and vitality, and sometimes even in virtuosity.

Surrealism can be understood to mean, I think, something more than a suprarationalistic arrangement of objects. It might be allowed to stand, generally, for the high flight of the imagination, and not merely for the school efforts with which it is (historically) associated. If such an extension of the use of the term were agreed upon, it would then seem that the unexpected appearance of (say) a limp fried egg, in a setting not intended to be related to breakfast, would be Surrealism in its lowest form. It does not require imagination, it only requires invention, to give a familiar object a distorted look and an unfamiliar setting.

English poetry long since went through a phase in which invention was accepted as a substitute for the play of the imagination. You have only to compare the imaginative poems of Robert Herrick with the same poet's conceits to see the difference between these two activities of the mind. Mexican Surrealism at its best—and it has reached its highest form at the moment with the advent of a new young painter, Guillermo Meza—is not, like so much of European Surrealistic art, invention at its wits' end, but the free rendering, in good plastic terms, of extraordinary visions.

The thing itself, if not the name, has had a long history in Mexico. Many of the *pulquería* murals were at least suprarealistic. In a barbershop in a cheap hotel near the bus terminal in Mexico City there are three large canvases painted about fifty years ago for the hotel bar. Taking their

[ 163 ]

subject from the name of the bar, *Los Toros*, they show several aspects of bullfighting, but the bullfighters are bulls and the snorting "bulls" are men.

When Wolfgang Paalen arrived in Mexico in 1939 with a collection of Surrealistic paintings and drawings which he and André Breton had assembled for exhibition in New York, he was taken to visit Roberto Montenegro. He inquired how the Mexican painter had happened to become a Surrealist. "It came to me quite naturally, my boy," said Montenegro, "rather a long time before you began to paint."

Roberto Montenegro, who works in a studio filled with rare and beautiful objects, Chinese portraits painted on paper, Spanish chests, Persian rugs and divers creations of popular art, paints with the fastidiousness, elegance and eclecticism that he displays in his collecting. It is probably more difficult to identify any one of his canvases than it is to name the author of any other contemporary Mexican painting; but it will always be distinguished, even when it is not very personal. There was a time, as we have noticed, when he drew in the style of Aubrey Beardsley; at another epoch he painted portraits in the manner of the best colonial portrait painters. But throughout his career he has introduced elements of fantasy into his work, and now he is producing in a deliberately Surrealistic style; a little hard, a little cold, perhaps, but always competent.

Montenegro is perhaps nearest of the Mexicans to the European school because his Surrealism is inclined to be literary. One of his pieces in the new manner, finished early in 1940, was originally planned as the portrait of a boy whom Montenegro had seen and wanted to paint. But while the boy was sitting for his portrait he recited a chapter from his domestic history: a narrative to which there are many analogies on the front page of the second section of any Mexican morning newspaper. Montenegro promptly put it into his picture.

The young man said that opposite his house in one of the suburbs of Mexico City there used to live a woman with a lover who frequently beat her. One day the boy's father, hearing the lady's screams, interrupted a merely routine beating. The lover ran away and the father went to live

[ 164 ]

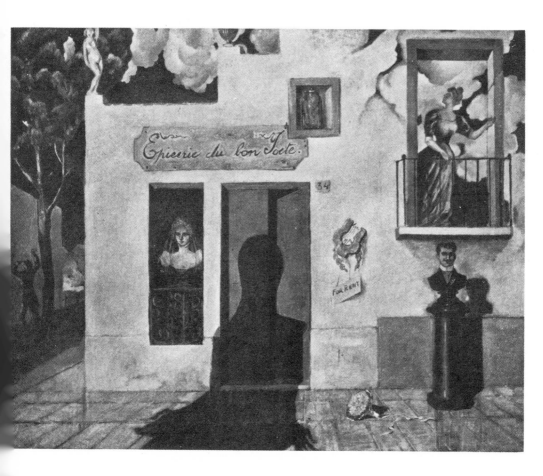

57. L'ÉPICERIE DU BON POÈTE

Oil on canvas, 1939. Roberto Montenegro

with the ill-used woman. After a few days the lover came back, more angry than repentant, it appears. At any rate, he shot and killed his mistress's protector.

As the finished portrait stands it shows the boy, simply treated in Montenegro's actively observed and carefully painted portrait style, against a background executed in a freely flowing, pseudoclassical manner, and illustrative of the harrowing tale. This work was exhibited in the "Twenty Centuries" show.

Another Surrealistic canvas represents the successive acts of a tragedy in which two lovers, portrayed first as busts on marble pedestals, are immutably separated by the madness of the woman and the suicide of the man. They are buried in the left background, and a laconic "For Rent" sign hangs on the front of their house. Pervading and coloring the whole work, as well as well-nigh filling the central foreground, is a purplish Shadow of Death. The style of this piece, at once formal in design and naïve in content, suggests that Montenegro's Surrealism has its origins in *retablo* painting, of which the artist is one of the chief historians in Mexico.

An interesting connection between Mexican and European Surrealism occurs in the person of José Moreno Villa. A man of fifty-odd years, a graduate of three European universities, Moreno Villa is poet, painter, writer and lecturer. His field is the history and criticism of art. During the days of the Spanish Republic he was sent to Washington as cultural attaché. Thence he went as a refugee to Mexico, to the *Casa de España*, a community of about fifty Spanish poets and scholars, the burden of whose exile has been considerably lightened by congenial provision for the pursuit of intellectual activities. He is also an active member of the new *Casa de la Cultura Española*, formed for the patronage of exiled painters and musicians.

About 1924 Moreno Villa began to paint seriously and more or less continuously. He set himself to the practice of Cubism, which, as an historian of art, he had failed to comprehend: hoping to acquire with his

skill what he could not understand with his mind. When he gave up trying to make Cubism intelligible to himself he began to paint subjectively. What he produced was in fact Surrealistic, although it had only a casual connection with the contemporary Surrealism of Madrid.

Moreno Villa was not a member of the group of writers and painters who first published journals of Surrealistic literature and art in Madrid, but he took a lively interest in their work. He was particularly impressed by Salvador Dalí, who was then a young boy living in the same house in Madrid, and frequently accompanied him to the Prado to compare his pictures with the works of great masters. He discussed the new plastic problems with Dalí and his young friends. He tried to teach them that in art, as in literature, there is an inflexible obligation to give interesting and competent form to whatever the painter undertakes to express; that it is much more to the point to paint movingly and personally than to paint cubistically or surrealistically, although the two kinds of object are not antagonistic.

Surrealism took hold in Madrid because the Spanish painters were bored with Cubism,—for the reason that poetry and the imagination were felt to be wanting from it, and because, at the time when a change was wanted, pathological psychology was in the air. Some of the young Spanish painters were attracted specifically to the French version of the new movement. Others, whose interests were largely political—practically all of them were Communists—repudiated Freudian Surrealism and remained in Madrid to work out their problems from another approach. Dalí, who is myopic and likes to work with minute objects, went from Spanish to French and then to German Surrealism: that is, from purely imaginative painting, stimulated by Freudian studies, into the study of pathological phenomena for their own sake. To this German phase of Surrealism belongs the minute and loving painting of worms and insects.

Foregoing the sadistic and masochistic aspects of Surrealistic painting, the Mexican Surrealists—except Frida Kahlo, who is independently and autobiographically an exponent of the school—commonly portray a poetic world. They understand Surrealism in this way: that first of all there is

the real world, in which painting is portraiture, whether of persons or objects. Beyond the real world there lies a world of Ideas, according to the Platonist; a celestial world, according to the religious man; or a world of imagination, according to the poet. The eyes of the Surrealist ought to be turned out upon one of those worlds, they feel, and not inward upon his own vexatious psychology. An example of the related use of the two worlds occurs in El Greco's "Burial of Count Orgaz," in which commissioned portraiture appears in a completely Surrealistic setting.

Moreno Villa's drawings and paintings are free fantasies from the poetic world, whereas Frida Kahlo's are introspective. Agustín Lazo paints witty and recollective projections of amusing childhood impulses against a background of rearranged phenomenal realities. Carlos Orozco Romero, who is a deliberate and self-conscious painter, creates somnambulistic moods. Guillermo Meza's designs come as mysteriously and spontaneously out of a young man's fancy as ever poetic expression flowed from what inexplicable depths through the pen of the youthful Keats.

I had tea with Frida Kahlo de Rivera in the house where she was born, and where she lived in the interval between her two marriages to Diego (and where Trotsky once lived as her guest), on the December day in 1939 when there was handed into the studio a set of papers announcing the final settlement of her divorce from Rivera. Frida was decidedly melancholy. It was not she who had ordained the dissolution of the marriage, she said; Rivera himself had insisted upon it. He had told her that separation would be better for them both, and had persuaded her to leave him. But he had by no means convinced her that she would be happy, or that her career would prosper, apart from him.

She was working then on her first big picture, a huge canvas called "Las Dos Fridas," a symbolic piece in a sufficiently Surrealistic manner to be included in the subsequent Mexican showing of the exhibition brought by Paalen from Paris. There are two full-length self-portraits in it. One of them is the Frida that Diego had loved. This Frida derives her life's blood from a miniature portrait of Diego which she holds in her

[ 167 ]

hand. The blood stream runs in an exposed purple artery to her heart, which is also laid out upon her bosom; winds thence around her neck and proceeds to the second Frida, the woman whom Diego no longer loves. There the artery is ruptured. The Frida scorned tries to stay the flow of blood, momentarily, with a pair of surgeon's forceps. When the divorce papers arrived, while we were looking at the picture, I half expected her to seize the dripping instrument and fling it across the room.

Frida Kahlo was born in 1910. Her mother was a Mexican of mixed Spanish and Indian descent. Her father, a German Jew, was a photographer who specialized in colonial architecture. She was preparing to enter the medical school in the University when, at the age of sixteen, she was in an accident from which she emerged more dead than alive. A truck crashed into a streetcar in which she was riding, and Frida was practically impaled on a steel bar projecting from the truck. Her first thought was that now she would be unable to fulfill her childhood aspiration to bear a child to Diego Rivera—whom she did not yet know. The surgeon's first thought was that his patient could not possibly survive.

After eighteen months of convalescence in hospitals and at home, and while she was still immured in a plaster cast, Frida began to paint. She had not studied painting, had theretofore not even tried to handle brushes. She had seen very little original easel painting, although she knew the frescoes of Rivera, Orozco and Montenegro. She made three pictures, and when she was able to walk a little she took them to Diego's house.

This was their first meeting, although Frida had often watched Rivera on his scaffold in the Ministry of Education. He told her that she painted like Montenegro, and, in his characteristic way, advised her to try something of her own. Then, when he had settled the problem of the painter, Diego began to examine the woman. He became sufficiently enamored of her to propose marriage. In a few months Rivera, for the first time, it is said, was one of the principals at a wedding. For Frida the marriage bed proved to be less productive of aesthetic impulse than the sick bed. She did not paint again until 1932, when she was recovering in the Ford

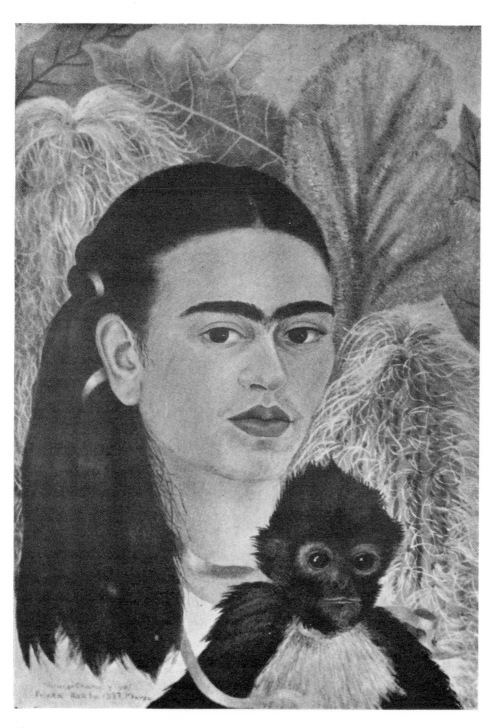

68. FULANG-CHANG AND I

Oil on gesso, 1937. Frida Kahlo. From the collection of Mrs. Solomon I. Sklar, New York

Hospital in Detroit from an operation after the first of a discouraging series of miscarriages.

With Diego's help Frida had begun to make the fabulous collection of two thousand *retablos* with which several of the bedchambers in her own house are decorated. In the Ford hospital she produced her first paintings on tin in the primitive and naïve style of those popular-art forms. One of them shows Frida lying on a bloodstained bed—the blood motif appears in almost everything she has painted—and from a surgical wound in her side there are projected, at the end of tubes which represent umbilical cords, six superficially unrelated objects, all of them reproduced in about the same size: a snail, an orchid, a decorated pottery vase, a fanciful bit of machinery to remind her of Diego, a grotesque little fetus and an anatomical fragment. In the background are the Detroit factories where Rivera was at work, drawing sketches for the murals which he was about to paint (Plate 22).

Another of the Detroit pieces, a bloody item which so far nobody has dared to reproduce, shows a decapitated woman lying in bed with her head between her legs. Called "Nacimiento," I forget why, it was recently bought by an enterprising American collector.

When Frida returned with Diego to Mexico after the Rockefeller rout she began the long series of forthright self-portraits for which she is chiefly known. One of them, framed in Mexican tin, hangs next to a Monet in the house of Edward G. Robinson in Hollywood. Others show Frida with Fulang-Chang, her spider monkey. An atypic *autoretrato*, with a background of birds and flowers, was bought by the Louvre. The self-portrait which is tonally perhaps the most beautiful of all was reproduced in color in *Vogue*, November 1, 1938.

The artist is seldom absent from the productions of her art. Her history is elaborately recorded. There is even a piece to celebrate her conception. Portraits of her parents and grandparents are connected by ribbons with a quaint stiff likeness of herself as a little girl. Upon the skirt of her mother's bridal dress reposes a fetus which represents Frida in about her third prenatal month. This work will of course evoke an image of Rous-

seau's "Present and Past." Elsewhere Frida frequently appears either in person or in symbol. One of her symbols is a Mexican costume. Wardrobes in her bedroom contain row upon row of traditional Mexican dresses which she has worn not only in Mexico but in New York and Paris as well. When I last took leave of her she was standing in her sunny patio, surrounded by her collection of Magaña's stone sculptures, and looking tragically pretty in a sweeping black lace dress.

Until André Breton came to Mexico in 1938 and told her she was a Surrealist, Frida Kahlo had never thought of calling herself by any such name. I think it is entirely probable that she was, as she says, unacquainted with the work of the European Surrealists when she began to paint. There have been pictures with even more morbid details since the tin paintings of 1932, but the seeds of the pathological development of her painting are implanted there, and no Parisian hand has sown them. It is from the pages of her large and esoteric medical library that her ideas have been derived, when they have not been autobiographical or purely inventive, rather than from reproductions imported from Paris. She never saw an original Dalí until the end of 1938, when she went to New York to attend an exhibition of her own work at the Julian Levy gallery.

The modern painter Frida most admires is Henri Rousseau, and there are frequent references to his works in the refined details of plants and trees and flowers recurring in her backgrounds. A tin painting made in 1939 for Dolores del Rio, "Little Girl with a Death Mask," really an enlargement of part of the picture which had first impressed André Breton, "What the Water Brought Me," is a perfect example of Kahlo-Rousseau.

In March, 1939, André Breton exhibited a collection of Mexican art in Paris. It included archaeological objects from pre-Cortesian times; eighteenth- and nineteenth-century primitives, amongst which were *retablos* from the collections of Breton and the Riveras; Mexican photographs by Manuel Alvarez Bravo; and several canvases and paintings on tin by Frida Kahlo. It was to be expected that Breton would write enthusiastically about her. He said that her art was "un art bien féminin, c'est-à-

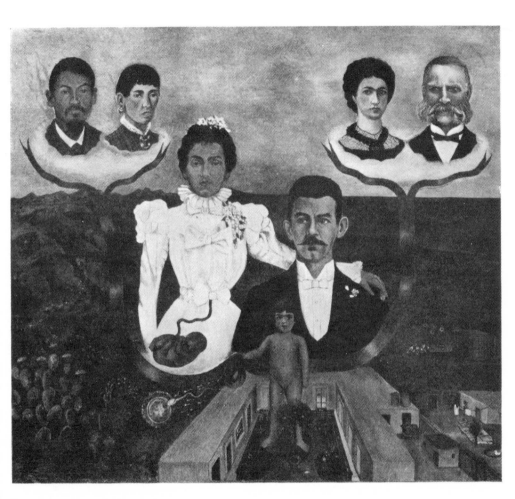

69. MY PRE-NATAL LIFE
   Oil on tin, undated. Frida Kahlo

dire tour à tour le plus pur et le plus pernicieux: un ruban autour d'une bombe." L.-P. Foucaud, writing in *La Flèche*, was also enthusiastic about the purity of Frida's color, the perfection of her designs, the probity and exactness of her workmanship: as compared, he said, to the imposture and carelessness of much contemporary painting in Europe.

The second of Frida's two most ambitious paintings was designed and executed after her separation from Rivera and before her remarriage. It is a Surrealistic piece in which the artist is seated at a table supplied with human legs. She has for company one of Diego's paper Judases, a Posada *calavera*, two children and a baby deer. In the ten years of her first marriage to Rivera she had painted only twenty-five pictures, most of them small. The scope and quality of the new work seemed for a time to justify Diego's view that separation might be good for Frida's art. She announced that she would now have to paint for a living, and her friends were hopeful that she would become an industrious professional painter. But within a few months she restlessly moved on to New York. She must have read frequently in the newspaper columns from Hollywood of Rivera's cavortings with Hollywood actresses. Toward the end of 1940 she went to California to see him, and on the eighth of December, Diego's fifty-fourth birthday, and the Feast of the Immaculate Conception, they were remarried by a municipal court justice in San Francisco.

When I received word of the wedding on the following day I was not altogether surprised. I remembered that after the divorce Diego professed to be lonely for Frida. When my wife and I invited him to come to a party on Christmas Day in 1939 he wanted to know whether Frida was coming. Tears came into his eyes when he asked me if I would go to her house and say that he would like her to come to the party with him.

The studio in which Agustín Lazo paints his imaginative, introverted and amusing oils and water colors suggests the private sitting room of a well-to-do Oxford don. Like the furniture of the mind of its occupant, its fittings are prim and orderly. Everything is fine and in good taste and in its place.

[ 171 ]

Lazo, who was born in Mexico City in 1910, was being prepared for the family profession by his father, a descendant of generations of architects, when Alfredo Ramos Martínez, the director of the Academy and an old friend of the Lazo family, invited him to become his pupil. Most of the students at the Academy were still making, out of habit, the same greasy copies of imported imitations of the old masters, although Martínez himself was then painting landscapes and flowers in good pure color and fresh clean technique. Martínez is perhaps not a highly original painter, but the sources of his inspiration were then untarnished and immediate. He persuaded Lazo that Mexican art needed new voices.

After a few drawing lessons from Saturnino Herrán, Lazo, like Rodríguez Lozano and Abraham Angel, went out to paint alone in the provincial towns and in the country. About the time the mural movement was being focused in the person of Diego Rivera, he went abroad to see the works of his favorite modern painters, Renoir, Seurat, Picasso, Chirico and Van Gogh. He experimented with the Renoir method of making color vibrate by laying it on with multiple strokes of pure juxtaposed pigment. He also tried his hand at Pointillism in the manner of Seurat. From these experiments he developed a personal style of crosshatching, in which fine crossed lines, instead of dots of paint, secure the effect of vibrating light and color. Lazo uses this stroke with telling effect in his water colors.

Although Europe would seem to have been the spiritual home of this mild and ceremonious man, Lazo was eager to return to Mexico. Back in familiar surroundings after an absence of eight years he painted a series of water colors based upon reminiscences of childhood. His grandfather had been the master of stables of thoroughbred horses, and Lazo had heard horsy talk for endless hours. Hence horses trot and gallop across his dreamlike papers. In a water color in my portfolio, "El Fusilamiento," a condemned soldier on a fawn-colored horse gallops away from a squad of frozen riflemen. In another paper an equestrian statue of Charles IV, which stands today, as it did in Lazo's boyhood, at the entrance to the Paseo de la Reforma, lies tumbled upon the ground, while the royal mount, prodigiously pleased, lopes off across the foreground. In "The

[ 172 ]

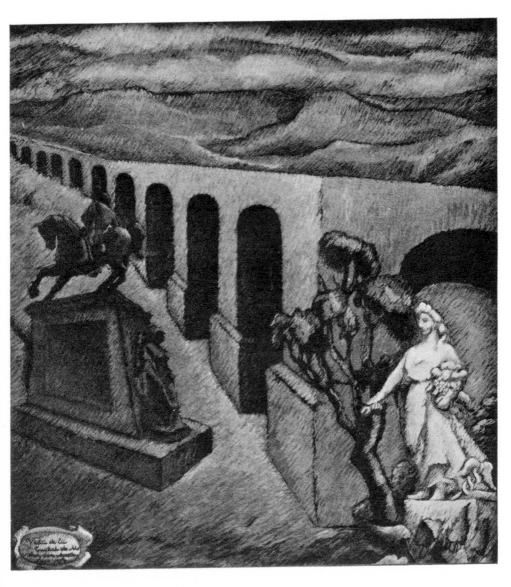

70. VIEW OF THE CITY OF MORELIA

Oil on canvas, 1939. Agustín Lazo. From the painter's collection

Portrait of the Artist as a Young Man," now in the collection of the poet Xavier Villaurrutia, a white horse prances across a patterned green carpet in the family drawing room.

Since 1935 Lazo has continued to illustrate in his oils, most of them landscape and figure studies, the thesis of Pointillism, although he applies the colors in brief strokes rather than at the point of the brush. The brush stroke is similar to that of Van Gogh in the St. Rémy landscapes, as well as to that of Renoir when he first began to enlarge the technique of Pointillism. There, where it begins, the resemblance of Lazo to these European masters ends. He is never violent like Van Gogh, and his drawing is less round than Renoir's and less realistic, and his color, although it is bright, is less luminous. In the newest canvases, to which there adheres a faint aroma of Surrealism, the color has climbed in key to a point beyond which it would be in danger of becoming garish.

Perhaps, instead of a book about Mexican painting, I should have composed a succulent work on Mexican cooking, my researches having been largely conducted in the aromatic atmosphere of Mexican food. I cannot tell exactly how many meals with painters have gone into the making of this book, but I should think an estimate of one hundred would not be a gross exaggeration. My mouth waters when I think about the things I have eaten in Mexico: none of your foul border dishes, but hot onion soups into which salads of ripe tomato and avocado are plunged; roasted snails and planked *huachinango*; baked pigeons with a *mole* sauce hospitably modified for the American palate; rabbit pie of the consistency of pâté de foie gras, and lean ribs of pork baked in deep pottery jars full to the brim with a golden brown nectar of traditional spices; and little wild strawberries with sour cream, and coffee as thick as melted chocolate.

A fortnight before I came home with my manuscript I had lunched or dined at least once with just about every living painter named in this book, except Carlos Orozco Romero: who had been for some months in the States on a Guggenheim fellowship because Guggenheim fellows are expected to travel whither they are not. But about two nights before my

departure for the North I had the pleasure of acquainting myself with the cuisine of the Señora Orozco Romero, sister of the famous Lupe Marín, and after that agreeable ceremony I was shown some of the sources of my host's characteristic plastic forms.

Orozco Romero, who was born in Guadalajara in 1898, first appeared in the public view as a member of the Siqueiros group in the city which has produced so many painters. Like José Clemente Orozco he was first known for his caricatures, of which he drew many for newspapers in Mexico City and some for the *Nation* in the United States. Drawn with telling line, they were reticent in disposition, like the drawings which introduce the several chapters of this book.

After a year or two abroad in the early 1920's Orozco Romero took up painting as a serious profession, although he has since experimented in all sorts of design: lithography, wood carving, furniture design and scenography. For a period of about five years he painted abstractions. In later years, his work has been called Surrealistic, although perhaps it would be more accurate to describe it as Somnambulistic. The titles of his pictures frequently indicate their origin in the subconsciousness, their dreamlike import: "The Dream of a Camera Man," "The Somnambulist," and the 1936 oil called "Desire."

Orozco Romero receives many commissions for portraits, which he executes, for discipline, in polished and relatively classical style. For the most part, however, he prefers free painting in which he can indulge his interest in forms and colors and textures. At one time or another he has been influenced by Tamayo, Mérida and Rodríguez Lozano, whose work he admires for its abounding originality and force. Many of his forms are copied directly or adaptively from objects of popular art, of which I was interested to see a considerable collection in his studio. One of the characteristic forms is a round flaring skirt. This is taken from a clay figurine from Oaxaca, molded into the form of a bell. Over and over again Orozco Romero uses as models clay money banks from Guadalajara. On exhibition in New York in 1940 were several oils which he had made from a

71. THE STAR

    Oil on canvas, 1936. Carlos Orozco Romero

pottery bank in the shape of a woman's head. A gold mask and some Tarascan idols from his archaeological collection have inspired several of his works. His color patterns are likewise traditional. For flesh tints he uses natural sienna, Indian reds and yellowish grays; in costume and background there is frequent use of bluish grays, ochre and reddish blues.

This interesting painter has a special gift for water color, a medium in which he often secures surprising effects by mixing colors to produce rich tones more commonly found in oil or tempera. He devoted the greater part of the year 1940 to engravings on copper according to new techniques and formulas of his own invention. He first makes a water-color version of the design to be engraved and then attempts to translate it as nearly as possible to the plate. The subtle variation of tone and texture is miraculously preserved in the process of translation, by means of delicate adjustments in the process of applying the acids and washing the varnished plates. After a plate is laboriously completed the artist makes his own prints, carefully comparing them with the original water colors and preserving, out of hundreds of prints, only a few which uncannily correspond to the original. In Europe, so far as I am aware, only Georges Rouault takes equal pains over the quality of his prints.

Orozco Romero has had a reputation in Mexico of being primarily a painter's painter. His apparently artless compositions, like the most expensive Paris fashions in other days, are achieved through subtle and costly means, and his colleagues have been quick to perceive and appreciate their values. Still, ever since 1930 his public has been steadily augmented. In that year René d'Harnoncourt, expert in the Indian arts for the American Department of the Interior, accompanied the first important American showing of the works of Mexican artists, on a tour sponsored by the late American Ambassador to Mexico, Dwight W. Morrow. Organized by the Carnegie Institute and circulated by the American Federation of Arts, the exhibition brought prestige to new exhibitors; amongst them, to Carlos Orozco Romero. Products of his diversified artistic gifts have been exhibited in many American cities and

acquired for about twenty public and private American collections, including that of Dudley Craft Watson of Chicago.

To do much more than to recite the name of Francisco Gutiérrez, one of whose works Miguel Covarrubias sent to the Museum of Modern Art for exhibition in 1940, I am unable. I am very much in the position of William Hazlitt, although not for a similarly snobbish reason, when he said at the conclusion of one of his lectures on English poetry, "There is a female poet named Mrs. Hannah More who has written a great many poems which I have never read." I have spoken of his membership in the Group of the Eighteen in the chapter on the younger muralists. I remember that a folio of his works was being shown in the Gallery of Mexican Art about the time I left Mexico, and I have seen one or two illustrated articles about him in Mexican periodicals; but I am familiar with too little of his work to be able to comment on it fairly. What I have seen reminded me, in nearly every case, of somebody else: Orozco Romero, Moreno Villa, Tamayo, Dalí, Picasso. In Mexico he is called a Surrealist. There were memorable qualities of sensibility and lyricism in the painting shown in New York; and in some pastels I have seen, low-keyed colors were used to poetic effect. If, as is said of him, he has taste and intelligence, he can probably one day throw off the influences which now appear to make him rather less than himself.

Mexico abounds in minor artists, some of them teachers of art, others merely talented men and women who have gone for a time to art schools, or have taught themselves, and who, living in straitened cirmustances, paint in their spare time. A few specimens of the work of some of these artists have been on exhibition at the Museum of Modern Art: Mario Alonzo, a self-taught painter who does local color and character pieces in ink and water color and has enjoyed the distinction of being painted by Roberto Montenegro; Fernando Castillo, a newspaper vendor who began at the age of forty to make primitive still-lifes; Juan Soriano, a young man of possible promise from Guadalajara; and Jorge González Camarena,

[ 176 ]

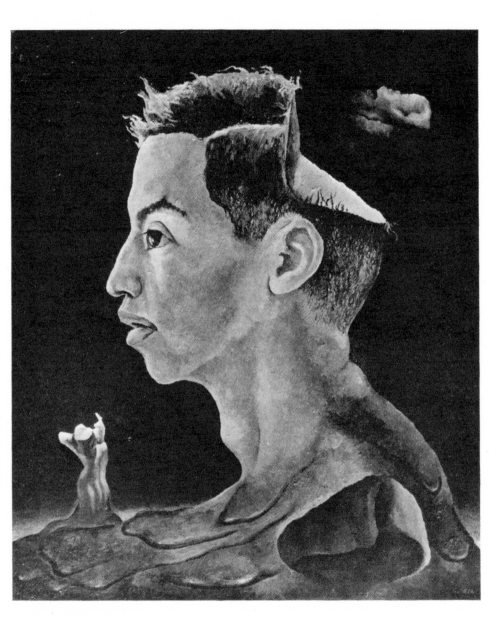

72. SELF-PORTRAIT

Oil on canvas, 1940. Guillermo Meza. From the author's collection

a commercial artist who in his free time has painted some gracefully rhythmic pieces.

The last of my *Solitos* is the youngest, the most inexplicable, and in many ways the most original of them all. Like Galván, he is a born painter. Apparently nobody has ever personally taught him anything much about painting; yet the first things he showed to Diego Rivera early in 1939 are as fine, of their kind, as anything he did in the succeeding sixteen months during which I had almost daily contact with his papers and canvases.

Guillermo Meza is a boy of twenty who took up drawing and painting in dark rooms behind his father's tailor shop because he had been diverted by poverty from the study of the mandolin! It appears that he had really wanted to be a strolling musician. One of many extraordinary paradoxes in this young man's career is that although he is one of the boldest painters of our time, he might never have put colors to paper or canvas if he had had fifty cents a week to pay for lessons in dance music.

To Diego Rivera, ever generous, is due the credit of being the first competent person to give encouragement to Meza. Diego consistently told him to go on working by himself. He thought the few small things the boy had brought to him might even find an immediate buyer. He sent him with a card of introduction to Miss Amor, who was quick to see great possibilities in the new painter. She talked plainly to him, telling him certain of the facts of life that every young artist ought to know. She promised to find a market for his work if he would be content for a time, until a following developed, with modest prices—enough money for materials, for his living, for relief from the fatigues of a gasoline-station job at which he had been working twelve or fourteen hours a day. She undertook to buy his work, to show it at once, and to try to sell and distribute it, if he in his turn would work hard and produce. The bargain was sealed. That day his career began.

Miss Amor summoned her friends. Mrs. A. C. Titcomb of Boston reached the gallery first and experienced the excitement of buying some-

thing from the earliest exhibited folio of a painter who is undoubtedly going to be the successor of Orozco, Rivera and Siqueiros. I am happy to say that I was not far behind. The thin first folio was soon dispersed.

With this small encouragement Meza began to paint feverishly. Now and again Miss Amor told him what she thought was good and why. His first gouaches were not uniformly excellent, but the poorest were never dull. All of them were founded on a sure instinct for drawing. A very good Mexican painter said, when he saw some of Meza's drawings, that he would have supposed their author had been trained for fifteen years in the best tradition. Even when the boy lets himself go with his paints, in a much freer style, it is with the authority of a mature man who knows exactly what he wants to do.

Josef Albers, who came to my house in Mexico just after I had hung two nudes from Meza's second folio—they are numbers five and six in the series of paintings he has allowed the public to see—pointed to one of them and said, "I am convinced by that." It is a monumentally conceived torso of a woman, done in greens and grays and white, with powerful thighs in brown and white and gray. When the painter Gabriel Fernández Ledesma first saw the same picture in my house he was astonished. "What unknown painter in Mexico," he asked, "could be the author of a work which any of the great masters would have been proud to sign?" Wolfgang Paalen recognized Meza as a natural Surrealist and borrowed for his exhibition a gouache called "El Cargador." It proved to be one of the notable pieces in a well-attended show.

Presently the venturesome Institute of Art in Chicago asked for an exhibition, but Meza accepted the advice of his friends to withhold so important a showing until he should have acquired greater proficiency in the use of oil paint. His first oils were by no means so complete as his earliest gouaches. He had asked nobody, and nobody had told him, how to prepare the first pieces of canvas he was able to buy. But quite suddenly, in January, 1940, he appeared to have begun to be at home in the more difficult medium. In February Miss Amor gave him his first exhibition in her new gallery at Calle Milán 18.

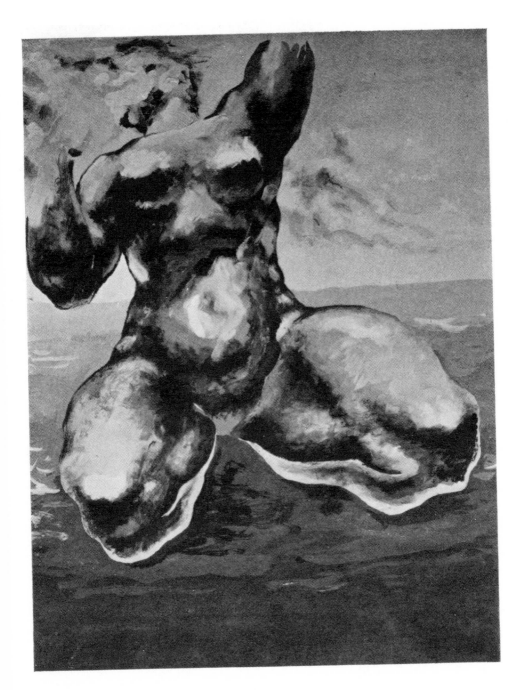

73. NUDE STUDY

Gouache on paper, 1939. Guillermo Meza

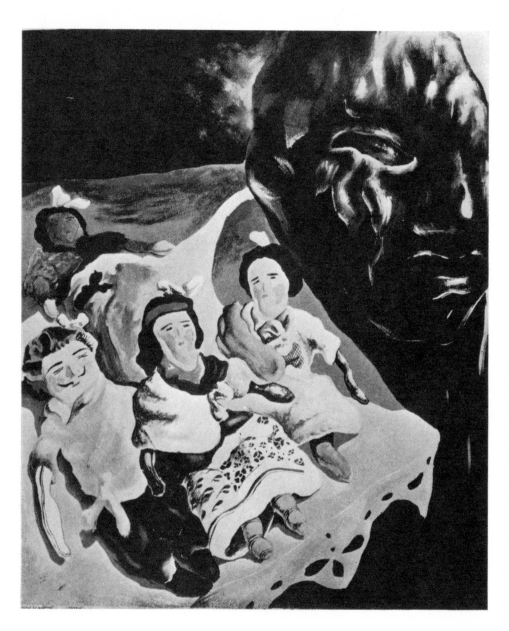

74. THE DOLL-MARKET

Gouache on paper, 1939. Guillermo Meza

The self-portrait reproduced here, a profile of the artist, is the first of the voluntarily realized oils. It shows a strong Indian face, intelligent rather than intellectual, radiant, preoccupied and shy. A segment of the bony structure of the skull is missing; the aperture is lined with sky tones which enliven the rather somber color pattern. Meza's instinctive feeling for what is profoundly right is shown in his use of the same blue tones in outlining the jaw and the ears. In some inexplicable way it is this appearance of inevitability in the use of color, rather than the Surrealistic design, which lifts the portrait far above the level of the ordinary. It is this kind of persuasively true exercise of imagination that makes his pictures exciting.

People to whom the first Meza folios were shown could not believe that they were the work of a relatively inexperienced young man. The quality of the painting, the choice and treatment of subject, seemed to imply a culture which the known circumstances of his underprivileged life could not have produced. The accuracy and expressiveness of his line, the rightness of his forms, the beauty of his color harmonies—even the elegance of his handwriting: these things, people said, do not appear spontaneously.

I invited Meza to come to my house to talk. He came, but he sat speechless and entranced, most of the evening, leafing through volume after volume of reproductions of European paintings. The time came when I was too sleepy to sit up any longer, and I excused myself. Guillermo begged permission to stay on for a time, and for all I know he may have sat up all night.

"I did not know such things existed in the world," he said. *"Desgraciadamente,* we have no such library in my father's house." I believe him when he says that before he went to call on Diego Rivera in 1939 he had seen nothing of European art save for occasional reproductions in the rotogravures.

I have the impression, and so do others of his friends, that Meza is still boyish mentally. He is like Orozco in the singleness of his interests and purposes. He is too young, as well as too instinctively a painter, to be

[ 179 ]

able to make conversation about his work, and he has had too little social experience to make very much conversation about anything else. If he has been endowed with perceptions and feelings which are unlike those of any other person in the world, he reserves comment upon them until he can translate them into paint.

Meza spent a week with me in Oaxaca in the late summer of 1939, in company with Mr. and Mrs. Albers and Alex Reed, and I doubt if he addressed two-score words a day to any of us; but he saw enough to cause him to paint, when he returned to Mexico City, a folio of thirty-two gouaches so widely ranging in design and color that people who like neat categories found they were unable to "type" him. When he paints he is ageless. When he talks, he is, like Keats, an adolescent boy.

It was fascinating to watch him make figure and color notes. Sometimes there was so little of recognizable matter in the sketches that I tried to memorize the scene, in order to compare the ultimate painting with the point of departure. When the shorthand notes had been translated into gouache, when the Oaxaca series was finished, I saw how the born painter experiences plastically what other people behold objectively and casually. For example, we stopped at a booth in the plaza to look at some painted cloth dolls. The hearts of little Mexican girls go out to those chalk-white hussies with rouged cheeks and lips made in the likeness of the Spanish *enamoradas* of the movie fans. Selling for a few *centavos* apiece, they invariably decorate provincial markets. Meza's gouache of three dolls and a gloomy shopkeeper transfigured while it fixed this familiar scene. The very essence of the decorative values of the booth is in the picture, but there is also a profound commentary upon the spirit of the Mexican market place: the contrast and conflict between the Indian's indolent and color-loving nature and the sober exigencies of getting his living; together with a reflection upon the irony of his attachment to the race given to exploiting him.

The piece which Paalen liked shows an unkempt Indian with a land-scape in his stomach,—a creature epitomizing an ubiquitous, iniquitous and omniscient figure in Mexican life. The *cargador* is a shabby redcap

[ 180 ]

who, in every city, carries in his memory all the mysteries, all the obscure and illicit relationships of the hidden life of his community, while he shuffles along with the baggage of the Republic upon his back.

Most of the American collectors who have visited Mexico City during recent months have promptly added something of Meza's to their collections. Some of his pictures have been acquired by staff members of the Museum of Modern Art in New York, and one of them, a portrait study in oil on paper, was lent by Monroe Wheeler for the "Twenty Centuries" exhibition. When the date of Meza's first Mexican exhibition approached, it was found necessary to borrow all of the pictures available in Mexico City in order to make up a representative complement.

It may appear that my enthusiasm for Meza has escaped the limits of control. I cannot help it. It is not often that a man is present at the emergence, from whatever mysterious prelife, of a fresh, original and authentic character into the world of art. It does not often happen that a man can take another by the hand and say, "This is my friend. He is going to be great."

CHAPTER TEN

# The Print-Making Artists

. . . . *the artist who works in this field must depend on symbols.*
*He has no palette and brush with which to interpret the blue of sum-*
*mer sea and sky, the green of rolling landscape, all the multiple*
*shades in which Nature clothes her works; only lines, and tones*
*built up of lines, with which to suggest the strength of the hills, the*
*subtleties of the human form, the nuances of cloud and wave; only*
*lines with which to tell the textural story of things; and, most diffi-*
*cult of all, only lines with which to express and evoke emotion.*
John Taylor Arms in Clare Leighton's *Four Hedges*

IN THE YEAR 1638 JOHN Harvard, a Puritan minister who had come out to the colonies from England, left to a "schoale or colledge" which had not yet been established, although a small sum had been voted for its organization, the half of his small estate and a trunkful of imported books. In the same year the first press in North America was set up in Cambridge. Yet by that time Mexican printers had produced, in Latin and Spanish, about three hundred books of theology and devotion, of which the first had made its appearance in Mexico City in 1535. That book was *La Escala Espiritual*,

[ 182 ]

translated into Spanish from the Latin of St. John Climaco by Fray Juan de la Magdalena and printed by Esteban Martín.

The title pages of the first Mexican books with decorations were usually woodcuts brought from Europe. There is one little book, *Dialectica Resolutio*, of the date 1554, with a title page imported from Edward Whitchurch, the London publisher. The earliest surviving native book decoration was made by an Indian engraver for a work dated 1556. During the last half of the sixteenth century Mexican playing-card makers augmented their incomes by turning out illustrative wood engravings for Lives of the Saints.

Until 1657 frontispieces, headpieces and full-page illustrations were invariably engraved on wood. After the introduction of copper engraving with a hand graver, by Belgian artisans called *abridores*, unbound prints of religious subjects made their way all over the country. Until the end of the eighteenth century the engravers usually copied Flemish, Italian and German stamps, but in 1781 Gerónimo Antonia Gil founded a school of engraving to encourage the production of original Mexican designs. There followed a flood of editions of secular works, notably of *Don Quixote*, with illustrations drawn by Mexican artists and engraved by native artisans.

It was to encourage the development of the art of engraving in New Spain that Charles III, the Spanish king with a passion for fine printing, built and endowed the Academy of San Carlos; but with the death of the first director, José Joaquín Fabrigat, in 1807, the Academy went into a period of decline from which it did not emerge until 1853, when the English engraver, George August Periam, was imported to teach there. After that time the art flourished for half a century. Under Periam's instruction artists learned the techniques of aquatint, mezzotint, roulette, dry point and pencil-imitation.

After the death of José Guadalupe Posada the engraving tradition again suffered a lapse. Nobody seemed to know the techniques. There was no lack of interest in the art amongst the makers of books, but nobody knew exactly how to produce the engravings the publishers wanted.

Then, about twenty years ago, the French artist, Jean Charlot, arrived in Mexico. He was heartily welcomed because, although he was hardly more than a boy, he was possessed of the skills which the Mexican artists desperately wanted to acquire, especially in the techniques of lithography and wood engraving.

Amongst the young men who had been enviously collecting engravings, the like of which they did not know how to produce, were two artists from the north of Mexico, Gabriel Fernández Ledesma and Francisco Díaz de León. Fernández Ledesma had gone to work when he was thirteen years old (he was born in 1900) in a machine shop in Aguascalientes, where he discovered a talent for sketching the geometrical forms turned out on the lathe. Díaz de León had likewise begun to draw when he was a boy. His father, a bookbinder, had encouraged him to study the printing and decoration of books, and when he was ten years old he engraved a set of illustrations for *Salambo*. He had cherished from childhood the Doré engravings for the *Divine Comedy* and *Don Quixote*.

Growing up in the railroad yards, and working as mechanics and carpenters, Fernández Ledesma and Díaz de León,—together with José Escobedo, who, if he had lived, might have become one of the greatest Mexican painters—quite naturally painted subjects of the sort that came to be called proletarian. They did not take any very serious social or political interest in the industrial problems of their town, they simply painted what they saw. Some of the older men in the railroad yards liked the drawings and paintings the boys handed about from time to time, and in 1915 hired a disused loft which was converted into a studio for them.

Presently, however, the town was plunged into the midst of the Revolution. The followers of Pancho Villa were entrenched there, and the Carranzistas came on from the South to mop them up with a technique of fire and shot. Ledesma met Siqueiros, who was then, at the age of sixteen, a staff lieutenant in the Carranza army, and invited him to dinner. He heard from Siqueiros, for the first time, that great things were about to happen in the world of art in Mexico. When Dr. Atl published a few numbers of his *Acción Mundial*, Ledesma and his companions subscribed to it and read about the Socialist movement in the Republic. When some-

body told them that their own painting was socialistic they wrote to ask Dr. Atl if he would come to Aguascalientes to look at it.

Probably no other man of Dr. Atl's consequence in Mexico would have paid any attention to a letter from three inexperienced painters from the North, but the busy Doctor characteristically sent a friend of his to have a look at the pictures. The Governor of the State was so impressed by the deputy's enthusiasm that he offered to send the boys to Mexico City to study. Unfortunately the gentleman died shortly after, perhaps of excessive emotion, and the new Governor could find only forty pesos a month for the venture. He offered this sum to Ledesma, who in turn agreed to share it with Díaz de León. Escobedo cajoled an allowance from his father and the three of them set out for Mexico City. Díaz de León carried in his pocket a crumpled reproduction of a painting by Rubens, Ledesma clutched an album of clippings from the rotogravures, and all of them strapped their carpenters' kits across their backs.

Settled in Mexico City, they entered a drawing class conducted by Saturnino Herrán, who had come from their home town. In the daytime they worked from models and at night Escobedo surveyed the day's work and destroyed it. Agustín Lazo, Amado de la Cueva, Antonio Ruiz and Rufino Tamayo were students in the Academy at the same time, and all of them would have left in discouragement if it had not been for Siqueiros, who organized them—no doubt the organization was announced in a secret manifesto—with a view to exploiting models provided without charge.

To eke out his living Fernández Ledesma found a job in the Department of Archives, copying plans of old *haciendas* for the use of government lawyers in defending dispossessed Indians. He learned first hand of injustices done by some of the great landholders who in times past had gobbled up entire villages. His newly awakened social interests fortunately led him not into politics, but into the hitherto almost unnoticed field of the popular arts. He was sent to Rio de Janeiro with Roberto Montenegro to decorate a Mexican pavilion for the Pan-American Exposition and especially to arrange an exhibition of Mexican ceramics. This commission led to his appointment as director of the pottery depart-

ment in the Ministry of Education, and in connection with departmental publications he turned to the study of printing and engraving. To these arts, as well as to painting, he has devoted twenty years of his life.

Díaz de León meanwhile was active in another of those tentative and temporary relationships with which the student of the history of Mexican art is constantly being diverted: the "Group of Seven." Through this association he was soon taken up by the literary society of Mexico City and early enabled to follow his bent for the design and manufacture of books.

The Mexican poets are fond of publishing single poems or small sheaves of verses in thin volumes with expensive paper and engraved decorations. I fear these works find small sale, but artistically they are often distinguished. Díaz de León and Fernández Ledesma have produced many such books, particularly of the poems of the latter's brother, Enrique Fernández Ledesma, whose death, before his time, occurred in 1939.

Before Charlot's arrival these artists, like everybody then interested in metal engraving, were working with amateurish techniques in a sort of medieval mystical style. Shortly after the revival of the traditional Mexican art forms, which he speedily learned to produce, Fernández Ledesma took his first wood engravings to Madrid and published them there in 1921. His finest prints occur in a series of etchings of circus subjects, sensitively drawn and printed in soft lilac and gray tones. He completed in the spring of 1940 a set of plates on the subject of death, for a book which he is writing on this favorite Mexican theme.

Fernández Ledesma's editorial work—he collaborates with Díaz de León in the art editorship of *Mexican Art and Life*—does not leave him with much leisure for his studio, but he is nevertheless a serious and interesting painter as well. Many of the qualities of his oil painting recall the *retablos* of which he has a large and partially published collection. It is characteristic of the *retablos* of the last fifty years that their authors have not held with any nonsense about perspective. There may be a multiplicity of planes in a *retablo*, but the forms which exist in them are drawn in psychological rather than visual relationships. That is, if a

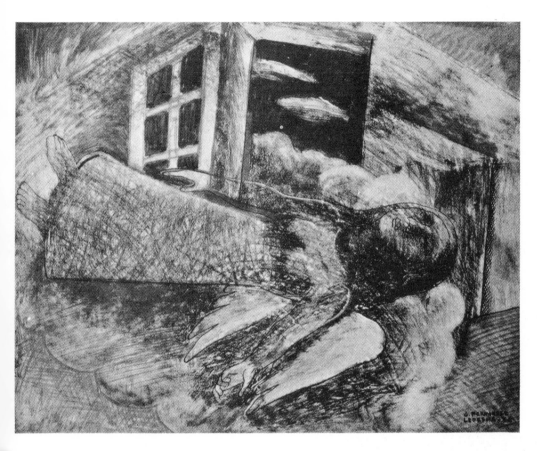

75. MILAGRO IN BLUE AND GRAY

Monotype, 1936. Gabriel Fernández Ledesma

form is important to the story which the *retablo* has to tell it will be a big form, regardless of the plane it occupies. The dramatic effect of the arrangement is thus enormously heightened. The *retablo* influence appeared in Ledesma's oil painting, "The Letter," which was shown in 1939 at the Golden Gate Exposition. His latest oils depict, in somber and tragic colors, the waste, erosion and dejection of the Mexican landscape. One of these new works, the "Adobe House," was exhibited in 1940 at the Museum of Modern Art in New York.

Fernández Ledesma's wife, Isabel Villaseñor, is also a talented artist, and before she gave up art for the superintendence of an attractive household and a savory kitchen she produced many interesting line drawings and aquatints. She fortunately maintains her repertoire of folk songs gathered from every part of the Republic. An evening party is made in Mexico City when "Chabela" Villaseñor can be persuaded to sing them in her full, throaty, unaccompanied voice.

Just before Charlot's arrival the "Group of Seven" created an open-air school at Chimalistac and all the best art students went to it. The prestige of the school was greatly enhanced by the frequent attendance of Lupe Marín who, till Rivera's arrival, used to entertain the lads with her songs and ample beauty. Eventually Díaz de León became the director of one of the many public open-air schools established for the instruction of nonprofessional students, particularly for children. In his book-and-print-lined house there is a fascinating collection of children's paintings of that epoch. Many of them are genuinely moving.

When an exhibition of pictures from the open-air schools went to France it excited the interest of Picasso, through whose influence child painting had immense vogue for a time. The Japanese painter, Kitagawa, a sometime pupil of Picasso, went to Mexico and taught in Díaz de León's school, where he was said to have been a great teacher and at the same time the best pupil in his own class. Kitagawa became in turn the director of the last of the government-supported open-air schools in Taxco. Most group showings of Mexican art, like the "Twenty Centuries" collection, contain at least one of Kitagawa's Taxco paintings. Translat-

[ 187 ]

ing his experiences into his own plastic terms, Kitagawa, more than any other visitor from a different culture—with the possible exception of his compatriot Foujita—sympathetically and accurately painted the spirit of Mexico.

Díaz de León published in 1925 a volume of children's stories, *Campañitas de Plata*, illustrated with linoleum prints and engravings on orangewood. Three or four years later he was invited to direct the department of engraving in the School of Plastic Arts, where his predecessors had acted like alchemists with mysterious secrets for sale. Díaz de León willingly communicated everything he had learned, from practice and from books, and became a leader in the renaissance of the art of engraving which presently matched the revival of painting.

The establishment of a school of the bookmaking arts is Díaz de León's latest labor of faith and love. Under government control, but with a pitifully small official allowance, this night school for working-men provides instruction and practice in the arts and crafts involved in the making of books, from the design and setting of type to the engraving and printing of decorations. The government provides a house on Avenida Bucarelli in Mexico City, supplies two or three teachers, including Díaz de León, and contributes about four American dollars a month toward the cost of operation. There are no tuition charges, but even so, most of the students cannot afford to buy the materials they need; consequently the teachers dig into their ill-lined pockets to buy paper and ink.

Another of the teachers is Koloman Sokol, a descendant of the man who gave physical culture to Czechoslovakia, when there was such a country. So far he has resisted several tempting offers of teaching positions in the United States and remains to labor like a missionary in the Mexican vineyard. Still another colleague is Feliciano Peña, a former pupil of Díaz de León in the open-air school of Tlálpan. He is a skilled wood engraver.

The School of the Arts of Bookmaking usually operates with about fifty students: barbers and streetcar conductors and commercial printers,

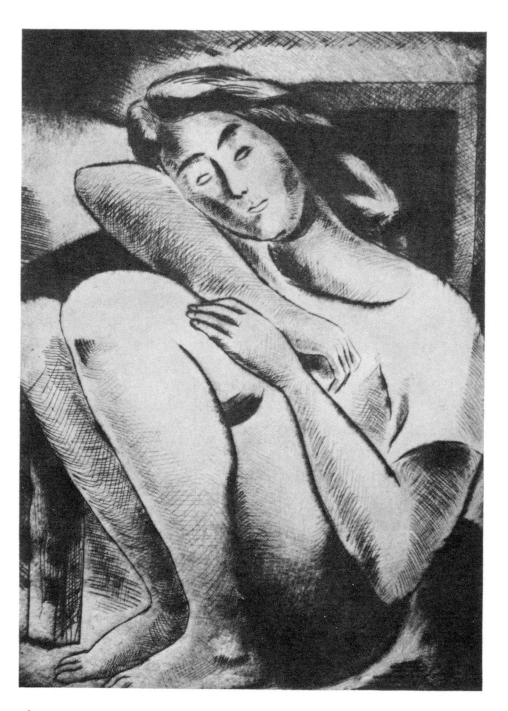

76. NUDE

Etching, 1934. Francisco Díaz de León

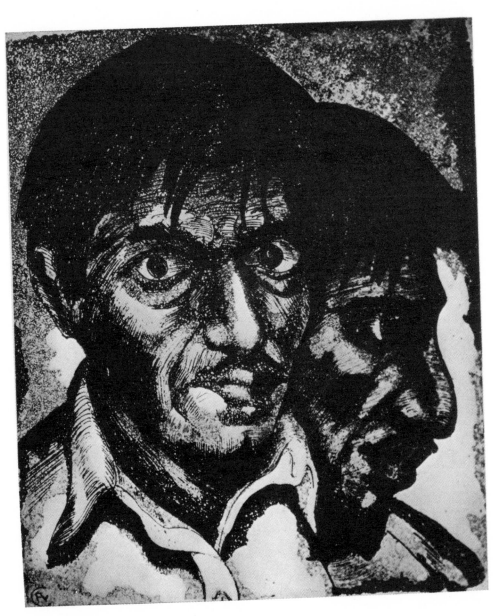

77. SELF-PORTRAIT
    Etching and aquatint, 1939. Francisco Vazquez

together with a few young professional artists, some of them from the United States. An anonymous soldier popped in one day, scratched an amusing satirical design on a plate, and disappeared, as mysteriously as he had come, before ever a print could be made. One of the most promising of the regular students is a versatile young man from Yucatán who signs himself Pancho V. Although Francisco Vazquez is a newcomer to the world of art he is already achieving interesting effects, especially with the transparencies and fleshly textures of his woodcuts. Ten of his works, examples of etchings and dry points, woodcuts and aquatints, were included amongst a group of 109 Mexican prints assembled by the American National Committee of Engraving for an exhibition which has lately been making the rounds of the important American museums. Other pupil and teacher exhibitors from the same studios were Abelardo Avila, Emilio Vera, Mariano Paredes and Gustavo Savin.

Of the Americans who have been guests in the school the most talented is Robert Mallary, a California youth who in a term or two slashed a score or more of vigorous and bold portraits and figure studies on copper plates. The freedom of his style perhaps suggests Rembrandt, at first glance, but his ideas and techniques are fresh, modern and exciting.

One evening I was engaged to meet a few friends, amongst them Paul O'Higgins, at Manrique's famous *tequila* establishment, where for *hors d'oeuvres* you get minute broiled fish with large black eyes. My companions decided the time was ripe for my introduction to the *Taller de Grafica Popular*. We walked over to the avenue Belesario Dominguez and down that shabby street into the dingy quarters of the old city. We entered the patio of an ancient palace, of which a portion of the stately entrance is occupied by a cobbler. It was one of those dreary tenements —you will too often find them in the heart of Mexico City—in which an open-air toilet in the middle of the courtyard disobligingly serves a couple of hundred tenants. In three small rooms off the patio twelve artists contubernally operate a shop which produces today, by and large,

the most glamorous prints to be found anywhere in the Western Hemisphere.

These young men have taken over social responsibilities shuffled off by scores of leagues of artists in the past. They are trying to do, through the medium of printing, what the Syndicate of 1922, the Groups of Seven, Eight, and Eighteen, and the Revolutionary League have severally failed to do: namely, to maintain a community for the pursuit of both aesthetic and political objects. The *Taller* has the advantage over its predecessors in having a sound economic basis. In the three hired rooms the members design their individual works, draw on stone, engrave metal plates, and print, exhibit and sell their several prints. Together they execute orders for commercial printing and lithography for the support of the shop. They make no artificial distinctions between art and politics and commerce, but instead of debasing their art they have succeeded in elevating and dignifying their political and commercial interests.

The manager of the *Taller* is Francisco Dosamantes, a lithographer whose prints, after those of Orozco, are amongst the best of their kind in Mexico. His most popular lithographs have been rhythmical figure studies drawn in rich and velvety blacks on immaculate white back-grounds; groups of women and girls whose *rebozos* and braided hair are wrought into decorative patterns. The profounder designs, for which there has not yet been a spectacular public demand, are usually highly imaginative and personal versions of historical and political themes. "War," the print reproduced here, is characteristic of this artist's treat-ment of serious subject matter. Several print-makers have said that tex-turally it is the finest recent lithograph in Mexico, and it is the artist's own first choice of his work. It bears his customary amusing signature "2amantes," the digit standing for the Spanish numeral *dos*.

Perhaps the leading spirit of the *Taller* group, the liaison man, is José Chavez Morado, a handsome young artist whose portrait appears in one of the murals at the Polytechnic School. Once a pupil of Díaz de León, he divides his time between the *Taller* and the School of Fine Arts in the colonial city of San Miguel Allende. The patron of the school is Cossio

78. WAR

Lithograph, undated. Francisco Dosamantes

79. CONFIDENCES

Lithograph in middle tones, undated. José Chavez Morado

del Pomar, the Peruvian painter, who has restored and fitted up a magnificent old convent to house a variety of departments for the study of the arts. Mexican painters staff the school, and American students have been discovering in increasing numbers that San Miguel, nearer the border than Mexico City, is an accessible, economical and congenial location for painting.

I shall try to outline the mechanics of Chavez Morado's technique because, with a few variations, it is typical of current Mexican lithographic processes. The drawing surfaces of two stones are spread, as is usual, with sand and water, and grained with a slow circular movement. According to the requirements of the design, the texture of the stone is reduced to smoothness or left relatively rough. When the stone is dry the design is drawn with wax pencil or ink, or etched through varnish. The wax of which the pencil is composed is mixed with copal if a hard quality is desired. The black of the pencil is usually lampblack, ground into the wax with ox-grease and turpentine. The ink is manufactured in soaplike form and dissolved in water. A thin solution is applied with a brush, a thick solution with a pen. With one or another of these media, Chavez Morado draws directly on the stone.

The finished drawing is covered with talcum powder, which adheres to the wax and protects and hardens the grease. The stone is then ready for its acid bath, a mixture of nitric acid and glue. This is the trickiest part of the process. As in good cooking, experience and intuition contribute to success. Different areas of a single subtle drawing require varying degrees of exposure to the acid. Next, the surface of the stone is brushed with glue. When the glue is dry the stone is washed with turpentine, which lifts the wax and leaves the drawing almost invisible,— a result which appears mysterious to the layman. Many lithographers leave this step in the preparation of the stone to professional printers, but the conscientious print-maker learns to do the work himself: he knows better than the printer the qualities he desires in the finished print.

There follow in the printing shop several tedious processes which are indispensable in good printing. The stone is vigorously rolled with at-

tacking ink and spread again with talcum in a mixture with resin, after which it receives still another acid bath and turpentine wash. Finally the stone is inked with printing ink, each time a print is made, and printed off onto damp paper. The unusual quality of the lithographic prints on exhibition at the *Taller* proclaims the scrupulous observance of the most fastidious rules of print-making.

Another engaging member of the *Taller* group is Leopoldo Méndez, whose most recent work is a still unpublished lithographic record of American industrial life, a Guggenheim project suggested by a similar work accomplished by the same artist in Mexico. I have seen half-a-dozen rough prints for the forthcoming book, sensitive and socially sympathetic studies of lower-class life in industrial cities in the South: New Orleans, Mobile, Knoxville, Birmingham. Done on zinc, because stones are hardly portable, they show how underpaid working-people look,—their houses, their clothes, their underfed babies. They make, altogether, a pitiful gallery. The Méndez print reproduced here has for its subject the first strike against the Díaz regime. A brief revolt in Orizaba was led by factory women, whom Méndez shows being mowed down by soldiers inspired by Díaz, their Commander-in-Chief.

Most of the *Taller* artists are on the government pay roll. Raúl Anguiano, a promising young man of twenty-four, an art teacher in a provincial school, returned to Mexico City, while I was there, with a series of droll lithographs descriptive of life in the provinces. Ignacio Aguirre, who teaches in an art school for workers, was once a pupil of Rodríguez Lozano, and his work still shows Lozano's influence in drawing and design. It is serene and sculptural. Its mood, recast by the artist's experience since his student days, soberly conveys Aguirre's sincere "folk" feeling. Angel Bracho, who teaches in a regional school for the Indians of Tlaxcala, effectively washes lithographic prints with water color. Like the Budapest artists of a decade ago, Bracho is primarily a painter who has turned to printing for the readier market it affords. An expressionist with personal means of communication, he uses brilliant color and produces rich textures. Interestingly enough, his most acquisitive patron has

80. THE FIRST STRIKE
   Lithograph, 1937. Leopoldo Méndez

been Galka Scheyer of Los Angeles, the American agent of the Blue Four abstractionists. In Puebla Bracho collaborated on Duco murals with Alfredo Zalce, of whose painting I have already written. Zalce, also a member of the *Taller* group, draws on the stone in a style faintly reminiscent of Posada.

Jesús Escobedo, a youth of twenty-one from the State of Michoacán, a pupil of Fernández Ledesma in the days of the open-air schools, is the youngest of the group and promises to have perhaps the greatest popular success. I was visiting the ever lively *Taller* on a day when Escobedo received an invitation from the Art Institute of Chicago to send his lithographic self-portrait on tour with a group of prints from the Seventh International Exhibition of lithographs and wood engravings. Another lithographic portrait, printed in violet ink, was one of the striking exhibits in the traveling show sponsored by the National Committee of Engraving.

Also represented in that exhibition were Isidoro Ocampo, a printmaker who works in the sharp, acid style of most of Orozco's prints, and three *Taller* associates whose work as painters has already been described, Luis Arenal, Antonio Pujol and Paul O'Higgins. The American muralist spends most of his evenings in the shop and enthusiastically shows his colleagues' prints to American visitors.

The *Taller* community has produced broadsides and occasional political newssheets with illustrated ballads and political commentaries sharply critical of Franco, Chamberlain, Daladier and Hitler, as well as Rivera and Almazán and other more immediate reactionaries. They use the traditional Mexican *calavera*, the animated skeleton, in commenting on the high cost of living, the arbitrary regulation of prices, the self-aggrandizement of government officials. A forthcoming production of the group as a whole will be a folio of thirteen lithographs on the subject, "The Mexican People and Their Enemies," in which, in a corporate style roughly suggestive of Daumier, there will be pointed criticism of the press, the trusts, the inadequacy of the national water supply, the bureaucratic mismanagement of expropriated wealth. Altogether, these young men lead an active, exciting and industrious life, devoted to art,

[ 193 ]

loyal to their well-intended political convictions, and accomplishing their objects with competence, intelligence and irony.

Practically every artist in Mexico at one time or another has made prints. Dr. Atl has published several folios of lithographs of Popocatépetl and the Valley of Mexico. Roberto Montenegro has also made many lithographs, including a published series about Taxco, and another which treats surrealistically of elements of Maya design. The Mexican successor to Jean Charlot, who is a master of color lithography, is probably Emilio Amero. He has achieved some quiet celebrity in New York for prints noted for their grace, rhythm, and effective color design.

I do not know how many lithographs Orozco has published, he does not remember himself, but there have probably been nearly one hundred. There are a few prints from a series drawn when he was painting in the Preparatory School; another series dates from his first visit to New York; a third was made in 1930; and a final group of nineteen lithographs was printed in 1934 and 1935. A good lithographic print of Orozco is closer to his murals than Rivera's portable pictures are to his. It is possible to acquaint oneself with the essence of Orozco's early mural period through the medium of black and white, so little was color, in those days, an integral part of his designs. Published, for the most part, in modest editions, the prints are already becoming rare. Some of the earlier ones fetch more than one hundred dollars in the United States.

Siqueiros, as we have observed, published a folio of wood engravings when he was in jail in Taxco. He has also produced a small number of "primitive" lithographs printed in sepia. Julio Castellanos has made several lithographs from his paintings, and Díaz de León thinks they rank amongst the best prints in Mexico. Certainly Castellanos secures many of the rare values of early lithography. He draws on a smooth stone, exquisitely grained, and produces incomparable tonal qualities and textures. Fernando Leal, who painted frescoes in the entrance to the *Anfiteatro Bolívar*, as well as in the staircase of the Preparatory School, is well known

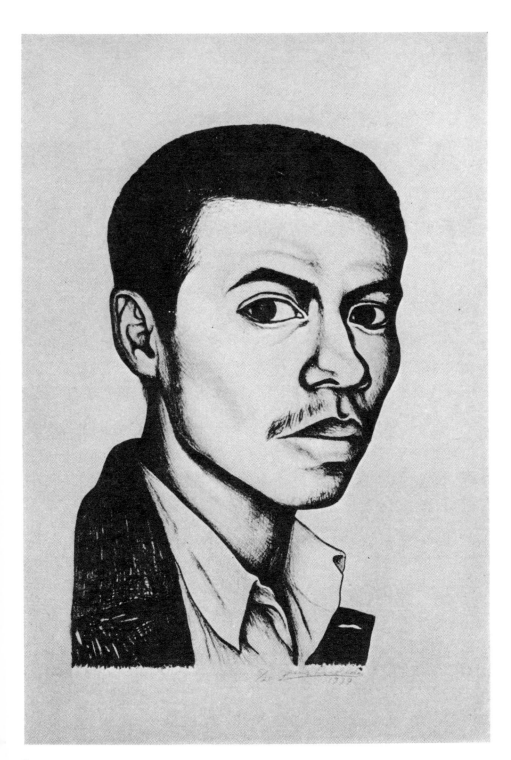

81. SELF-PORTRAIT

Lithograph, 1939. Jesús Escobedo

in Mexico for his woodcuts. He has had several pupils, of whom the most promising is Gonzalo de la Paz Pérez.

Lola Velázquez Cueto, the former wife of Germán Cueto, the sculptor, has lately returned from Paris where she produced tapestry designs, and is now working at engraving in Mexico City: especially woodcuts, aquatints and soft ground varnishes. The mood of her designs suggests the work of a successful American lithographer, Dorothy Gregory. The official teacher of engraving in the School of Plastic Arts is Carlos Alvarado Lang, who has himself produced many handsome prints. He is one of the editors of *Arte en Mexico*, and has written articles on the history of engraving for the new University art periodical, *Arte Plasticas*, edited by Rodríguez Lozano. The ablest cartoonist in Mexico, a man not unworthy to be in the succession of Posada and Orozco, is Ernesto García Cabral of the daily newspaper *Excelsior* in Mexico City.

A book about Mexican artists cannot, of course, omit good-natured and serious-minded Miguel Covarrubias, but outside the pages of *Vogue* it is hard to know where to put him. I have therefore simply put him off till the last, although he would have made a good *Solito*. When he turned up in Mexico City early in 1940 to assemble some pictures for the modern section of the "Twenty Centuries of Mexican Art" exhibition at the Museum of Modern Art in New York, many of the Mexican painters were resentful. "What," they asked, "does Covarrubias know about Mexican art today? He is never here, and besides he isn't Mexican."

Covarrubias was born in Mexico City (in 1904) and keeps a delightful house in suburban Coyoacán, but it is perfectly true that he has lived outside of Mexico for the greater part of his adult life. He early formed a profitable association with slick periodicals in the United States, notably with *Vanity Fair* (before that magazine was economically devoured by its fashionable sister) and when he has not been cultivating his following in New York he has been making literary and pictorial explorations of the South Seas.

For the most part, his painting has been documentary,—straightfor-

ward expressionist representation of the subjects which he handles wittily in black and white. Now that he has definitely expressed a greater interest in writing than in painting, it seems fair to say that in some mural maps he made for Pacific House, the theme building of the Golden Gate Exposition, he just about summed up his special interests and proficiencies as a plastic artist. Six decorative maps, upon which Antonio Ruiz collaborated—three of them were reproduced in *Fortune*, May, 1939, from color photographs by Michael Roberts—compare, by means of amusing forms, the racial stocks, the economy, the flora and fauna of the lands and islands of the Pacific. They represent a fair amount of research and are designed to give painless instruction. The forms are competently drawn with facetious disregard for realistic relationships. It is expert painting, all in good fun, and that is about all there is to be said about it.

On the other hand, some of the Covarrubias drawings and lithographs, for all their smart competence, carry the real weight of observation, partake of the seriousness and insight of first-rate caricature. Good caricature can strike the mind and the heart as well as the funny bone. That Covarrubias can play upon the feelings he has shown in some of the lithographs taken from the colored hot spots in Harlem; whereas the caricatures in *The Prince of Wales and Other Americans*, a successful volume in its time in the United States, seemed to me to afford very little more than superficial amusement value.

Covarrubias and his American wife, Rosa Rolanda, have for their newest joint project a descent into the Tehuantepec peninsula, to write and illustrate a book under the patronage of the Guggenheim Foundation. This expedition may be taken as a good sign that Covarrubias found himself as a kind of scholar-draughtsman during the production of his ambitious work, the *Island of Bali*, published in 1937. That offering contained a substantial text of four hundred pages of excellent writing about the Island and its people, and was illustrated with seventy-five line drawings, ten gouaches and five oils, besides an album of photographs by Rosa Rolanda. Because Covarrubias' researches were sympathetic and extensive, his drawings, always simple and sensitive at their best, were dis-

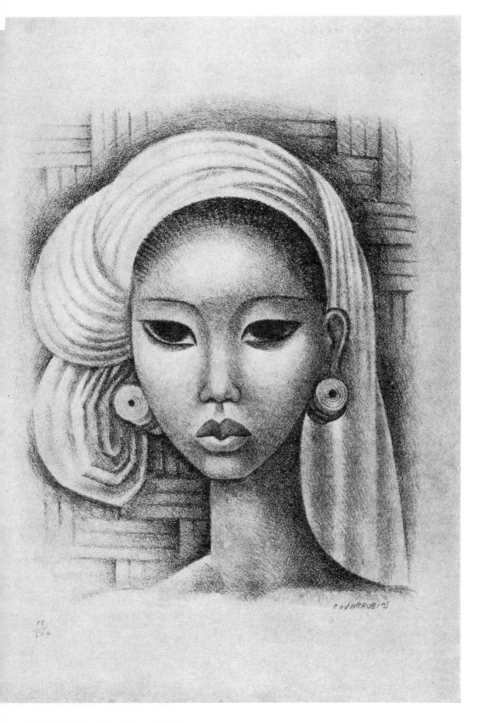

**2. PORTRAIT OF AYA KTUT**
Lithograph, undated. Miguel Covarrubias

tinguished by rather more feeling than is commonly found in documentary art. Covarrubias may, on the whole, have contributed more of publicity than of lasting art to the Mexican movement, as they say of him in Mexico today, but his work is typical of the movement in this wholesome respect, that it is contemporary and alive.

# EPILOGUE

### (for Bill Estler)

I HAVE SAID THAT FROM THE POINT OF VIEW OF THE
Mexican artists themselves there is, properly speaking, no Mexican school
of painting. There is more diversity amongst them than a "school"
logically comprehends. There once was, if you like, a Rivera school, but
that existed at a time when the master did most of the painting and the
pupils merely held the brushes. Ultimately, every good Mexican artist
has gone pretty much his own way.

Even the muralists, for all their syndicates and associations, have not
been coherently related by any really persuasive identity of object. The
Rivera wing of the mural movement has been labeled literary and polit-
ical, but Diego himself has rarely allowed his interest in plastic forms to
be finally distracted by the ideas conveyed in them. On the whole, Rivera
has made a nicely balanced approach to the problem of equalizing the
logical and pictorial elements of representational painting. Opposed to
him on the left flank, openly accusing him of both ideological and plastic
timidities, were younger artists who more frankly, if usually with less
technical proficiency, propagandized the Revolution. His chief adversary
on the right flank, José Clemente Orozco, was intellectually indifferent
to the common ideas of his time. He cared for them only as they were
susceptible of translation into pictorial and emotional values.

As for the *Solitos*, I feel I have nearly done violence to actuality in
reducing the real disparity amongst them by arranging them, to meet the
needs of bookmaking, in conventional chapters. Some of them do, it is
true, fall into recognizable categories, especially the "Mexicanists" and the
suprarealists; but there is today only one consciously coherent group of

artists, the politically minded print-makers of the *Taller de Grafica Popular.*

On the other hand, there are invariable qualities which have been observed in all good modern Mexican art by people who have lived amongst the artists and their works: qualities which establish a given work as Mexican and modern. I have tried to show that these qualities are not necessarily dependent upon the treatment of specifically Mexican subject matter; that a picture which gets its Mexican stamp from a representation of a plaza or a market place dressed up for a festival is only superficially Mexican. The recognizable identificality of a Mexican work of art depends upon something more personal than subject matter taken from the outward scene, something not to be perceived as quaint or picturesque or cute. It proceeds from the inherent structure of the temperament or disposition of the Mexican artists, or is invoked by an atmosphere which stimulates their creative impulses. Three of its outward signs are earnestness, sincerity and unworldliness. Yes, in spite of its aggressive secularity, it is unworldly. The inward and spiritual gift which animates the work is taste, nourished by familiarity with noble antecedent cultures.

I have suggested that three predominant feeling tones are appreciable in the whole range of modern Mexican art: mysticism, pessimism and a strongly inhibited, melancholily conditioned mirth. But the presence of one or another of these feeling tones is not a certain guide in the detection of specifically Mexican qualities, because they appear in the pictures unequally and variably. The ultimate invariable quality or character of a convincingly Mexican work of art is its vitality.

Everybody I know who has made a sympathetic study of the Mexican pictures and has had the experience of living amongst them has put vitality in the first category of appreciation. Alma Reed, a distinguished patroness of Mexican art, wrote in her Foreword to the catalogue for the Macy show in 1940, "Probably no national art in the world today has the vitality of the art of Mexico." The Mexican pictures of which I have been speaking are all alive and communicate to the observer the excitement of partaking in their animation.

[ 199 ]

There is, strictly speaking, no regional painting in Mexico, for the reason that the best painters live in Mexico City. But every man amongst them is rooted in the soil and has been fostered by the traditions of his country. He has created his works of art out of intimate and acute experience of the contemporary life and the living past of a country which is being reborn. The vitality of the new democratic race of Mexicans has been urgent enough to awaken even Indian artists from their natural drowsiness.

To the spectator from the North, accustomed to a European tradition which has assumed technical excellence as an essential means, much of the Mexican painting may seem, at first glance, not altogether proficient. There is precious little virtuosity in Mexico, there is even too little sacrificial taking of pains. But more than two-score living Mexican artists have got something that practice, competence and technical proficiency can never in themselves produce. They have the supreme gift of translating experienced emotion into works of art which give off emotion. And that, I take it, is what those of us are after who go to look at pictures.

# Index of Names

[ 203 ]